Greek Art

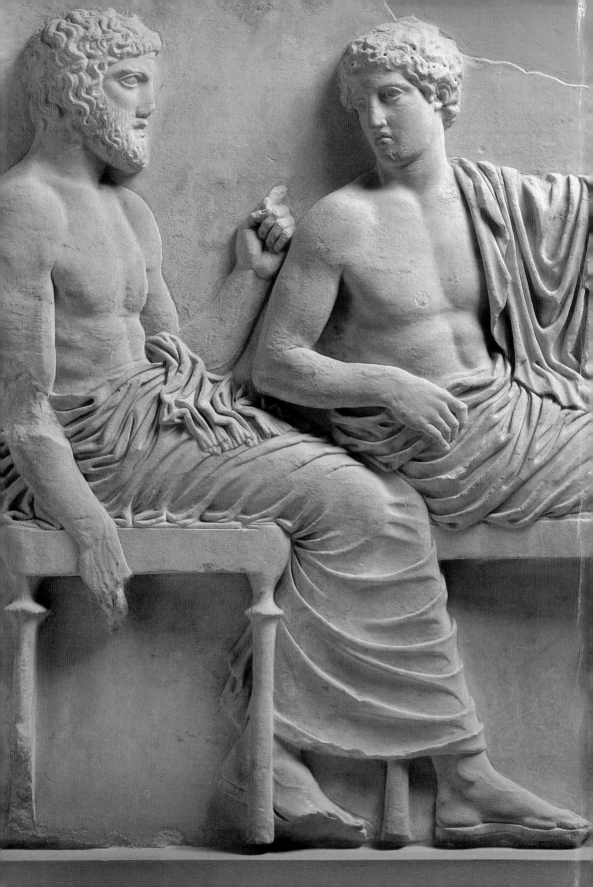

Greek Art

Mark D. Fullerton

CAMBRIDGE
UNIVERSITY PRESS

To Monica, Alex, and Austin

Acknowledgments

The ideas in this book evolved from classroom teaching and informal discusssions with innumerable students and colleagues over the past two decades or so. Especially influential were my many conversations with Alice Donohue and Bruni Ridgway. In addition, Professor Ridgway and Timothy McNiven read through this manuscript in draft form and made many valuable suggestions. For their help, and for that of my editor Katharine Ridler, I am most grateful. Above all, I would like to acknowledge the contribution of my wife, Monica Barran Fullerton, who helped me work through this book from its formulation to its conclusion, who read each word of each draft, and who supports me and my work in every possible way.

Picture Editor Susan Bolsom
Designer Sara Robin

PUBLISHED BY THE PRESS SYNDICATE OF THE UNIVERSITY OF CAMBRIDGE
The Pitt Building, Trumpington Street, Cambridge, United Kingdom

CAMBRIDGE UNIVERSITY PRESS
The Edinburgh Building, Cambridge CB2 2RU, UK http://www.cup.cam.ac.uk
40 West 20th Street, New York, NY 10011-4211, USA http://www.cup.org

© 2000 Calmann & King Ltd
This book was designed and produced by Calmann & King Ltd, London

First published 2000

Typeface Bembo 10.5/13 pt. System QuarkXPress®
Printed in Hong Kong/China

Library of Congress Cataloging-in-Publication Data is available

A catalogue record for this book is available from the British Library

ISBN 0-521-77973-1

Frontispiece Two figures from the Parthenon's east frieze, page 111 (detail)

Contents

MAP OF ANCIENT GREECE 6–7

INTRODUCTION *Concepts of the Classical* 9
Ancient Views 11
Modern Constructs 19
Contemporary Developments 23

ONE *Art and the Polis* 27
The Parthenon Pediments and Periklean Athens 27
The Emergence of the Polis and Geometric Art 35
Political Aspects of Greek Art 43

TWO *Greeks and Others* 53
The Parthenon Metopes: Conflict and Otherness 53
Orientalizing and the Formation of Greek Art 59
Self-Definition 67

THREE *Myth, History, and Narrative* 79
The Parthenon Frieze and History 79
Archaic Art in Context 88
Greek Narrative 97

FOUR *Style* 109
Parthenon Styles 109
Three Critical Periods in Classical Style 116
Style Pluralism 128

FIVE *(Re)constructing Classicism* 141
The Athena Parthenos and its Legacy 141
Hellenistic Classicism 150
Classicism and the Roman Empire 159

TIMELINE 168
BIBLIOGRAPHY 170
PICTURE CREDITS 173
INDEX 174

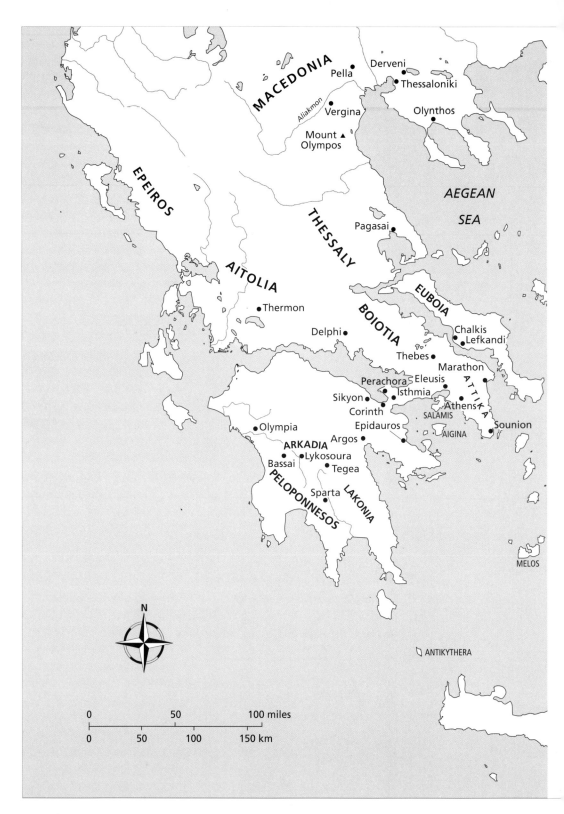

MACEDONIA

Derveni
Pella
Thessaloniki
Aliakmon
Vergina
Olynthos
Mount ▲
Olympos

EPEIROS

AEGEAN

SEA

THESSALY

Pagasai

AITOLIA

EUBOIA

Thermon

BOIOTIA

Chalkis
Lefkandi

Delphi

Thebes

Marathon

Perachora Eleusis
Sikyon Isthmia
Corinth
Olympia
Epidauros
SALAMIS
AIGINA
Athens
Sounion
ATTIKA

ARKADIA
Argos
Bassai Lykosoura
Tegea

PELOPONNESOS
Sparta
LAKONIA

MELOS

N

ANTIKYTHERA

0		50		100 miles
0	50	100	150 km	

Map of Ancient Greece

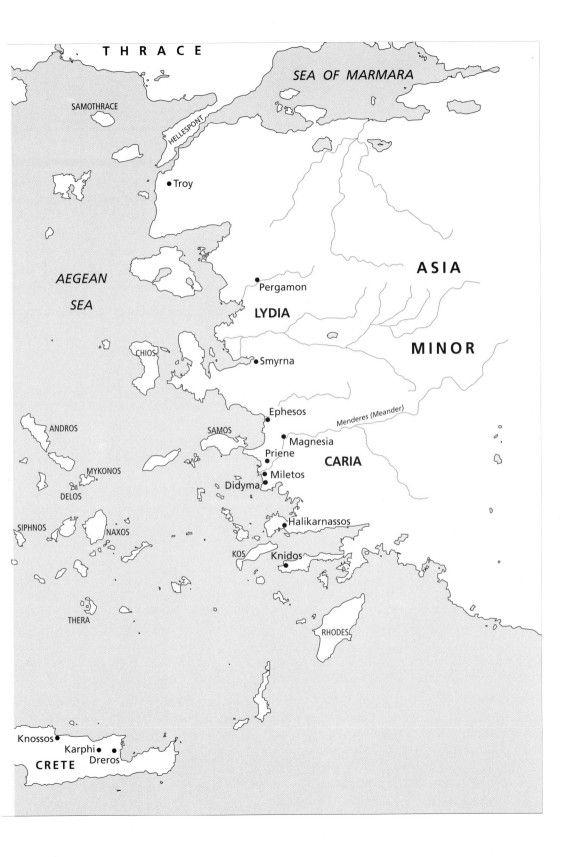

THRACE

SEA OF MARMARA

SAMOTHRACE

HELLESPONT

● Troy

AEGEAN

SEA

ASIA

● Pergamon

LYDIA

MINOR

CHIOS

● Smyrna

ANDROS

SAMOS

Ephesos

Menderes (Meander)

MYKONOS

● Magnesia
Priene ●
● Miletos
Didyma ●

CARIA

DELOS

SIPHNOS

NAXOS

● Halikarnassos

KOS

Knidos
●

THERA

RHODES

Knossos ●

Karphi ● ● Dreros

CRETE

Concepts of the Classical

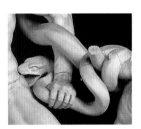

1. Statue of Aphrodite from the Cycladic island of Melos (thus, "Venus de Milo"), ca. 150 BC. Marble, height 6'8¼" (2.04 m). Louvre, Paris.

Found in 1820 and displayed the next year in Paris. Recognition later in the nineteenth century that this was a Hellenistic rather than a Classical work was an important stage in acknowledging the phenomenon of ancient classicism.

When discussing the study of the Classical world, we frequently apply the language of death. Latin and Greek are "dead" languages, and we read of the "death" of the Classics in our schools and colleges. "Who killed Homer?" a recent book asks. Surely, as in any historical discipline which focuses on eras previous to this century, Classics and Classical archaeology concern themselves with the cultures and accomplishments of individuals now deceased. However, we also take for granted that some part of that ancient civilization is alive, that it should be, and in fact that it must be. For much of the second millennium, we in the West have taken for granted that Classical Greece (ca. 480–323 BC) was the source of our shared European institutions and values—the very model of the Western "us" in contrast with the Oriental "them". Thus we commonly accept Classical culture as the "foundation" or "roots" of our own—metaphorical terms which strongly connote the concept of stability, a stability that Western culture has deemed a primary and necessary element of its own self-definition.

It was the Greeks themselves, however, who taught us that all things are in flux and that change alone is eternal. The challenge to the normative status of the Classical is not limited to a benign neglect of Greek and Latin studies. Today, scholars are more concerned than ever with what might be called the "constructedness" of the Classical. Every aspect of that civilization— history, literature, art, philosophy—has been pieced together from scraps of surviving evidence. This process depends on the existence of a framework into which the pieces may be fitted— a framework which is itself strongly preconditioned by *a priori* reasoning. Thus, it may be argued, each generation's understanding

of the Classical is based more on the needs and expectations of that generation than it is on any "factual" Classical past. How can such a protean concept function as a model for anything?

For that matter, why should we even study Classical art? What is its appeal? In what ways is it the foundation for our own artistic traditions? On a very superficial level we can easily recognize its visible legacy, whether in the Renaissance rediscovery of Classical humanism or in the wide variety of "Classical revivals" in architecture, painting, and sculpture that continue into the postmodern present. But the lure is much stronger than that. What separates Greek art from that of other ancient civilizations (and ostensibly Western from Eastern) is its ability to embody an ideal conception of the human form while that embodiment itself continually changes form over time. The appeal of Greek art lies in its unique capacity for displaying both the need for permanence and the inevitability of change; from this quality derives its normative role as a paradigm for later viewers. The story of Greek art today, therefore, can be seen to lie in a series of paradoxes. Greek art is idealist at the same time that it is concerned with the variability of human experience. It is conservative and primarily religious in function while its forms and subjects are constantly developing and expanding. It serves as a model for emulation at the same time that it is constantly recreated and reinterpreted by succeeding generations.

Our view of Classical Greek antiquity is therefore the result of a series of inherited constructs, although the apparent stability of Greek art veils the "constructedness" of the many themes inherent in its study, such as: image, text, and context; race, gender, and sexuality; citizen, nationality, and state. Yet just as much as it is a modern construct, Classical Greece is a historical reality; it did exist, and in that sense it was constructed in another way, not only by its own inhabitants but also by preceding generations. Classical Greece grew from something earlier; its social institutions, values, attitudes, and fundamental artistic principles are traceable back for half a millennium from the time of its greatest achievements under Perikles in the mid-fifth century BC. An understanding of Greek art of the Classical period must be based on an understanding of those earlier developments that made the accomplishments of the Classical era possible.

Ultimately, however, we must focus attention on the constructed entity itself. Rather than suppress or deny the central role of the Classical in our understanding of ancient Greek art, this book instead pushes that centrality to the foreground. The ambiguity inherent in the term classical is exploited, since this text uses

the term Classical narrowly defined (as the period 480–323 BC) to explore certain common features of the term classical broadly defined (as Greek and Roman culture generally). In the remainder of this introduction, I shall present an overview of developing concepts of the Classical from antiquity to the present day. Each succeeding chapter identifies a theme crucial to the reading of ancient Greek art—the political purposes of art (Chapter One), its role in self-definition and the depiction of the "other" (Two), its narrative and historical function (Three), the importance of style in the construction of meaning (Four), and the afterlife of the Classical (Five). Each chapter begins by illustrating its particular theme through the example of the Parthenon. A structure which has stood continually and conspicuously since its completion in 432, the Parthenon more than any other single monument has captured the imagination of succeeding generations as the very symbol of Classical (and classical) civilization. It is unusually well documented, it was richly embellished with figurative imagery, and its materials are, despite the vicissitudes of time, exceptionally well preserved. In the second section of each chapter, the chosen theme serves as the key to exploring one specific period in the development of Greek art; a concluding section demonstrates the universality of that theme throughout Greek art. The object is to respect the chronological development of the visual arts in Greece while at the same time acknowledging the unity of Greek art, especially in terms of the functions it served and the values it reflected. Exploration of the unfamiliar is relieved by periodic engagement with the familiar when the text returns to the Parthenon, as have tourists, students, and scholars for nearly 2,500 years.

Ancient Views

The works of Perikles are even more admired—though built in a short time they have lasted for a very long time. For, in its beauty, each work was, even at that time, ancient, and yet, in its perfection, each looks even at the present time as if it were fresh and newly built. Thus there is a certain bloom of newness in each building and an appearance of being untouched by the wear of time. It is as if some ever-flowering life and un-aging spirit had been infused into the creation of these works.

(Plutarch, *Life of Perikles*, 13 trans. Pollitt, *Art of Greece*)

Like most effective leaders before and since, Perikles (ca. 495–429 BC)—the statesman who guided democratic Athens

2. View of the Akropolis, Athens, from sw to NE showing the Parthenon (built 447–432 BC) and the sw side of the Erechtheion, work on which ended in 406 BC. Other elements of Perikles' Akropolis building program include the Propylaia, a monumental gateway built 437–432 —and the nearby temple to Athena Nike, completed ca. 425.

during the last three decades of his life—grasped the importance of art and architecture. As his biographer Plutarch (ca. AD 50–120) testifies, the monuments erected as part of the Periklean program had an impact lasting far beyond their own time. Of these structures, the most prominent were those on the Akropolis; this high rocky outcrop in the middle of Athens was sacred in its entirety to Athena and thus the center of Athenian religious activity (FIG. 2). Predecessors to each Periklean structure on the Akropolis had been destroyed in 480 BC during the Persian invasion and sack of Athens, but in the following year the Persians themselves were driven from Greece by the Athenians and their allies. After a delay of over thirty years, Perikles' rebuilding of Athens symbolized a closure of the Persian conflict and the beginning of a new era of power and prosperity for Greece's now pre-eminent city-state. Begun in 447 and broken off in 406, the work on his Akropolis program extended over nearly the entire second half of the fifth century, although Perikles himself died well before its completion.

Specialists refer only to the era from 480 to 323 (from the Persian defeat to the death of Alexander the Great) as the Classical period proper. Within this, the half century from 450 to 400—the period of Perikles and his building activities—enjoys the status of being called the High Classical; such designation derives from its universal assessment as a culminating moment in the development of Western culture. Although in modern times we tend to accept this valuation without question, one might wonder how this brief era came to achieve such a status. How, when, and why did later generations come to prize its accomplishments and contributions even more highly than their own?

This concept of the Classical was fully developed by the time of Plutarch and is manifest in the passage quoted. Admiration for Perikles and his works is not limited to Plutarch's heavy use of superlatives—a literary device appropriate to his rhetorical style of biography. Far more revealing is his use of metaphor: the buildings "bloom" and are possessed of an "ever-flowering" spirit. Inherent in this language is the suggestion that art and architecture are to be conceived in terms of an organic process analogous to the cycle of birth, flourishing, decline, and death which governs living forms. In this system, such buildings as the Parthenon represent a stage of absolute ripeness, while earlier and later monuments fall into line accordingly. Yet when applied to marble monuments, this organic quality of perfection becomes permanent rather than momentary and thus is capable of overturning

3. The Canopus of Hadrian's Villa at Tivoli, near Rome, ca. AD 130. Note the statue of Mars, a Roman creation in Classical style. Other statues around the pool include copies (reduced in scale) of the Erechtheion karyatids.

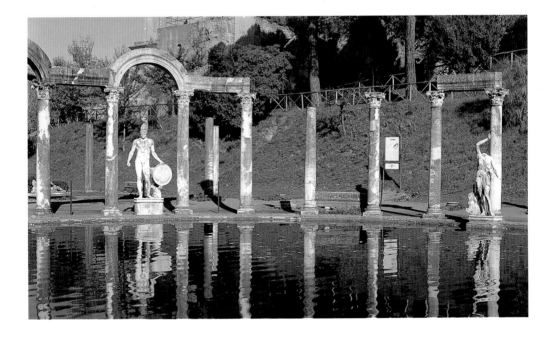

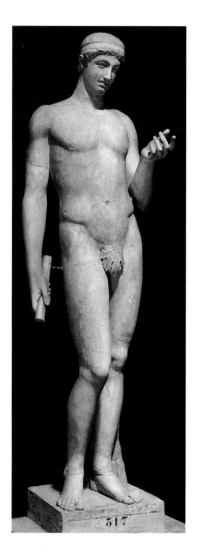

4. Statue of a youth by Stephanos, ca. 50 BC. Marble, height 56¾" (144 cm). Villa Albani, Rome.

Stephanos has signed the statue as a pupil of Pasiteles, who is documented by Pliny and Cicero as a sculptor, metal worker, and historian of sculpture active in the first half of the first century BC. The Classical idealism of this work is believed to reflect an interest in the past attributed to Pasiteles and his school.

the natural order. Plutarch tells us that these buildings are ancient yet look "fresh" and "newly built"; he does not mean simply that they are well preserved, but also that they are timeless in their perfection and thus constitute an everlasting model for emulation. Thus both elements essential to the conception of a Classical art are already present in Plutarch's time. first, a Classical art reflects the peak of a development and thus possesses an unexcelled quality. Second, because of its having achieved a state of perfection, a Classical art functions as a standard or "norm" against which other forms of art are measured.

Plutarch's idea of the Classical is also in accord with our own in its specific association with the era of Perikles; an explanation might be sought in the background of Plutarch himself.

A native of Chaironeia in central Greece, Plutarch—priest of Delphic Apollo, historical biographer, and Platonist philosopher—lived when the intellectual lives of educated Greeks centered on the so-called Second Sophistic. From the late first century to the mid-third century AD, this openly revivalist movement consisted of rhetorical composition and public declamation in patent imitation of canonical Classical orators, most often on a historical topic set in the time before Alexander. For the very wealthy, such display embellished a larger program of public benefaction that provided amenities (for example, libraries, baths, or gymnasia) to the populace and also brought Imperial Roman attention and even consular rank to the benefactor. In most cases, however, these speeches were empty exercises that satisfied the yearnings of a local aristocracy whose education was still focused on rhetoric but whose opportunities for participation in government were limited. A knowledge of, interest in, and yearning for a Classical past were the emblems of prestige and sophistication.

Not unaffected by this environment—and indeed adept at using it for his own ends—was Plutarch's younger contemporary, the Roman emperor Hadrian (r. AD 117–38). He traveled far more extensively than any of his predecessors and conspicuously changed the image of the emperor to a more Hellenized form. At Tivoli, not far from Rome, he built for himself an extravagant villa, sections of which were given "the names of provinces and places, such as the Lyceum, the Poikile, and Tempe" (Historia Augusta, *Hadrian*, 26.5). By referring to Greek locales of such historical, cultural, and religious impor-

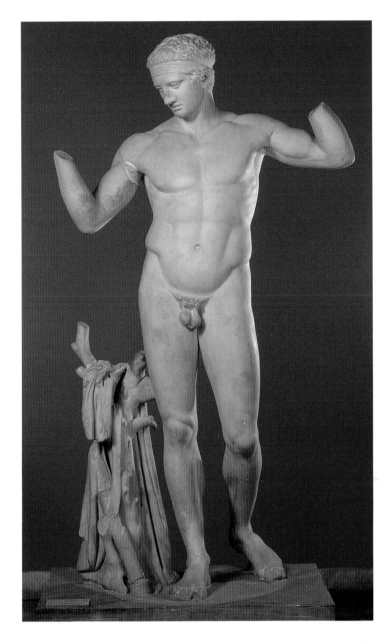

5. Copy of the Diadoumenos of Polykleitos (a lost bronze of ca. 430 BC), ca. 100 BC. Marble, height 6′4¾″ (195 cm). National Archaeological Museum, Athens.

The statue was found in a house on Delos, a Greek sanctuary and major port under Athenian control after 167 BC during the early stage of Roman domination in the eastern Mediterranean. Its title means "youth tying his fillet" and it is held to be the earliest to-scale Roman copy after a Greek original.

tance, Hadrian imbued his retreat with the atmosphere of Hellenism, and reinforced the effect with sculptures. The reflecting basin called today the Canopus (FIG. 3) included in its decorative scheme copies of Classical Greek statues as well as Roman statues created in a Classical style. Although the architecture here was unmistakably Roman, it is clear that the villa's designer wished to fill it with Classical Greek associations in accordance with the Emperors intellectual interests and his cosmopolitan view of empire.

Such reference to the Classical is termed by modern scholars classicism, its examples described interchangeably as classicizing or classicistic. While Hadrian was especially interested in the cultural authority to be derived from a connection with the Greek past, he was certainly not the first to exploit the power of classicism. Earlier emperors—most conspicuously Augustus (r. 27 BC–AD 14) had already used the idealized forms of Classical art to suggest for themselves and their dynasties a status fluctuating between mortality and divinity. In doing so, the emperors continued a tradition stretching back through the preceding Hellenistic period (323–27 BC) in which such images were deemed most appropriate for both the depiction of Greece's anthropomorphized gods, goddesses, and heroes and, by extension, of the human ideal itself. In rhetoric as in art, meaning was conveyed through a contrast between a dramatic or "Asiatic" style and a more reserved or "Attic" counterpart. The Atticists, like their successors of the Second Sophistic, identified the Classical Athenian orators as those most worthy of emulation, although the issue depended more on stylistic appropriateness than any obviously revivalist sentiment. It was in this milieu that the practise of copying Greek statues in marble originated alongside that of creating new statues in imitation of Classical style (FIGS 4 and 5).

The continuing cultural authority of Classical Athens and its art was also acknowledged by the monarchs whose rule replaced that of the very political system (the city-state or *polis*) which made these exemplary achievements possible. Macedonian kings and their Hellenistic successors alike treated Athens with particular respect, despite its relative lack of strategic or economic importance. Several were responsible for significant public works in Athens. The kings of Pergamon, perhaps because of their parvenu status among the Hellenistic dynasts, were particularly enthusiastic about establishing connections with Athens in order to participate in the traditions it represented (FIG. 6).

It is impossible not to wonder whether the Classical Greeks themselves had any notion of how lasting an impact their achievements would have. This was certainly a culture concerned with the ideal. Socratic philosophy as preserved in Plato's dialogues (especially *The Republic* in sections 596–7) asserts the existence of a world of ideal and rational forms that existed behind and apart from the more variable world of human perception. The most tangible reflection of this sentiment in art is the Canon of Polykleitos. We are told that this Argive sculptor (fl. ca. 450–420) "made a statue which artists call the 'Canon' and from which they derive the basic forms of their art, as if from some kind of law" (Pliny,

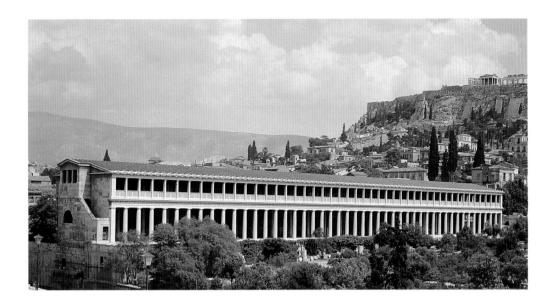

Natural History, 34.55) and that the artist published his system of proportions in a treatise also called the "Canon." Over a century ago, this statue was identified with the *Doryphoros* (spearbearer) type mentioned by Pliny as a work of Polykleitos and preserved in several Roman replicas (FIG. 7). In the view of one Classical Greek artist at least it was deemed appropriate that a work of art should embody an ideal that, in turn, should be followed by others.

Perikles himself clearly felt that the Athenians of his time were exemplary. In the speech attributed to him by the Athenian historian Thucydides (ca. 460–400) and delivered a year before his death, he praises his fellow citizens, their political system, religious customs, and cultural institutions (Thucydides, *History of the Peloponnesian War*, 2.35–45). They serve, he says, as an "education" to other Greeks as to what they could and ought to emulate. The tone of the speech is arrogant and, to use a modern term, nationalistic; it was designed by Perikles to hearten the Athenian populace at the beginning of a difficult war and was used by Thucydides to depict a prevailing mind-set in High Classical Athens.

While Perikles conceived of Athens as a model for the other Greek city-states at the time, it is less clear whether he, or Polykleitos for that matter, believed that his model would have eternal validity or that its status would be recognized by succeeding generations. It is clear that Thucydides, at least, gave some thought to the impact of art and architecture on later observers, as is evident from his ironic comment that, if based on physical remains, future judgments of Athen's power would overestimate,

6. Stoa of Attalos II (King of Pergamon, 159–138 BC) in the Athenian Agora.

The building we see now is a modern restoration of the Hellenistic structure and gives the most vivid picture possible today of the original effect of ancient public architecture. A Pergamene king also dedicated sculptural groups on the Akropolis which commemorated Attalid victories in Asia Minor.

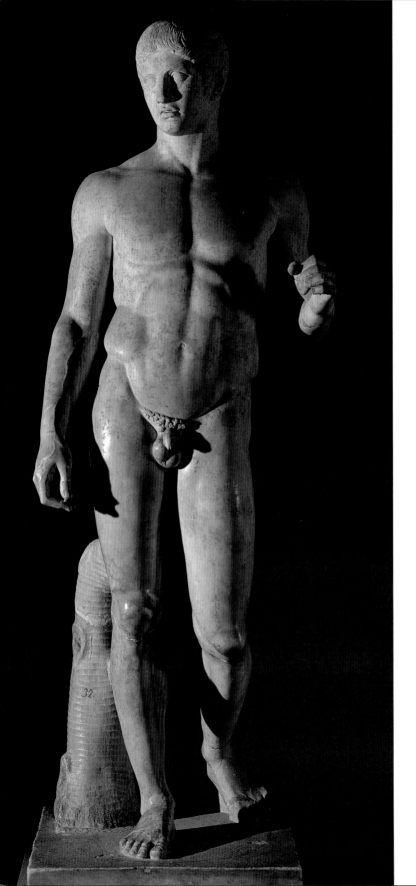

7. Copy from Pompeii of the Doryphoros type, believed to represent the "Canon," a lost bronze original by Polykleitos, ca. 440 BC. Marble, height 6'11½" (2.12 m). National Archaeological Museum, Naples.

This statue embodies a system of proportion and perfect dynamic balance that has come to stand for the idealistic nature of the High Classical period generally. The original's influence was great from the moment of its creation, as seems to have been the intent of its sculptor.

those of Sparta's underestimate (1.10). As we shall see, the Greeks throughout their history were interested in identifying and analysing ideals, and while there may have been some sense among Perikles and his contemporaries that they were living in a special time, the normative status eventually enjoyed by the Classical epoch could only be bestowed by posterity.

Modern Constructs

The term Renaissance means, of course, rebirth and what was reborn in Europe beginning in the fourteenth century was an interest in and respect for the Classical past. During the millennium which separates pagan antiquity from the Renaissance, the accomplishments of the Greeks and Romans were far from entirely obliterated or forgotten. If not for the industry of medieval scribes, for example, our knowledge of Classical literature would be meager indeed. But for the most part Classical humanism and idolatry was considered at best alien and at worst threatening. When Renaissance scholar-artists sought expression for their newly awakened sense of reason and individual value, antiquity offered an alternative model to the "barbarism" of an oppressive High Gothic spirituality with its ornate forms. It was no accident that the Renaissance first took root in Italy, where antiquities were virtually springing from the ground. At least in part inspired by the increasing numbers of ancient statues and reliefs, Italian artists of the early Renaissance developed with unprecedented success the craft of representing the world in a style both highly idealized and grippingly naturalistic, especially in contrast with traditional medieval forms.

A few points about Renaissance attitudes toward the Classical are of special importance. first, Renaissance artists did not revive or imitate Classical styles and figural types so directly and thoroughly as did their Hellenistic and Roman predecessors. Secondly, the rebirth itself was as much an intellectual, spiritual, and literary phenomenon as it was grounded in the visual arts. Renaissance culture reflects an intimate encounter with the Classical world, but it is itself something entirely different and, importantly, Christian rather than pagan. finally, the Classical world which captivated the Renaissance imagination was essentially a unity, with no concern for the Greek–Roman dichotomy that organizes more modern approaches (FIG. 8).

The most important Renaissance legacy for the later study of ancient art consists of the many great collections of ancient objects, especially sculpture, eagerly assembled by the great papal

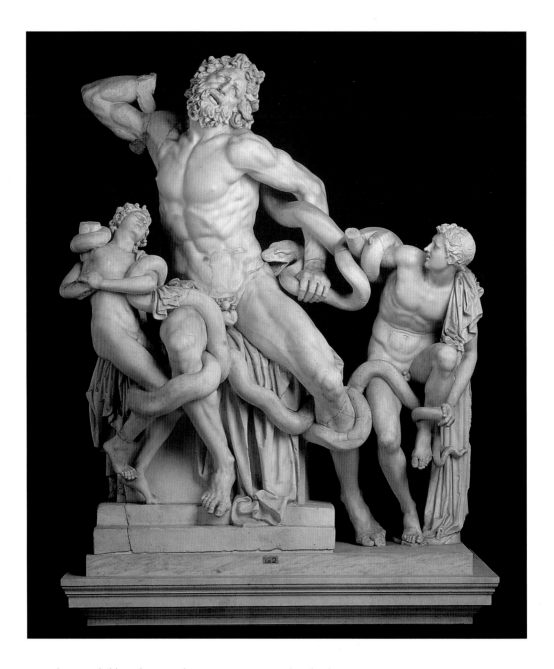

8. Laokoön, probably Early Imperial Roman (Augustan to Julio-Claudian eras), 1st century BC–1st century AD. Marble, height 72½″ (184 cm). Vatican Museums, Rome.

The Trojan priest Laokoön and his sons are being attacked by two long snakes at an altar, perhaps in punishment for advising against admitting the wooden horse into Troy. The statue was found in Rome in 1506 and valued for the next three centuries as one of the greatest works of ancient art. It is believed to preserve or copy a late Hellenistic or Roman group seen by Pliny (d. AD 79) and carved by the Rhodians Hagesandros, Athenodoros, and Polydoros. Its vivid, even exaggerated, emotional style seems to our eyes the very antithesis of Classical idealism, but such distinctions did not exist until modern times.

families of Rome from the sixteenth century onward. The names Medici, Farnese, Ludovisi, and Borghese are still imprinted on many famous statues, as will be seen in this book. The habits of the powerful were eagerly taken up by those of lesser circumstances: for some three centuries following 1500, one can trace a proliferation of collections both major and minor, the diffusion of objects from Italy to the rest of Europe, and a widening spread of familiarity with superb ancient works through casts, prints, and pattern books. And all this took place with little or no interest in separating the Greek from the Roman.

Such a distinction became increasingly evident in the second half of the eighteenth century as a consequence of more careful reading of ancient literature, a greater familiarity with actual examples of Greek art, and an intellectual environment that fostered the construction of a classical ideal. Although Cyriacus of Ancona had brought back sketches of the Parthenon as early as the fifteenth century, access to Ottoman-controlled Greece was for Westerners severely limited. However, between 1751 and 1787 at least three different studies of the most important visible Greek monuments were published in France and England—complete with detailed drawings of architectural elements and sculptural embellish-

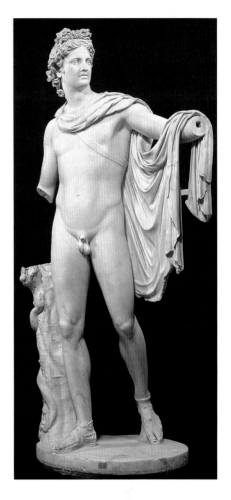

9. Belvedere Apollo, 2nd century AD. Marble, height 7'4¼" (2.24 m). Vatican Museums, Rome.

So-called from its location in that portion of the Vatican complex, the statue's first record shows that it was already in the papal collection in 1509. It was regarded by Winckelmann as the epitome of Greek achievement, exemplifying his "beautiful" style. Scholars today consider it a Roman work, perhaps deriving from a Hellenistic source.

ments. At the same time, in the turmoil of revolution and the excitement of the Enlightenment, an entirely new interest arose in identifying a truly classical (in every sense) model for emulation—one which displayed a purity of form in contrast with the excessively indulgent and monarchic Baroque.

For our purposes, the most important work of that time was undertaken by Johann Joachim Winckelmann (1717–68), "the father of modern art history." In his *Geschichte der Kunst des Altertums (History of Ancient Art)*, Winckelmann seized upon the organic metaphor preserved in Plutarch and used it as an organizing principle for a history of Greek art. His "history" consists of four stages: an "older" style corresponding to the pre-Classical (before 480—what we call Archaic), a "grand" style corresponding to our Early and High Classical (480–400), a "beautiful" style corresponding to our Late Classical (400–323), and finally an era of "imitators" located in Hellenistic and Roman

times (FIG. 9). His system of flowering and decline includes a rather long "peak," since he is not at all clear as to whether the "grand" or the "beautiful" style should be considered the ultimate achievement. Winckelmann did not stop at establishing this pattern of stylistic development, he also provided an explanatory context. Although his historical observations sometimes contradict his organic model, his main point is clear: the great achievements of Classical Greece are to be understood as resulting directly from the democratic circumstances of their creation. He was indeed a man of his times.

It is remarkable that Winckelmann was able to formulate his theories in almost complete ignorance of actual works of Greek art. It has only recently been recognized that his system was based at least as much on his familiarity with ancient literature as it was (as he himself claimed) on his direct examination of works of art. Nonetheless, his basic principles—the periodization of Greek artistic style, the elevation of the fifth and fourth centuries as "Classical", and the tight linkage of stylistic development to political history—remain to this day the foundation of the study of ancient Greek art. Indeed, modern attitudes toward the Classical, despite two centuries of refinement, still tend not to vary greatly from the Enlightenment awe so eloquently represented by Winckelmann.

During the nineteenth and twentieth centuries studies of Greek and Roman art, like everything else, have become more scientific. The period began with a dramatic increase in the direct knowledge of the subject from the enormous influx of original Greek art into Western Europe. This era was ushered in by the display in 1807 of the Parthenon marbles brought to England by Lord Elgin and since 1817 to this day housed in the British Museum. These sculptures were later joined by others from Greece and Asia Minor. Around the same time the Louvre acquired its two most famous Greek statues, the Winged Victory (Nike) of Samothrace and the Aphrodite from Melos, the Venus de Milo (FIG. 1). European museums were further enriched by systematic excavations in the Greek world, such as those which provided the Aigina sculptures in Munich and the Pergamon sculptures in Berlin.

The nineteenth century was also the era when modern philological scholarship was born, and a byproduct of this systematic scrutiny of texts and inscriptions was the compilation of documentary data about ancient artists. It was inevitable that scholars would attempt to connect the images with the sculptors. However, the examination of original sculpture (most of it anonymous architectural work) made clear one discouraging limitation. Virtually every "classical" statue at hand in Europe

was in fact Roman in date. Therefore, in the late nineteenth century a system was inaugurated that still underpins the study of ancient statuary. If it can be assumed that the Roman statues which look Greek in style actually copy particular Greek models (usually lost bronzes), then it should be possible through the study of these "copies" to recreate at least an idea of the bronze originals appearance. Using Winckelmann's system of stylistic development, one can assign a date to this conceptualized image and through the usually brief description in ancient authors, it can be identified with a particular work of a particular sculptor. Thus the history of Greek art is made a history of Greek artists. While the process is highly positivistic, it was entirely consistent both with the academic climate of the time and with the increasing incorporation of ancient art history into Classical archaeology—a discipline which depends heavily on the inference of much from little.

During the twentieth century, there has been much refinement of and addition to the systems and methods introduced by these earlier scholars. Ancient painting (almost entirely limited to painting on vases of which very few bear signatures) has been organized according to artists, a process as positivistic as that used for statuary, although with the advantage that the vases, unlike the sculptures, are all originals. Excavation has increased the quantity of material, although original bronze statuary remains very rare. More intense study of previously overlooked evidence has at times caused some to question the validity of traditional methodology, but the latter seems at each instance to weather the assault. As for attitudes toward the classical generally, perhaps because of the Enlightenment and idealist foundations of the discipline itself, these seem to have changed very little over the past two centuries—until recently.

Contemporary Developments

Current methods of scholarship and the attitudes toward antiquity which they inevitably involve seem to have reacted to two major forces; the first is practical, the second more conceptual. The sheer magnitude of modern scholarship and the evidence it brings to bear have increased exponentially with each succeeding generation. Thus, both the closer study of long-familiar works and the discovery of new pieces have at times revealed serious flaws in the inherited methods and systems. A good example is provided by the two bronze statues fished from the sea in 1972 near Marina di Riace in southern Italy (FIG. 10). Most agree

that these were created in the same workshop at the same time, yet the stylistic differences in pose, proportion, and muscular treatment are obvious. A very recent study of bronze-casting techniques has demonstrated that the differences are explained by variations in the way the separate parts were put together as part of a mass-production process. This conclusion seriously undermines the assumption that Classical style is consistent at a given point in time—the very assumption on which the organic model of development depends. We are also made to question the Renaissance notion of artistic genius which Romantic scholars of the nineteenth century attributed to ancient artists. More problematic still, at least one eminent scholar believes the Riace statues to be "classicizing" creations from the Roman era.

If experts have difficulty in distinguishing between Classical bronze originals and later works, then the identification of copies within the huge corpus of Roman marbles may be more difficult than has traditionally been assumed. Indeed, concomitant with the discovery and analysis of new bronze originals is the restudy of the assumed Roman copying process itself, of the distribution and uses of Roman statuary, and of the meanings of these images in their contexts. Taking together the new evidence and the new approaches, some scholars have seriously questioned the usefulness of using copies to reconstruct lost prototypes, while other scholars defend the process with equal vehemence. This is not a trivial dispute; at stake in the controversy is much of the very evidence most often used to construct our ideas about Greek and Roman art.

Such debates are being conducted in a "postmodern" intellectual environment that certainly encourages iconoclasm. Trends in art historical theory, ultimately rooted in semiotics, invite us to question received constructs, to consider the viewer as much as the maker in the interpretation of meaning, and to problematize the relationship between image and historical context. In the process of "reading" images, can we separate identification from interpretation? Can we continue to accept pictures as a simple reflection of some external reality (like a mythological "text" or real-life activity), or are works of art better understood as participating in the construction of the reality they purport to depict? Anthropologically based scholarship favors a study of ancient art that rejects the traditional limitation to the materials of "high culture", that focuses on evidence and artifacts with archaeological context, and that considers all aspects and levels of ancient Greek society as contributing equally to our understanding of the whole. Closely related is the consider-

10. Riace Warriors A (right) and B (left), ca. 450–440 BC. Bronze with copper, silver, and glass inlay, height (A) 6′8¾″ (2.05 m); (B) 6′5¼″ (196 cm). National Archaeological Museum, Reggio di Calabria.

Although the scale, subject, and material of both statues are the same, the poses, proportions, and degree of torsion in the two figures is quite different.

ation of how classical art treats subjects other than the ideal youthful aristocratic male, whose image—like the Belvedere Apollo—has come to stand for classical culture in its entirety. How, when, and where are women depicted, or non-Greeks, or the aged, impoverished, and infirm? Can Western civilization continue to idealize classical culture, if the ideals of that culture are so different from our own? These questions have contributed great richness and much controversy to scholarship of the past decade or two, and it is inevitable that they color our attitudes concerning the nature of the classical past. This is above all a self-conscious and anti-positivist scholarship. It is conscious of its aims and methods, of the scholarly traditions within which it operates, and of the power over it of inherited constructs. Thus its issues are inextricably linked with concepts of the classical, both ancient and modern—concepts that repeatedly turn back to Periklean Athens, as we shall now.

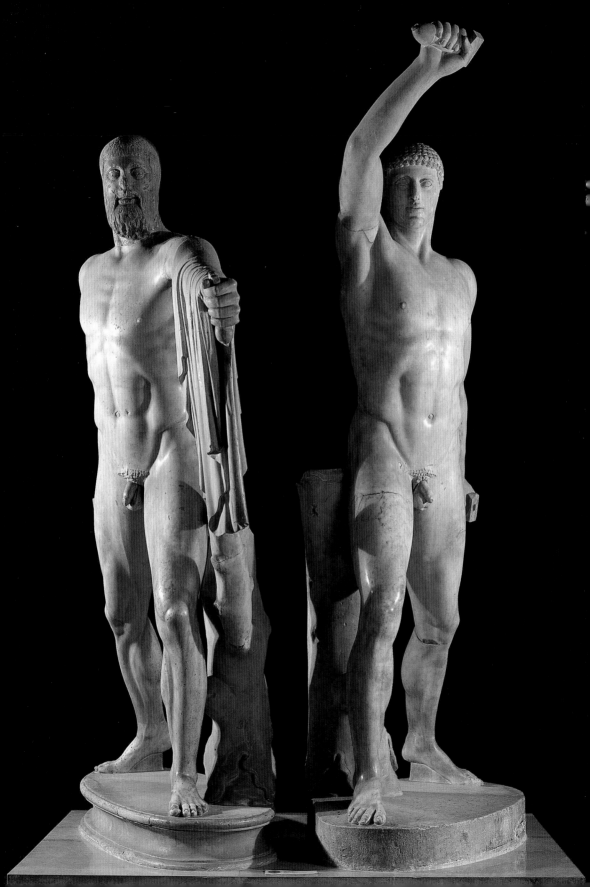

ONE

Art and the Polis

The large empty triangular space formed by a gabled roof seems to cry out for adornment. Sculpture was first placed in a temple's pediment at the beginning of the sixth century BC—a generation at least before the use of sculptural adornment on metopes, friezes, or architraves. On those temples with architectural sculpture, the pediment remains its most common location throughout Classical times, and its continued post-Classical popularity is evident from Imperial Rome to Neoclassical Washington, DC. Perhaps the impetus was practical (a need to mask the masonry of the pedimental wall), or perhaps the location was so conspicuous that its potential for symbolic display could not be overlooked. On temples where pedimental sculpture forms but one part of a full complement of such embellishment, the pediments enjoy pride of place. Compared to those on metopes or sculptured friezes, pedimental figures are higher, larger (by far), and limited to the building's two primary facades. The space itself demands a far more complex narrative scheme than do the small squarish metopes, yet, unlike a continuous frieze, it dictates a closed composition comprehensible from a single viewing point.

The Parthenon Pediments and Periklean Athens

Pausanias, in his second century AD description of the monuments of Greece, often mentions pediments alone when describing buildings loaded with representational sculpture. Even by these standards, however, his comments on the Parthenon are remarkably succinct: "As you go into the temple called the Parthenon, everything on the pediment has to do with the birth of Athena; the far side shows Poseidon quarreling with Athena over the country" (*Description of Greece*, 1.1, 24.5).

Slight though it is, we should be thankful that he did preserve this information, since from extant remains alone the pediments would be the most incompletely known of all the Parthenon sculptures. The central section of the east pediment was destroyed

11. Harmodios and Aristogeiton, the "Tyrannicides." Marble copies of original bronzes set up in 477 BC. Height 6'4¾" (195 cm). National Archaeological Museum, Naples.

These figures are known from a relatively small number of Roman copies, and can be identified on the basis of depictions in vase painting and relief sculpture. The right arm of the younger Harmodios is restored here improperly; it should be lower, nearly resting on top of his head.

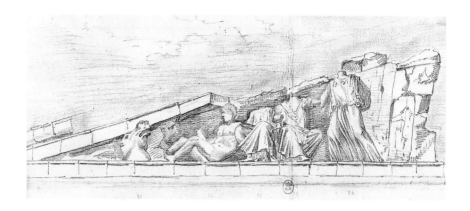

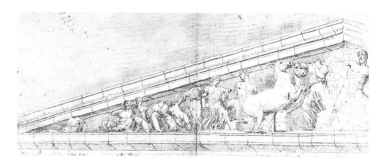

by the addition of an apse and window when the temple was converted into a church in the seventh century AD. Most of the remaining sculptures were removed during Lord Elgin's activities at the beginning of the nineteenth century, and although this resulted in the preservation of the figures themselves, essential contextual information about the original arrangement was lost. The best evidence for that arrangement is provided by the drawings of 1674 attributed to Jacques Carrey (FIGS 12 and 13). His sketch of the east pediment presents a group of figures arranged on either side of, and in some cases reacting to, a central scene already lost in Carrey's time and unidentifiable from context. While the central figures of the west pediment are included in Carrey's drawing, their action is far from self-explanatory.

The east pediment, Pausanias tells us, presents the birth of Athena and the west a local Athenian legend involving a contest between Athena and Poseidon. Although architectural decoration tended to reprise certain themes, neither of these myths was ever depicted on another ancient building, and the latter occurs nowhere else in extant Greek art earlier than the Parthenon itself. The identification of the subjects of images (or "iconography") is a comparative science; we cannot read the Parthenon pediments without Pausanias' clue because we have no frame of

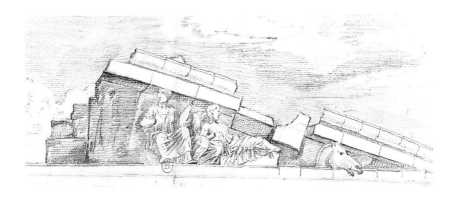

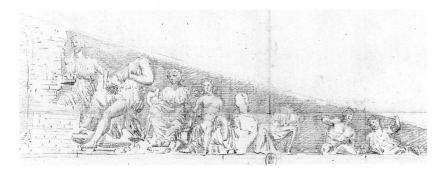

reference. Since the pedimental sculpture was the prime element of the temple's entire sculptural program, the selection of its topics was highly significant; if there was no tradition for the depiction of those topics, then that choice is all the more remarkable.

The choice of subject for the east, or front, facade is logical enough on a temple to Athena, and the story itself is well known. Zeus, having impregnated Metis, a goddess of intelligence, swallows her up in order to avoid detection by jealous Hera. Zeus develops an intolerable headache, Hephaistos offers relief by splitting his skull with an ax, and Athena springs out fully formed and armed. The story of the ostensibly motherless goddess emphasizes her closeness with Zeus as well as her somewhat ambiguous fulfillment of traditional gender roles. The Akropolis was Athena's rock and the Parthenon was Athena's temple. As we shall discover, the Parthenon was designed to celebrate Athenian virtue as much as Athena herself, and it especially emphasized the goddess's virginal and warlike character.

Unfortunately, owing to the paucity of evidence for its central scene, the east pediment is the more difficult of the two to reconstruct (FIG. 14). Earlier parallels are known only from painted vases and relief sculptures, where the composition tends

12, 13. Jacques Carrey, drawings of the east and west pediments of the Parthenon, 1674. Bibliothèque Nationale de France, Paris.

Note that the entire central section of the east pediment was missing at the time of the drawing. The west pediment was more fully preserved in Carrey's time than the east, so its composition can be reconstructed more securely. However, it is still not clear what, if anything, was placed at the center of the pediment (an empty space would be highly irregular) and details such as the object under Athena's horses remain enigmatic.

14. E. Berger's 1977 reconstruction of the east pediment of the Parthenon. This scholar favors a seated, torsional, and three-quarter view for the central figure of Zeus. As a compromise between the equally unsatisfactory frontal and profile seated views, this arrangement maintains the central axis usually emphasized in pedimental arrangements without violating the compositional flow. Other scholars prefer a central standing Zeus very like that of the east pediment at Olympia.

A B C D E F G

to center on a Zeus shown in profile, as was conventional in Archaic and early Classical two-dimensional art. For a pediment, such an arrangement would diminish both the axiality of the central figure and the dynamic flow of the composition by orienting the viewer toward one side of the pediment only. However, no proposed reconstruction with a frontal Zeus is appreciably more satisfying, and any solution offered remains speculation. By contrast, the figures from the two wings of the pediment are quite well preserved, most of them having been taken to London by Lord Elgin. Helios the sun in his chariot rises in the (viewer's) left corner and Selene the moon descends at the far right; the two celestial deities both frame the scene and locate the action away from the world of mortals. Some of the flanking deities react

15. East pediment figure D. Marble, height 51¼" (130 cm). British Museum, London.

This reclining male has long been nicknamed Theseus, but the Attic hero should not have been present at Athena's birth. The feline skin on which he reclines has caused scholars to read here Dionysos or Herakles, and others have seen Ares, although no identification is without its problems.

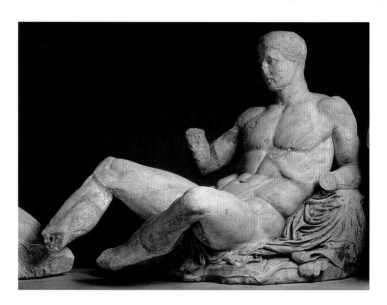

H K L M N O

directly to the apparition in their midst, others sit or recline more peacefully while they watch, and still others seem to pay no heed at all. The action moves out from the center to each corner, and the figures turning toward the center draw the viewer's eye back to the main locus of action. The composition is carefully designed both to emphasize the story being depicted and to invite the viewer to take in the entire tableau.

Aside from Helios and Selene, the preserved figures are difficult to identify because each has lost, or never had, any identifying attribute and because no comparable images exist to provide a clue. All agree that the Olympian deities would have been present at the birth, and names can be proposed but none is secure. Zeus, Athena, and Hephaistos (of these, only a torso perhaps of the

Below

16. East pediment figures K, L, and M. Marble, height of K 52¾" (134 cm). British Museum, London.

This group from the Parthenon sculptures is often nicknamed the "three Fates." Figure L, in whose lap Aphrodite (M) rests, was thought to be Dione, her mother. Identification of figure G (see FIG. 14) as Hekate has led some to see Artemis here. Figure K is most often connected with Hestia.

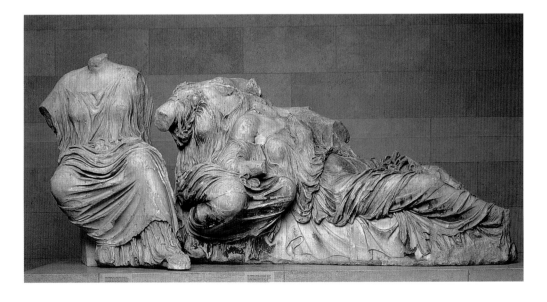

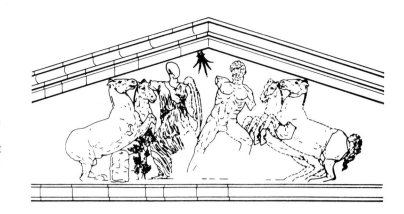

17. E. Simon's 1980 reconstruction of the central group, west pediment.

The suggestion that the central figures recoil from a thunderbolt of gilt bronze, suspended from the pedimental ceiling, is at first sight odd. Yet it is clear that something violent occupies the center, and Simon's suggestion is corroborated by at least one late fifth-century red-figure painted vase.

last is preserved) were present at the center. Figure D (FIG. 15) is probably Dionysos since he reclines on a pelt; two goddesses seated on chests—E and F—are likely to be Demeter and Persephone, and the goddess striding rapidly toward them is now thought to be Hekate. A fragmentary standing draped female probably stood to left of center and represented Hera. Of the seated and reclining female figures from the right wing—K, L, and M (FIG. 16)—only the last is identified with any agreement as Aphrodite and this on the basis of her sensual pose and diaphanous "wet" drapery rather than on any more explicit attribute.

The subject of the west pediment is a much less well-known story and one of purely local interest. Athena was believed to have contended with Poseidon for patronage of Athens at some point in that city's early history. Each was to produce a gift for the Athenians; that deemed of the greater benefit would prevail. Athena brought forth an olive tree; Poseidon a salt spring. The former obviously constitutes the more valuable resource, but an argument arose between the two deities that was resolved only through Zeus' divine intervention by means of a thunderbolt. There is no agreement concerning which point in the story is depicted here. Some favor the arrival of Athena and Poseidon on the Akropolis (where the contest took place), others propose the point at which both tree and spring are conjured, still others prefer the aftermath.

The individual figures of the west pediment are not nearly so well preserved as those of the east, but the evidence of Carrey's drawing allows a more reliable reconstruction of the overall composition (FIG. 17 and see FIG. 13). Athena and Poseidon are posed in diagonals which diverge sharply from the pediments center. What occupied that center (tree and spring? thunderbolt?) is far from clear. Are they recoiling or dismounting from the chariots being halted behind them? The arrangement behind each

chariot team is similar to that of the east pediment, but these seated and reclining spectators are far more fully engrossed in the violent activity in their midst. They are also bereft of obvious attributes; identification is even more difficult since they are assumed to portray the legendary Athenian kings and their families, for whom the iconography is far less canonical. If, as is often assumed, the corner figures represent the Ilissos and Kephissos streams, they clearly demarcate the earthly setting of the story and contrast it with the more celestial locale of the east pediment. Here as on the east, the designer has constructed a scene that through position and pose incorporates all elements into the action of the center; the composition in its entirety emphasizes and complements the subject and its significance.

The very idea that Olympians would strive in earnest to be worshiped by the inhabitants of a particular place reflects a remarkable arrogance on the part of those constructing the story. As we have seen, Athens of the Periklean era did not lack such communal self-regard, and the earliest reference to this myth (in Herodotos) is roughly contemporary with its portrayal on the Parthenon. Where the east pediment emphasized those qualities of Athena which made her the most appropriate divine emblem of glorious Athens, the west pediment states that the goddess desired so strongly to serve this role that she was willing to contend for it with Poseidon himself. Taken together, these two pediments provide the most explicit and articulate statement of the Parthenonian (and Periklean) program: that Athens was the most eminent of Greek city-states by virtue of the unique qualities of its citizens and customs—independence, reason, cultural excellence, and moderation. Athens, even more tangibly than her eponymous goddess, stood as the manifestation of these virtues.

The Greek temple was a communal product; it required a concentration of resources that made it both a locus of religious activity and an extravagant votive offering to its deity. From early times, competition among city-states (peer polity interaction, as some call it) motivated the construction of larger and more elaborate temples from more costly and permanent materials. In keeping with the status of the Classical, the Parthenon is often seen as the culmination of that development, but it is essential to recognize the special circumstances of its construction. Perikles funded the Athenian building program from a treasury collected for the defense of Athens and her allies (the League of Delos, founded just after the Persian invasions) against any future possible Persian threat. Athens negotiated a treaty with Persia and thereafter felt at liberty to dispose of the defense funds as it saw fit. Perikles stated that

they "did not owe an accounting to the allies as long as they protected them and kept off the barbarians; for the allies supplied not a single horse, nor ship, nor soldier but only money which belongs not to those who give it but to those who receive it, providing that they furnish the services for which they receive it" (Plutarch, *Life of Perikles*, 12). It is as though Athens had not simply the right but the divine obligation to appropriate resources and use them in the service of those gods who helped raise her to the status of city-state without peer.

In this context, the iconographic ambiguity of the pediments, not entirely the result of fragmentary preservation, seems significant. That figures should lack conspicuous attributes and be distinguished simply by pose and garment indicates that the intended viewer was an initiate familiar with even subtle iconographic clues. Classical Greece was an image-intensive society in which reading from representations was even more common than reading from texts, and the Greek city-state is traditionally held to have been a highly homogeneous entity. Yet the Athenians did not simply assume this homogeneity as a means of narrative convenience, they emphasized it both to promote their own greatness and to marginalize things non-Athenian. Athenian art reflects little concern with conveying its message to those not familiar with local gods, customs, and laws not because the uninitiated audience did not exist, but because, at best, it did not matter. The Parthenon in particular was a monument built by Athenians for Athenians in order to glorify Athenians—all the more noteworthy since it was built with other people's money.

As communal symbols with both religious and political potency, temples were designed and erected not simply to elicit favor from the worshiped but also (and equally) to attract admiration from other Greek states. The temple functioned for its *polis* in much the same way as more modest works of art (such as statues, relief sculptures, and funerary or votive vases) served the individuals who set them up. Most or all ancient Greek art was primarily a form of religious expression, but the religious aspect of ancient Greek culture was inextricably bound up with the political, economic, and social; the separability of these realms is an entirely modern concept. Since the gods worshiped were the gods of the city-state, divine favor functioned to situate a person or polity favorably within an appropriate peer group. Thus art in ancient Greece also had everything to do with status, whether it reflected the status of the individual within the social structure of the *polis* or the status of one *polis* among others. It was within rigidly structured systems of both status and style that

Geometric art and the Greek *polis* emerged together from the smoldering ashes of the Mycenaean palaces.

The Emergence of the Polis and Geometric Art

Athens has been referred to thus far as a *polis* (pl. *poleis*; generally translated "city-state") with little explanation of that term. In Greece during the first millennium BC, most people lived in communal settlements, often walled and with a fortified height (*akropolis*), and with public areas for commerce and social interchange (agoras) or religious activity (sanctuaries). The people living there controlled a region outside the town proper which had acknowledged, if fluid, geographical borders. One segment of the population inhabited this more rural area, working land which sometimes was owned by the town's inhabitants; geographically speaking, *polis* refers to the settlement and the land it controlled. The *polis* was a culturally homogeneous entity, closely united by common cults, customs, and dialect.

Despite our archaeological emphasis on material indices, the Greeks themselves clearly felt that it was the people who constituted the *polis*, not the structures with which they housed and protected themselves and their gods. Power was exercised within the *polis* through processes that, for ancient times, were markedly participatory. Divine or quasi-divine monarchs on the Near Eastern model did not exist in Greece after the Bronze Age. Some states (like Athens) had residual titular kingships with ceremonial functions. Even in a *polis* like Sparta that retained hereditary kings, there also existed an equally powerful council of leading citizens. In all states the basis of power was a combination of wealth and birth. Especially in the Archaic period, popularly supported "tyrants" ruled as bulwarks against the aristocracy, from whose ranks the tyrants themselves were usually drawn. In the democracy of Classical Athens it was theoretically possible for anyone to achieve high political position through their own virtues and efforts but, as in all democracies, leaders tended to emerge from a social elite. Only male citizens (necessarily sons of male citizens) could vote or hold office, so even the most democratic *polis* would not be considered inclusive by modern standards. The *polis* placed a high premium on individual and familial status. Each member of a *polis*—male citizen, woman, resident alien, slave— had a clearly prescribed role and was expected to strive to fulfill that role to the best of his or her ability. Thus the *polis* fostered ambition and competition and to varying degrees presented the appearance of a meritocracy.

The material remains of Bronze Age Greece corroborate the record of Homeric epic (and local legends such as Athens') that Greece in the heroic age had been ruled by kings. At some point during the twelfth century BC, the great palaces and attendant *tholos* tombs at Mycenae, Pylos, Tiryns, and Thebes ceased to function as such. We may never know what brought down these and other citadels (drought, famine, earthquake, invasion, or some combination of these), but the collapse of the monarchies they supported was complete. There followed a period from which remains are meager (the so-called "Dark Age"), and when the archaeological picture comes into clearer focus about two centuries later, the basic elements of the *polis* were firmly in place. Hallmarks of the *polis* in the material record include signs of a distinct but moderate differential of wealth, monumental architecture devoted to public rather than private functions, and religious activity reflected by both public and private signs of devotion. In other words, a *polis* is apt to leave behind temples rather than palaces or several wealthy burials rather than one or two opulent tombs.

18. Lefkandi Centaur, ca. 920–900 BC. Terracotta, height 14¼" (36 cm). Archaeological Museum, Eretria.

Not only is this a very early representation of a centaur, it is by far the earliest identifiable depiction of any figure from Greek myth. Some have proposed that the gash on its knee (deliberately rendered and not a break in the fabric) identifies it as the good centaur Chiron (accidentally wounded by Herakles), who was tutor to Achilles and known for his healing powers.

Although the institution of the *polis* in all its aspects evolved only in the eighth century, the preconditions were in place much earlier. To select a "first" example of Greek (as opposed to Mycenaean) art is an arbitrary act, but the terracotta Lefkandi Centaur (half horse, half man) is as good a candidate as any (FIG. 18). We first note the simple forms of its individual parts, for example the cylinders of the body and legs or the sharp oval of its head. The body of this creature was thrown on a potter's wheel, and the painted decoration is drawn from the limited repertoire of geometric forms found on contemporary vases. Such simplicity of structure and ornament has given the name "Geometric" to the entire epoch (900–700 BC) ushered in at this time. The centaur statuette, from the slightly earlier "Protogeometric" era (around the tenth century), was quite a surprise when discovered at Lefkandi, since it predates by two centuries the era when sculptured, or even painted, representation became common. There is no doubt, however, that it belongs to the new age rather than the old; the centaur itself is unknown among the many monsters of Near Eastern and Aegean

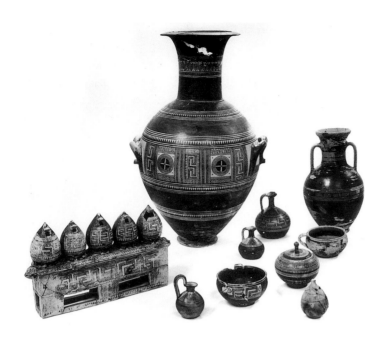

19. Funerary urn and other vessels, ca. 850 BC. Agora Museum, Athens.

As is characteristic of Geometric pottery, the decoration is carefully chosen and arranged to complement the shape of the vase, an amphora. The main area of ornament is the widest part (the "belly") of the amphora, and the pattern of concentric circles accents its semi-spherical form.

Bronze Age art, while it is a common protagonist in Greek art of the first millennium.

The Lefkandi Centaur was found in a grave—perhaps a treasured object taken to the afterlife or a symbolic object offered by loved ones on behalf of the deceased. In any case its uniqueness suggests a special status for the person so honored. By far our fullest evidence for early Geometric art and culture comes from funerary contexts. Unlike the Mycenaeans who exclusively inhumed their dead, Greeks of the Protogeometric and Early Geometric eras more often practiced cremation. Ashes of the deceased were interred in relatively simple pit graves, which have been discovered grouped together in often extensive cemeteries. The funerary urns (FIG. 19) found in such graves are thin-walled and well made; the characteristic geometric decorative motifs are carefully designed and meticulously applied. A vase such as the large pot here is the result of a linear progress in quality clearly detectable in pottery since the end of the Bronze Age. The funeral itself was a public event, and it was important to the ninth-century aristocrat that the deceased's remains be preserved in an object with obvious aesthetic appeal. Competition among patrons—and thus among potters and painters—prompted the first occurrence of Greek art's most characteristic feature, stylistic development.

The identification of the woman buried in the grave in the Athenian Agora as an aristocrat is supported by the other grave

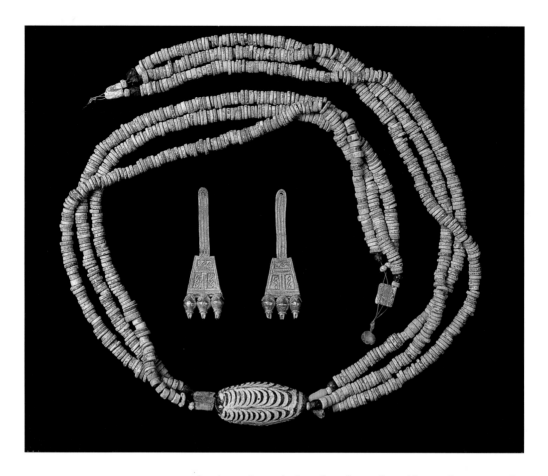

20. Gold, glass, and faience jewelry from the same burial, ca. 850 BC. Agora Museum, Athens.

Most elaborate are the gold earrings worked in filigree and granulation with geometric designs. The glass and faience are surely imports.

goods. An enigmatic box has five spheroid attachments to its lid, which are now generally agreed to represent model granaries. These constitute an obvious reference to an increasingly agricultural (as opposed to pastoral) economy and may even refer to a grain-based definition of wealth and social class, as is known to have existed later. From the same grave came jewelry made of exotic materials like gold, glass, and faience (FIG. 20). The geometric style of decoration on a pair of earrings indicates that they were not simply rare imports; demand must have been sufficient to support a workshop in Greece itself, although the craftsmen may well have been Phoenician.

Already in earliest Geometric times, then, the occasion of the funeral was used to establish the differentiation of a wealthier, land-holding class from the less fortunate and powerful. Within a century, by which time the first true *poleis* had been established, such differentiation was well entrenched. In Athens, cremation had given way to inhumation, and the resources invested in a monumental funerary vase were no longer buried out of sight.

Enormous vases like the Dipylon Amphora (FIG. 21), as tall as the person buried beneath, were conspicuous and expensive monuments to the status of the deceased and her family. Two developments in decoration are obvious: the geometric patterns are now spread across the entire vase, giving the whole a look reminiscent of textiles (perhaps not coincidentally), and the focal point of the ornamental scheme is now a scene with human figures.

The Dipylon Amphora is an exemplary work of geometric painting and as such illustrates well the appeal of the style itself. As in earlier times, the decoration reflects the structure of the vase in very obvious ways. The main scene is still located at the widest part of the pot and framed by zoomorphic (resembling a ram's head) handles. The tallest band of meander decoration is centered on the elongated neck; the next tallest are symmetrically placed above and below the central figured scene. The geometric bands become increasingly simple as the eye moves below center and the vase tapers to its narrow base. Each band is separated from the next by a consistently recurring theme: a band of small dotted diamonds ("lozenge" pattern) with three plain dark lines above and three below. On Geometric vases such as this, decoration reacts directly to shape; all is order, structure, reason, and appropriateness. Whether the genesis of a geometric style in Greece at the beginning of the millennium was a Mycenaean carry-over, reflective of a search for organization in a time of chaos, or simply an element common to several Balkan Iron Age cultures, its evolution in Greece to the style of the Dipylon Amphora cannot be separated from that same psychology of order, structure, reason, and appropriateness that gave rise to the formulaic epic poetry of Homer (also composed in the eighth century) and to the *polis* system itself.

The amphora was not the earliest geometric vase painted with a figural scene, but it does stand at the beginning of a centuries-long tradition in which such figural painting is common, even expected, on fine painted wares. The scene here was chosen to complement the function of the vase. Depicted is the *prothesis* (laying out of the deceased) that formed an essential part of the aristocratic funeral. The repeated images

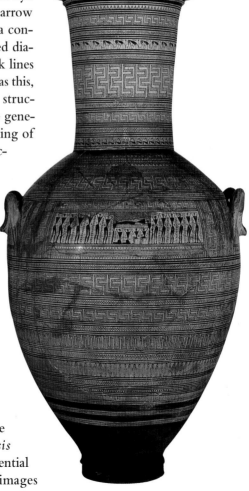

21. Dipylon Amphora, ca. 760 BC. Height 61" (155 cm). National Archaeological Museum, Athens.

The tall funerary vase takes its name from its findspot in a Geometric cemetery adjacent to the later Dipylon ("double-door") Gate in Athens. This was a female burial, as suggested by the figured scene showing the deceased wearing a skirt and the amphora shape itself.

22. Dipylon Krater,
ca. 750 BC. Height 48″
(122 cm). National
Archaeological Museum,
Athens.

This great wine-mixing
bowl marked the grave of
a man. Thus, the elaborate
funeral procession is
complemented by a scene
of warfare. Another reading
would have the chariot
frieze refer to funeral
games, implying a heroic
status for the deceased by
analogy with Homeric
figures like Patroklos. The
association with martial
prowess and aristocratic
virtue is undiminished by
such an interpretation.

of mourners underscores her much-lamented status. Other late geometric vases such as the Dipylon Krater (FIG. 22) extend the funerary story to the procession (*ekphora*), an even more public event in which the funeral bier is taken by cart through the assembled populace to its final resting place. This vase adds a lower register presenting a repetitive frieze of warriors in chariots who are probably not part of the funerary procession but rather refer to the military experience of the deceased. Warfare was a crucial activity in defense of the *polis* and a man's martial prowess was throughout Greek history a critical element in his fulfillment of public duty and aspiration to aristocratic virtue (*arete*). Thus scenes of war are increasingly common, both alongside funerary scenes and by themselves, on painted vases of the late eighth century. The shape of this vase—a krater or large open bowl for mixing wine with water—was an allusion to the symposium, a drinking party which provided socially significant "male" bonding opportunities for warrior aristocrats.

In these compositions, each figure is stylistically identical to the others in geometric conception. The artist's primary concern seems to be clarity and legibility in distinguishing between the parts of each figure (head from torso, torso from arms and legs) and between the types of figures represented (male from female) rather than with pictorial verisimilitude. Thus Greek art's essentially generic and analytical quality is detectable at its very inception, as is that same desire for reason, structure, and order that created the *polis*. It has been said that the occurrence of figural decoration on such vases was as much an emblem of aristocratic stature as were the expensive vases themselves and thus that the very use of images was the preserve of the elite in the eighth century. Whether or not the use of images was limited to the elite at that time, it is certainly demonstrable that they were capably used by the elite in an attempt to support and reinforce their claim to supremacy. An attractive recent theory proposes further that the proliferation of figural scenes on late Geometric pottery, as well as in Homeric epic, was developed specifically as a statement by the aristocracy about the aristocracy in

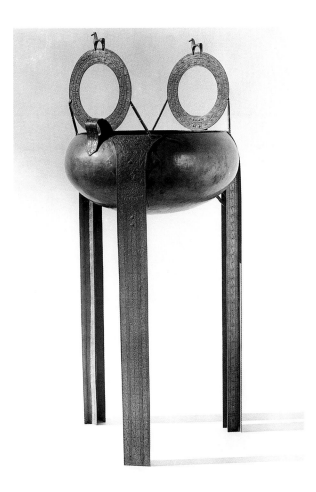

23. Geometric cauldron with horse-handle attachments. Bronze, height 60½″ (154 cm). Archaeological Museum, Olympia.

This is a modern reconstruction based on finds at Olympia from the eighth century BC.

24. Warrior figure from Olympia, ca. 8th century BC. Solid cast bronze, height 9½″ (24 cm). National Archaeological Museum, Athens.

The simple style and scheme of this figure, which originally held a shield in its left hand and a spear in its right, is frequently found in Geometric-era votive objects.

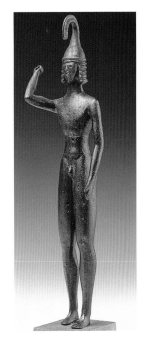

reaction to incipient social instability of the eighth century.

Religious activity in Geometric times is displayed in two characteristic features developed more conspicuously later—first, the building of temples usually equipped with altars for offerings and sometimes containing images of one or more deities, and, second, the dedication of sculptured, figurative votive objects. Cult practises took place at special locations in the *polis* as well as at sometimes "Panhellenic" sanctuaries built outside the town proper. The most famous of the latter, Olympia, had a traditional foundation date of 776 BC. Geometric bronze votive objects of various sorts are common here (FIGS 23 and 24). Tripod cauldrons served as both prizes at the prestigious Olympic Games and thank-offerings from the victors; their horse-shaped attachments repeat a common emblem of the Geometric aristocracy. The institutionalization of athletic games as religious events and their subsequent popularity and significance emphasize the highly competitive nature of this civilization. Successful participants were

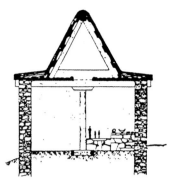

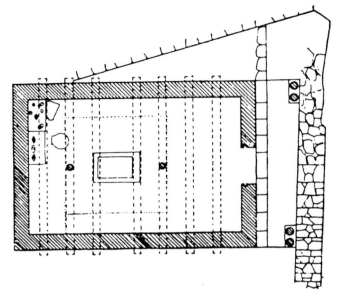

Above and right
25. Plan and section of the temple at Dreros, Crete, ca. 700 BC.

The drawing by the French excavators shows a possible reconstruction of the super-structure based on the well-preserved stone foundations and lower wall courses. This complex includes the basic elements of Greek temples—altar (in later times the altars were set up in front of rather than within temples), columned porch, and temple statuary.

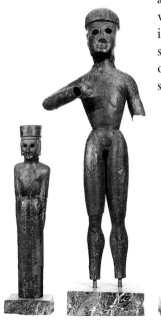

greatly honored by their home *polis*, since the Olympics then as now were considered contests as much among states as among individuals.

The style of Geometric bronze offerings is characterized by precisely the same simple, straightforward, analytical forms as those found on contemporary vases. The types repeat, but the subjects are not without variety. Horses are frequent, for reasons already familiar; other animals like bulls or sheep reflect dependency on agriculture and husbandry and suggest livestock as a measure of wealth and status. Anthropomorphic figures also present differing forms. It is not clear whether the numerous armed soldiers should be read as reflecting the dedicator's *arete*, like the charioteers on the Dipylon Krater, or whether they actually represent a warrior god. On a fundamental level, the distinction is moot, since the figures function in an identical way whichever is the case; perhaps that is why iconographic ambiguity is so common in Greek votive objects from all periods.

Geometric temples have been identified at a variety of sites, especially on islands stretching across the Aegean (such as Samos, Chios, Andros, and Euboea), and terracotta temple models are known from mainland sites like Perachora and the Heraion at Argos. Perhaps the best-preserved eighth-century temple is that of Apollo at Dreros in eastern Crete (FIG. 25). It was set off in its own space within the settlement, its importance indicated by its columned front porch.

Within the main room was an altar for offerings; on a stone bench at the back of the same room were found three hammered bronze (*sphyrelaton*) statues (FIG. 26); the male figure is about half life-size, and the two females are about half the size of the male. These probably represent Apollo with his mother Leto and sister Artemis, although it is not agreed whether they were present as symbolic recipients of cult or were themselves votive objects. While not monumental by later standards, this building and its equipment reflect for its times a considerable dedication of resources and therefore a concerted effort to create a public cult center as an expression of communal piety—in its basics no different from the Parthenon itself.

Political Aspects of Greek Art

To summarize, there emerged by 700 BC a Greek society based on participation, co-operation, and competition both among citizens within the *polis* and among the different city-states themselves. It was distinct from earlier and non-Greek cultures based on coercive domination and divinely sanctioned monarchic authority. This individual liberty had as its price social stability, so we should not be surprised to see an artistic style develop that is characterized by dynamic struggles between order and freedom and between unchanging ideals and fluctuating appearances. Moreover, Greek art both in its Geometric origins and in its fully developed Classical form served very similar functions for the *polis* and for the individual as part of that *polis*. In Greece before the age of Alexander, there was no truly private art. Even decorated vases often had votive, funerary, ceremonial, or cult functions; many others were designed for the symposium with its patent political associations. At this stage in Greek history, monumental architecture was always public and most often religious. Sculpture could be set up by individuals as public expressions or by the polis in honor of its citizens, collectively or individually. The *polis*, after all, was the people, and the public display of images, whether by person or by *polis*, was a political act.

Large ceramic tomb markers came to be replaced, in the sixth century BC, by sculptures—either grave reliefs or statues, most of which take the form of the standing nude young man (*kouros*) or draped young woman (*kore*). Both forms served equally (and earlier) as votive objects, and in both functions they retain the same ambiguous identity we discerned in Geometric sculptures. Owing to their youthful vigor and long flowing hair, *kouroi* (FIG. 27) were once believed to represent Apollo but are no longer

Opposite
26. Statues from Dreros temple, ca. 700 BC. Bronze, height of male 31½″ (80 cm); height of females 15¾″ (40 cm). Archaeological Museum, Heraklion.

While some have dated them to the seventh century, their simple, analytical forms are consistent with the temple's late Geometric date.

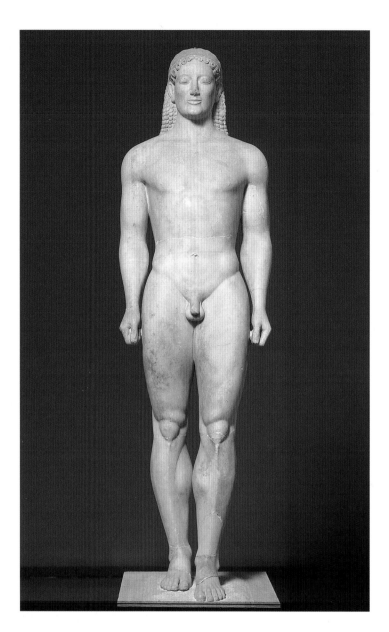

seen as representing any particular deity. Nor is the *kouros* generally thought to be a "portrait" of deceased or dedicator, although its idealized forms certainly were meant to say something about the virile virtue of the person for whom or by whom it was set up. As its inscribed base makes clear, this monument glorifies the action of fighting on behalf of the *polis*, which was itself, as the poet Alcaeus (fl. 600 BC) said, nothing other than the men who defend it. Yet not a single feature explicitly suggests a soldier; it is the quality of *arete* itself that is embodied here, and the *kouros'*

generic nature made it appropriate for funerary and votive object alike. The *kouros* pose was used without variation for well over a century, and through its lack of change it embodies the culture's most revered qualities as a model for mortal emulation. A recent reading of the *kouros* type sees its very repetition as a statement of specifically aristocratic and conservative values in the face of an increasingly empowered populace; it is true that only individuals or families of means could erect so costly a monument.

There is evidence, on the other hand, that such wealth had also accrued to those engaged in the production and exchange of goods and was thus no longer limited to a traditional landholding aristocracy. A *kore* from Athens (FIG. 28) was dedicated to Athena and set up on the Akropolis. Its large scale and elaborate carving indicate that it was a work not cheaply acquired; yet, if its base has been correctly identified and restored, it was dedicated by a potter from the first fruits of his labor. In this case there is no question of equivalence between image and dedicator. As the female counterpart to the *kouros*, the *kore* expresses in a similarly generic way societal values deemed appropriate for women. She stands demurely and heavily draped, elaborately but decorously bejeweled and coiffed. With each element securely in order, she functioned as an ornament to her family—a source of pride in the *polis*. The dissemination of aristocratic values to the more prosperous of the working class is not a difficult phenomenon to grasp, not only because of the aspirations of the latter but also because these were values genuinely shared across class lines throughout the citizenry.

A funerary monument could make a more explicit reference to the deceased's contributions to the *polis*. The Dexileos relief (FIG. 29) in the form of a gravestone (*stele*) was set up in a family plot within Athens' primary Classical cemetery, the so-called Kerameikos area outside the Dipylon Gate. An inscription gives us Dexileos' name, his father and home town, and the particulars of his youthful demise in battle. The depiction itself is as generic as

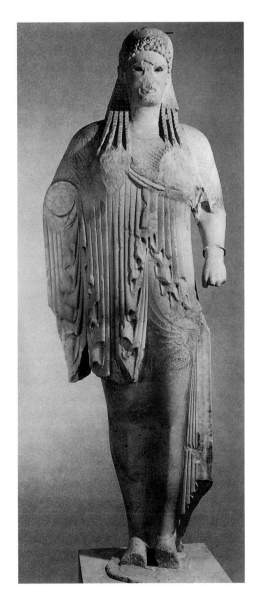

the inscription is specific. The figures are drawn from a repertoire of fighting figures found on the numerous battle reliefs adorning Classical temples. What is conveyed here is the idea of the noble young aristocrat fighting on horseback and despatching the enemies of the *polis*. Yet this monument did not mark his final resting place, since Dexileos was buried with his comrades in a communal tomb. That his family chose to erect this relief and thereby to make a very public statement about Dexileos', and by extension their own, noble sacrifice on behalf of all Athenians is a clear index that such sculptures may in every case have been far more than mere grave markers.

Individuals could also be honored by publicly commissioned monuments. Rare at first, the earliest set up in Athens was a bronze statuary group which was cast by Antenor in 509 BC and portrayed the so-called Tyrannicides (or "tyrant-slayers"), Harmodios and Aristogeiton. The group itself was carried off by the Persians in 480; three years later replacement statues were substituted, newly cast by Kritios and Nesiotes. The original group was restored to Athens after Alexander's conquest of Persia, and both pairs stood together in the Agora for the remainder of antiquity. Only the later group is identified in Roman copies (see FIG. 11). These again are generic figures portrayed in legible and expressive, if unnaturalistic, poses. They display a clear characterization of Harmodios as more youthful than the mature Aristogeiton, since such a distinction was critical to the story. But more than anything else they stood for the idea of the rejection of tyranny and thus played a significant emblematic role in democratic Athens. That Athenians of the Classical epoch like Thucydides were well aware that the two did not slay the real tyrant Hippias in 514 BC (they killed his ineffectual brother, Hipparchos) seems not to have weakened the group's symbolic value.

As mentioned at the outset, a *polis* often commissioned and erected monuments designed to honor the *polis* itself. These were sometimes located at home, like the Parthenon and the other Akropolis buildings. Tyrants of the later Archaic period in the Greek cities of Asia Minor, Sicily, and even the mainland embarked on what was nothing less than an orgy of building impossibly colossal temples (at Samos, Ephesos, Didyma, Selinus, Akragas, and Athens itself), all of which were too ambitious to be finished in the tyrant's lifetime, if ever. These are not to be construed as failures, however, since their function was not limited to vain display. By employing vast numbers of citizens, such projects (identically to Perikles' program) could serve to distribute wealth to the populace and solidify the tyrant's power base. City-states

29. Dexileos *stele*, 394/393 BC. Marble, height 68¾" (175 cm). Kerameikos Museum, Athens.

The inscription reads "Dexileos, son of Lysanias of Thorikos/Born in the archonship of Teisandros [414/13 BC]/ Died in that of Euboulides [394/93 BC]/[As one of] five cavalrymen at Corinth."

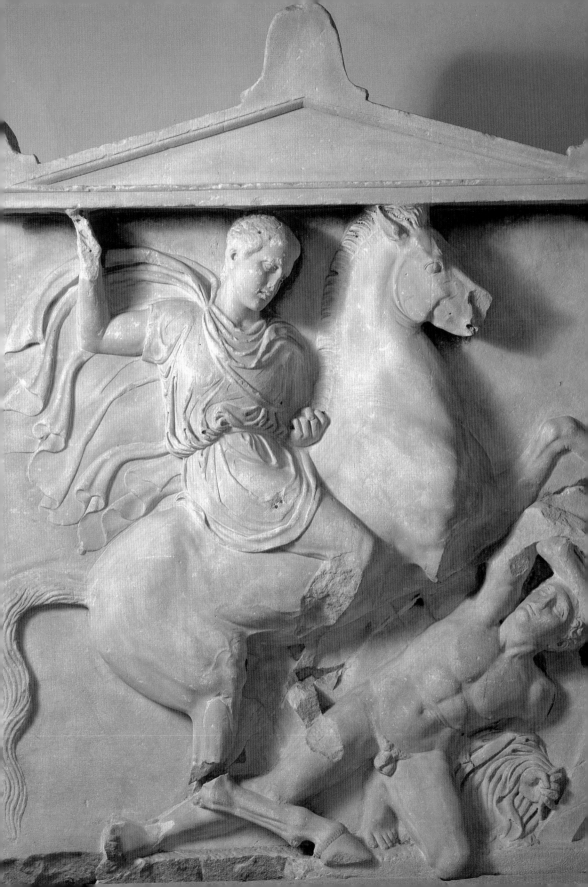

30. Nike of Paionios, ca. 420 BC. Marble, height 6'4¾" (195 cm). Archaeological Museum, Olympia.

This statue was originally set up on a high triangular pillar. Its inscription reads: "The Messenians and Naupaktians set [this] up to Olympian Zeus as a tithe from the spoils taken from the enemy. Paionios of Mende made it, and he also won the commission to make the akroteria for the temple [of Zeus]."

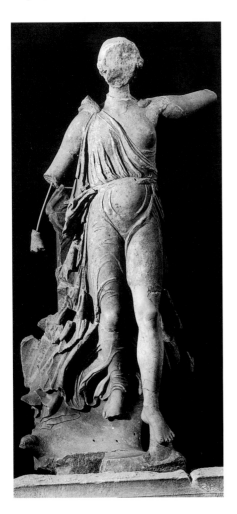

were also quick to appreciate the value of a broader audience offered by the Panhellenic sanctuaries. At Delphi and Olympia they built small, often highly decorated, buildings ("treasuries") that still bear the cities' names. That built by the Athenians at Delphi in the early fifth century was entirely re-erected and restored by the city of Athens at the beginning of the twentieth century—ample testimony to the lasting function of these structures as an expression of civic pride. The primary route through the Delphic sanctuary (the Sacred Way) was thronged with bronze statuary groups and other monuments commemorating specific military victories by various city-states, often set up in direct response to one another.

These Delphic groups are known from Pausanias' account (*Description of Greece*, 10.9–11), their foundations, and scattered blocks from the bases. However, a rare well-preserved dedication of a similar sort does survive—if only a single figure. Pausanias (5.26, 1) saw at Olympia a statue of Nike (goddess of victory) set up by the people of Naupaktos and Messene; the sculptor was Paionios of Mende in Thrace. Both statue (FIG. 30) and dedicatory inscription survive. The former shows the goddess alighting, her wind-blown drapery outlining her body and suggesting her motion in a style reminiscent of, but more exaggerated than, that of the Parthenon pediments. A date in the 420s seems likely, and Pausanias repeats (but does not believe) the Messenians' assertion that the statue commemorated a victory which they and the Naupaktians (and the Athenians as well) won over the Spartans on the island of Sphakteria in 425—a turning point in the first stage of the Peloponnesian War.

The inscription itself is cagey; it states only that the Nike monument was paid for from spoils taken from "the enemy"—no name, no site, no date. Pausanias repeats the idea that the vagueness was intentional, motivated by fear of Spartan reprisal. Indeed, the Messenians in particular were the perennial whipping-boys of their more warlike neighbors, so the explanation is credible. In its cautious, even half-hearted, boastfulness, the Nike dedication seems the polar opposite of the arrogant self-glorification readable in the slightly earlier Parthenon pediments. How-

ever, this means of marking a military victory must have been not simply expected but even compulsory if a people would opt to do so at its own peril. So tied together with the duties of the *polis* and its citizens were the functions of Greek art that considerations of tradition and appropriateness must have outweighed those of expediency.

In fourth-century Macedonia, as is typical of monarchic societies, glorification of the state can manifest itself in the commemoration of a king. Both a part of and apart from the culture of southern Greece, the Macedonians favored burial in elegantly equipped chamber tombs, some of which were provided

31. The facade of Tomb II at Vergina, ca. 340–310 BC.

The most conspicuous element of the facade is the painted hunt scene above the lintel. Several hunts are combined (lion, boar, and deer), thus confirming that the subject here is emblematic (and regal) rather than historical or mythological.

with elaborate architectural appointments, both carved and painted. Our knowledge of Macedonian royal art was enormously increased by the discovery of a group of tombs at the Greek village of Vergina, the ancient Macedonian capital of Aigai. Although by the time of Philip II (d. 336 BC) the capital had moved to Pella, the royal family continued to be buried at the older center. During the 1970s three such tombs were excavated within a great mound of earth (tumulus)the only visible sign of the tombs in antiquity.

The most famous of these, Tomb II, is by all accounts the resting place of a king, although scholars argue whether it was built for Philip II or his son Philip Arrhidaios (d. 317), the figurehead successor to his half-brother Alexander. It is a barrel-vaulted, two-roomed structure of ashlar masonry. Although it is only minimally decorated within (unlike some other tombs with elaborately painted and sculptured interiors), it bears an impressive facade (FIG. 31) that reveals nothing of the vaulted structure behind. Its Doric columns and triglyphmetope frieze imitates a well-known type of small temple and is designed to evoke the majesty of public religious buildings. Above the frieze is a high band, unknown on any real Doric building, which is painted with an elaborate hunt scene. The landscape setting and sharply receding diagonals recall the interest in spatial illusion that later Roman writers attributed to painters of the fourth century BC. Indeed, the excavator at Vergina was convinced that the artist of these and other paintings at Vergina must have been among those mentioned by name in Pliny's *Natural History* (Book 35). The paintings on the Vergina tombs now constitute our best evidence for understanding and experiencing Classical monumental painting.

Depictions of the hunt—largely or entirely mythological—are not common in earlier Greek art. During the fourth century, one finds "historical" hunts among the iconographic schemes of such structures in Asia Minor as the Nereid Monument at Xanthos and the Mausoleum at Halikarnassos—royal funerary structures like those at Vergina. The subject is drawn from the traditional iconography of Near Eastern monarchs, which also included historical battle scenes and assemblages of ancestral

32. Head from Tomb II, Vergina, ca. 340–310 BC. Ivory, height 1½″ (3.4 cm). Archaeological Museum, Thessaloniki.

One of several similar pieces that were originally inlaid into wooden furniture. Both bearded and clean-shaven types are represented—typical characterizations of maturity and youth. Many cannot resist the temptation to see Philip and Alexander themselves among them—a reading that is possible but beyond proof.

images. Its presence here has been cited as an argument for the later date, but it is clear from the Nereid Monument and the Mausoleum—both produced by Greek artists—that these subjects were familiar to Greeks well before Alexanders conquest.

As befits a king, the furnishings of this unlooted tomb were spectacular indeed, including many vessels of precious metal, a full panoply of intricately wrought armor, ivory furniture inlays (FIG. 32), and heavy gold chests (*larnakes*) containing the cremated remains of the deceased. Especially striking is a massive gold crown of oak leaves, which marked its wearer, surely the king himself, as descended from Zeus, to whom the oak was sacred (FIG. 33). Such opulence is in strong contrast with the more modest grave goods of the Classical Greeks, who had no kings and whose public display was focused on the marble tomb markers discussed above. It is not without irony that in 317 BC the latter were outlawed as excessively conspicuous by Demetrios of Phaleron, the Macedonians' puppet governor over Athens. At this point in history the independent *polis* gave way to an era of Macedonian hegemony; art of the *polis* became secondary to art of the king during this transitional stage from a Hellenic to a Hellenistic world.

33. Oak leaf crown from Tomb II, Vergina, ca. 340–310 BC. Gold, diameter 7¼" (18 cm). Archaeological Museum, Thessaloniki.

Of the many gold pieces from the tomb, this is perhaps the most spectacular. The crown was laid over the cremated remains of the male figure buried in the main chamber. It is likely, therefore, to have been a royal crown, while its delicacy makes it probable that it was ceremonial (even funereal) in function. Note the many carefully worked acorns among the leaves. This interest in vegetal forms is common in Macedonian metalwork and became a hallmark of Hellenistic decorative art.

TWO

Greeks and Others

34. Gigantomachy scene, east frieze, Great Altar from Pergamon, ca. 175 BC. Marble, height 7'6½" (2.3 m). Pergamon Museum, Berlin.

Artemis and her hunting dog stride over a fallen giant while another giant in his death throes violently gouges the eye of Artemis' dog. The juxtaposition and intermingled hair of man and beast with similarly exaggerated features emphasize the inhumanity of the giants. Contrast them with the features of Artemis herself, smooth and idealized. The actual function of the monument is unknown but it may have been a hero shrine for the Pergamene founder-hero Telephos.

I n 1687, thirteen years after Jacques Carrey's visit to Athens, the Parthenon was hit by a Venetian artillery shell. The Turks who then controlled the Akropolis were using the building as a gunpowder depository, and the resulting explosion destroyed the central part of the lateral colonnades, including the exterior frieze course with its sculptured metopes. Yet the lacunae in Carrey's drawings make clear that the Parthenon had already suffered significant damage before his time (see FIGS 12 and 13). As seen above, the absent central figures of the east pediment were destroyed when the temple was made a church in early Christian times. Carrey's sketches of the metopes are limited to those on the south flank (intact in his day), and a glance at the extant metopes indicates that all metopes but one on the remaining three sides had been deliberately defaced. There is no direct evidence as to who was responsible, nor do we know why only the south metopes (and one north metope) were spared, but anti-pagan zeal is most often cited. While it is not easy to explain the basis for distinguishing the offending themes from those deemed safe, the act was strongly motivated since the task of destruction was a challenging one. Archaeological interpretation is necessarily synecdochic, but rarely is it so well known why and by whom the missing pieces were obliterated. It is not without irony that the metopes suffered as innocent bystanders in the crossfire between conflicting cultures and value systems—Christian against Pagan, Venetian against Ottoman—since such conflict serves as the unifying theme of the metopes themselves (FIG. 35).

The Parthenon Metopes: Conflict and Otherness

Given the metopes' uneven preservation, some subjects are easier to identify than others. A majority of the south metopes depict battles between centaurs and humans, although Carrey's drawings suggest a different topic for eight or nine central metopes. The east metopes show combats among divine protagonists, the battle

FRIEZE: Chariots and Riders METOPES: Ilioupersis

W. PEDIMENT:
Contest of Athena
and Poseidon

E. PEDIMENT:
Birth of Athena

FRIEZE: Peplos
Scene, Olympians,
Head of Procession

FRIEZE: Riders

METOPES:
Amazonomachy

METOPES:
Gigantomachy

FRIEZE: Chariots and Riders METOPES: Centauromachy

35. Ground plan of the Parthenon with the topics of the architectural sculptures.

between gods and giants (Gigantomachy). The opponents of the Greeks in the west metope combats wear Oriental dress, and most scholars favor the mythological interpretation (Amazonomachy) over the historical (Persian wars). Of the north metopes, one (FIG. 36) shows a woman, probably Helen, taking refuge at a statue in the presence of Aphrodite. The sack of Troy (Ilioupersis) must be meant here, but the example of the south metopes should keep us open to the possibility that the obliterated central panels may well have depicted something else.

Each story here explores a conflict between polar opposites. As argued in the previous chapter, Greek art must be interpreted primarily in terms of its function as a public statement by and about an individual or a *polis*. Such statements have to do with identity—of the individual among peers within the *polis*, or of the *polis* among other *poleis*, or of the Greeks in the world at large. The search for identity necessitates the construction of ideal models for emulation—a (perhaps the) primary goal of Greek art and literature. But the definition of identity is not limited to recognizing what one is, can be, or should be; it must include the exploration of what one is not, cannot be, or should not be. Self-definition is impossible without consideration of what is often termed "the other". Each conflict portrayed in the Parthenon metopes embodies a relationship of otherness (or alterity). Nor should these themes be seen as specific to the Parthenon. Unlike the subjects of the pediments, each myth presented by the metopes both draws on and perpetuates a rich iconographic tradition. To understand the polarities implicit in these stories is to understand the most basic values not only of Periklean Athens but of Classical Greek culture in general.

Pride of place was given to the Gigantomachy of the east metopes, a subject also woven into the *peplos* (type of dress) presented to Athena at the Panathenaia; this major festival may itself have been a commemoration of Athena's significant role in the Olympian's triumph. The story is the subject of Hesiod's *Theogony*—one of the earliest works of Greek literature—and deals with the overthrow of the giants (offspring of Ge and Ouranos—Earth and Sky) by the Olympian gods, whose success depended on their assistance by a mortal (Herakles). The episode explains how the Olympians came to be the pre-eminent forces of the cosmos (literally, "order"), and thus it functioned as a sort of Genesis for Hellenic cult. It is found in the very earliest and very latest examples of Greek temple sculpture, on pediments, metopes, and friezes alike. Since the giants were an unruly lot and the Olympians less so, it is believed that the subject's popularity in religious art derives from its exemplification of the victory of order over chaos and civilization over barbarism. The importance of order to the Greek *polis* and its reflection in the development of Geometric art has already been noted, and in so competitive and participatory a culture, respect for customs and adherence to accepted laws were always preconditions for social stability.

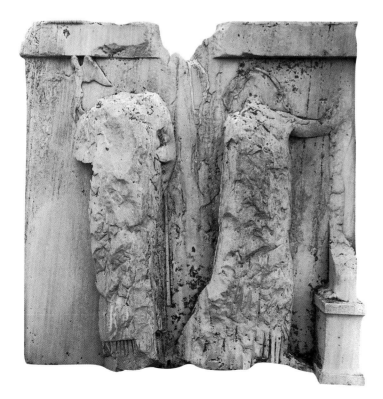

36. North metope 25 from the Parthenon. Marble, height 52¾" (134 cm). Akropolis Museum, Athens.

The chisel marks on these figures show deliberate defacement such as that suffered by all but one of the north, east, and west metopes. This is one of the most legible of the north metopes, clearly showing a draped figure taking refuge at an archaizing statue. The second figure can be identified as Aphrodite from the small Eros figure above her right shoulder.

This general theme is both extended and focused by the subject of the west metopes, the Amazonomachy. As a subject of architectural sculpture, Amazons are not documented as early as are giants, but they occur with increasing frequency in later Archaic art. The Amazonomachy is repeated on the exterior of the shield held by the Athena Parthenos—the colossal gold and ivory (chryselephantine) statue within the Parthenon. Thereafter, the subject enjoyed great popularity in temple and tomb sculpture of Late Classical and Hellenistic times. Amazons were female warriors who lived in a remote area of Asia Minor; their conflicts with Greeks take place both at home and abroad. Achilles, Herakles, and Theseus were each at some time involved in an individual battle with an Amazon queen; the last resulted in a retaliatory Amazon raid on Athens. It is not clear which Amazonomachy is the subject of the metopes, given their patchy preservation, but it may well have been the Athenian episode depicted also on the shield.

The Amazons' alterity is twofold. first, they are non-Greek. With their masculine actions and sometimes androgynous physiognomy, many can only be identified by their Oriental (Skythian or Persian) garments and armaments. As barbarians, they stand for the threat of the alien against a *polis* system that assumes, asserts, and depends on a high degree of cultural homogeneity. Secondly, they are women who do not behave as women should, according to roles assigned by the *polis* system. It is not simply their "gender-bending" appearance and activities that are threatening, but that the Amazons reject the male altogether, using them only for the purpose of procreation. The Amazons thus stand for a precise inversion of the actual gender roles that existed in ancient Greece, with some exaggeration to enhance their menacing aspect. Their inevitable defeat by heroes and Athenians stands for the maintenance of social order itself.

Centaurs also participated in numerous conflicts with Greeks, both individually and in groups. Most famous, and most commonly found in architectural sculpture, are the battles between Lapiths and centaurs at and following the wedding of the Lapith Peirithoos and Hippodameia. The story is well known: the centaurs, incapable of holding their wine, began making off with women and youths. The Lapith men first defended their dependants at the wedding festival, then the struggle spilled over into a field battle between armed adversaries. The several abduction scenes indicate that the outbreak of conflict at the wedding party is the subject of at least the eastern and western sections of the Parthenon's south metopes. As seen in Chapter

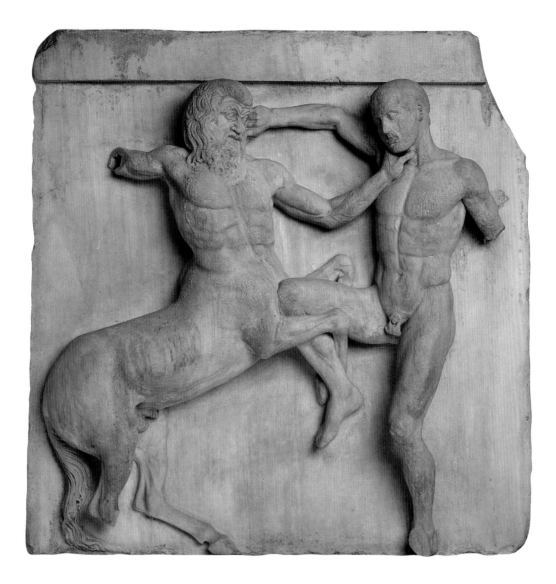

One, a centaur is the subject of the earliest work of Greek representational art (see FIG. 18), and the creatures recur frequently on painted vases and in architectural sculpture both before and after the time of the Parthenon. Their depiction here must be read within this tradition.

Centaurs, like Amazons, lived on the fringes of the civilized Greek world (in eastern, northern, or very rustic areas), and thus their defeat can be read, like those of the giants and Amazons, as yet another emblem of the victory of order over chaos, civilization over barbarism, Greek over alien. Yet centaurs were not all bad; two at least (Chiron and Pholos of Arcadia) are seen to be wise, tutors to heroes, with skills of particular value.

37. South metope 31 from the Parthenon. Marble, height 52¾″ (134 cm). British Museum, London.

Note the strongly contrasting facial treatments of the two protagonists.

The centaurs were generally well-behaved until something (often a combination of alcohol and lust) caused them to throw off restraint. This ambivalent character has caused some to recognize that centaurs stand less for the external threat to society than the internal, that what is at stake is not the barbarism from without, but the barbarism within humankind—the struggle between animal desires and societal necessities that occurs in all individuals. One can easily read this conflict in the expressions of Lapith and centaur on one particularly well-preserved metope from the Parthenon (FIG. 37). This contest within oneself was of particular importance in a *polis* culture which depended heavily on the qualities of reason and moderation in its participants, qualities which were also at the very heart of that Classical Athenian ethos which the Parthenon in its entirety symbolizes.

More ambivalent still is the Ilioupersis. The story of Troy's demise must have been one of the most familiar from Greek myth; although it is not a common subject of architectural sculpture, there seems to have been at least one example before the Parthenon and several thereafter. It was not as obvious a choice for inclusion here as were the other three subjects, and its meaning might best be sought in its relationship to them. The theme of victory over an alien foe is of course shared by all four. Owing to the nearly sacred status of Homeric epic, the story of the conflict with Troy is not as subject to variations of detail and locale as are the battles with Amazons and centaurs. Moreover, the Trojans themselves present an uneasy parallel to giants, centaurs, or Amazons. They are not monsters; they are not even alien except in the fact that they lived in coastal Asia Minor (fully Greek by the time of the Parthenon). Their customs seem not very different from that of the Achaian host. Indeed, if any figure in the *Iliad* lives up to the aristocratic model of *arete*, it is Hector, the Trojan prince. The fall of Troy resulted more from disputes among the Olympians and the Greeks' resoluteness in pursuing their perceived duty than from any real failing on the part of the Trojans themselves. Being out of favor with the prevailing Olympians must itself have been enough to mark the Trojans as other; certainly, the state of being favored by the gods was an important aspect of Athenian self-definition.

The Trojan war also presents a misogynist subtext, since so much seems to be blamed on women and goddesses (Helen, Eris, Hera, Athena, Aphrodite). In any case, this was an uneasy conflict: signs of Greek sympathy for the Trojans are clear in both Athenian art and literature (as in Euripides' play *Troiai*), and the sentiment was surely not unrelated to the experience of Athens'

own sack in 480 BC. The Parthenon was built to replace a temple destroyed at that time, and at some level this choice of subject must connect with that event, although a fuller discussion of the Parthenon's historical reading must await Chapter Three. The inclusion of an Ilioupersis here reminds us, as perhaps it did the Athenians, that alterity is dependent on perspective and thus identity is a nuanced and relative matter—sophisticated concepts but not at all beyond the capabilities of Periklean Athens.

The Parthenon metopes as a group therefore present a variety of subjects around a consistent theme. The Greek *polis* was a fragile construct dependent for its very existence on the willingness of each participant to strive for a level of excellence, even perfection, in fulfilling his or her role. Necessary qualities were reason, courage, and moderation. The construct was vulnerable since its enemies were many, and they existed both inside and outside the society itself; some were obvious, others much less so. Otherness was far more than simply the quality of being foreign— it included anything which constituted a transgression of the rules of the *polis*. The message of the metopes can be seen to extend from the claim to Athenian pre-eminence legible in the pediments. The *polis* is the people; they are inextricable and mutually dependent. The greatness of Athens depends on the vigilance of the Athenians in adhering to its rules and resisting its enemies, both external and internal.

Orientalizing and the Formation of Greek Art

That the Greeks were concerned with the definition of self against other is no surprise, since it was the very confrontation of Greeks with non-Greeks that forged Greek culture as we now think of it. Traditional chronologies of Greece identify the seventh century BC as an "Orientalizing Period" which separated the preceding Geometric from the succeeding Archaic. It is more accurate (and currently more common) to think of orientalizing as a process rather than a period; it was the way in which Geometric Greece became Archaic. Contact and influence between Greeks and easterners far predated 700 BC. We saw elements in the gold earrings from an Early Geometric Athenian tomb (see FIG. 20), but the interaction was not limited to such material goods. Similarities in script indicate that Greeks learned to write from Phoenician models in the early eighth century, and it is increasingly acknowledged that Greek mythology adopted many characters, themes, and episodes from Near Eastern prototypes. While the ubiquity of Phoenicians in the Mediterranean resulted in early and

This figure is one of
three found in a burial;
accompanying pottery
indicates a late Geometric
date.

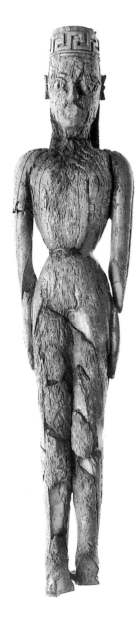

frequent contact with Greece, orientalizing borrowings were not limited to Phoenician sources. North Syrian, Neo-Hittite, Mesopotamian (at that time Assyrian), and eventually Egyptian elements can all be detected in Greek art of the late eighth and seventh centuries.

Heated controversies surround the charge that Classical studies have suppressed the magnitude of the Greek cultural debt to the Semitic civilizations of the Levantine coast (Syria, Phoenicia, Palestine) and to Africa. It has been shown that nineteenth-century Classical scholarship was at least partly concerned with constructing a concept of Greek cultural purity by clearly demarcating the difference between Greek (western) and Oriental (eastern) cultural features and by denying or ignoring any influence of the latter on the former. Since these early Classicists also strove to establish connections between Classical Greece and Northern Europe, they seem to have allowed their own concerns with self-definition to enter into their scholarship; some attitudes may well have been racist, as is often charged. The degree to which Classical culture was indebted to sub-Saharan Africa is a highly controversial question, and is likely to remain so, yet the dispute itself brings into sharp focus how deeply ingrained this question of self against other has remained throughout history. Entirely undisputed, but rather increasingly acknowledged, is that the Greeks were long in contact, directly or indirectly, with the Near Eastern cultures of Egypt, Mesopotamia, and the Levant and that by around 700 BC, their influence was deeply felt.

Several features of an ivory figurine from a grave in Athens' Dipylon cemetery underscore its identity as a work of Geometric Greek art (FIG. 38). The female's sharply articulated anatomy recalls contemporary figure painting; the pill-box cap (*polos*) bears a geometric meander. However, the material is imported, and female nudity, while commonly found in Near Eastern art (representing the Semitic goddess of love Astarte), is rare in Greek art—virtually unknown for the depiction of goddesses until late Classical times. The artist has taken the Near Eastern material and type and transformed them into something purely Greek. The act of doing so is at the same time a mark of respect for and emulation of the eastern craft tradition and an assertion of Greek identity. The resulting object serves the same function of perpetuating aristocratic values as do other Geometric images, but the addition of the exotic (and expensive) renders its elitist associations more obvious still.

The Dipylon Ivory is widely cited as a harbinger of orien-

talizing, yet it is more than a century later than the Early Geometric gold earrings. Why was there such a gap between the beginning of contact and its widespread manifestation in Greek art? The most likely answer lies in the extent of involvement of the Greeks outside the mainland. Beginning in the first half of the eighth century, certain *poleis* sent out colonies to the northeast (Black Sea coast) and west (primarily Sicily and South Italy). By the end of the century, these coasts bore a string of Greek cities, and Greek culture thereafter extended across the Mediterranean from end to end. Greeks were no longer simply consumers of Phoenician goods, they were competitors in an international marketplace. This was necessarily so, since figural art had become an important apparatus of power for the aristocracy, and the creation of images was something at which the Phoenicians were especially adept.

Like the Dipylon Ivory, much Greek art of the succeeding seventh century also reveals a widespread adoption of Near Eastern materials, subjects, and decorative motifs. At the same time the types of objects created, the functions they served, and the most fundamental stylistic principles remained unchanged from Geometric times. In their competition with Levantine artists for a lucrative market in small luxury goods, Greek craftsmen sought to secure their advantage by blending the exotic with the familiar. Demand for such objects was increasing, since their emblematic value as symbols of status was essential both to the traditional aristocracy and to the parvenu wealthy mercantile class. The portability and desirability of such goods facilitated the diffusion of this style across the Greek-speaking world. But orientalizing was not a phenomenon limited to these small objects: it soon extended to large-scale stone sculpture and architecture, both of which originated in the seventh century and developed into characteristic features of Greek artistic production.

A small flask made in Corinth around the middle of the seventh century (FIG. 39) was sold containing scented oil—an ornate dispenser for a luxury product not unlike the cut-crystal perfume bottles of modern times. Its decorative scheme retains the separation into friezes that characterized Geometric vase-painting, but the figures here are more detailed and intricate than their Geometric counterparts. Anatomical details were picked out by incision—thin lines scratched into the unbaked clay which, after firing, appear sharp and light against the dark-colored figures. The resulting technique is termed "black-figure," and it dominates the decorated fine wares produced at all Greek centers from the late seventh century to the latter part of the sixth. The use of

39. Scent bottle (*aryballos*), ca. 660 BC. Height 2½" (6.8 cm). Museum of Fine Arts, Boston.

Its style is called Protocorinthian (begins ca. 720 BC) as a precursor to the Corinthian animal style of the Archaic period (begins ca. 625 BC). Such vases are found in seventh-century contexts all across the Mediterranean; here, the mythical hero Bellerophon astride Pegasus confronts the monster called Chimaera.

40. Amphora by the Analatos Painter, ca. 690 BC. Height 31½" (80 cm). Louvre, Paris.

The vase is named after the suburb of Athens in which it was found. It displays the earliest stage of the so-called Proto-Attic style of pottery that was produced for much of the seventh century.

incision may itself be an orientalism; it is borrowed from metalwork, and many ornate incised gold, silver, and bronze vessels with figural friezes arrived in Greece from Levantine workshops. The dominance of animal (real and fantastic) figures in Protocorinthian (ca. 720–625 BC) and other orientalizing styles is also a feature shared with Near Eastern decorative art. finally, and perhaps most revealing, the subsidiary non-figural decoration seen here— intertwined floral chains, filling rosettes, and the cable band—is a clear rejection of Geometric pattern and drawn directly from the Oriental repertoire. Yet the object itself is fully Greek. No Near Eastern potter made vases anything like this and the subject matter here is a purely Greek myth.

Corinthian potters and painters were the first to orientalize patently; they quickly came to dominate the production of highly decorated small vases. This was no doubt a result of Corinth's early and successful entry into the colonization process and of its extensive involvement in trade. Athens, better provided with arable land, showed little interest in colonization. The city continued to produce large ceramic tomb markers reminiscent of their Geometric predecessors, but the craft was far from untouched by Oriental influence (FIG. 40). Sphinxes now stride where deer grazed earlier. Ornament is now curvilinear rather than rectilinear; not only are the cable and rosette prominent, but geometric triangles are now curved or hooked. The subjects are unchanged from those of late Geometric times—mourners and war chariots—but this is clearly an era of stylistic and technical experiment: faces painted in outline have a lighter and more naturalistic hue; incision is used on the horses. Athens, like other *poleis*, imported many fine vessels from Corinth in the seventh century, and Greek vase painters were influenced by Protocorinthian wares as much as by actual Oriental models. By the last quarter of the seventh century the experimental phase of this Proto-Attic style was over, and a fully black-figure style, unapologetically "Corinthianizing," was firmly established, although the scale continued to be monumental in the Attic tradition of conspicuous tomb markers for the wealthy.

Like many earlier Proto-Attic vessels, the name vase of the Nessos Painter bears clearly identifiable mythological scenes (FIG. 41). On the neck, Herakles slays Nessos (labelled Nettos here in Attic dialect), the unrestrained centaur who attempted to abduct Herakles' wife Deianeira. Beneath, in large scale, are two running

gorgons followed by the stumbling and headless Medusa. Perseus, her slayer, and Athena, his helper, are depicted on the sides of the vase. A primary characteristic of Greek seventh-century art is its increasingly mythological (as opposed to funerary or generically emblematic) iconography, and concepts of self and other play a central role in the myths chosen. Bellerophon and Perseus, both with divine favor, overcame adversaries who were at the same time monstrous and eastern, remote, impossible, unknowable, and female. These suggest (like Homer's *Odyssey*) a seventh-century Hellenic culture that was wide-ranging, exploratory, and risk-taking, yet at the same time conservative and circumspect. Greek attitudes toward the east were ambivalent: Homer describes the Phoenicians as both unparalleled craftsmen and irrepressible cheats. The east was a source of enrichment, both materially and intellectually; it was also a threat, not simply as a competitor for lands and markets but by its very state of being different. The significance of the centaur, here as on the Parthenon, resides in its role as the intersection of self and other; it underscores the even greater necessity of self-control in an increasingly unfamiliar world. Mythology was a means through which the Greeks assimilated new experiences into their *polis*-oriented value system. The themes detected in the topics of the Parthenon metopes were clearly drawn from a longstanding tradition.

Around the middle of the seventh century, three-dimensional art of an orientalizing nature began to appear in a variety of materials. Characteristic works show frontal female faces with sharp features, large almond eyes, and triangular masses of horizontally scored hair (FIG. 42). Since terracotta figurines in a similar style are especially common on Crete, the style itself is called "Daedalic" after that island's legendary craftsman Daidalos or Daedalus. The ultimate source is clearly to be found among Syrian and Phoenician ivories on which the hairstyle is a reflection of the typical Egyptian headdress. The Daedalic style represents a fusion of these more

41. NESSOS PAINTER
Amphora, ca. 620 BC.
Height 48" (122 cm).
National Archaeological
Museum, Athens.

The Nessos Painter is the earliest-known Attic black-figure artist. Much subsidiary ornament (dot rosettes, incised rosettes, swans, and owls) is modeled on Corinthian prototypes.

42. Late Protocorinthian *aryballos* by the Boston Painter, ca. 650 BC, height 2½″ (6.8 cm). Louvre, Paris.

Since Protocorinthian pottery is the most easily dated of seventh-century artifacts, this piece offers important evidence for the chronology of the Daedalic style and the origin of Greek stone sculpture.

Opposite above

43. NIKANDRE, *Kore*, ca. 640–630 BC. Naxian marble, height 68¾″ (175 cm). National Museum, Athens.

Somewhat over life-size, the statue found on Delos bears an inscription along the side of its skirt, which reads: "Nikandre dedicated me to the far shooter of arrows, the excellent daughter of Deinodikes of Naxos, the sister of Deinomenes, the wife of Phraxos [now ?]."

softly modeled Middle Eastern forms with the traditional Geometric emphasis on the precise delineation of structure. Wood and ivory figurines in this style have been found at Greek sanctuaries (especially Hera's at Samos), and at some point in the second half of the century, Cretan artists began to carve somewhat larger Daedalic figures in limestone (FIG. 44). Although derived like the nude Dipylon ivories from Astarte figures, these are demurely draped in an often elaborately decorated garment; the abstract incised and painted pattern may reflect weaving or embroidery. This interest in ordered and often ornate arrangements extends to the hairstyle, and is encountered again in the *korai* of the next century.

The translation from ivory to wood and terracotta, and then to limestone are important developments, but the birth of Greek sculpture as we commonly think of it coincides with the first Daedalic figure at human scale and in marble (FIG. 43). Although the surface of Nikandre's dedication is very weathered, it clearly

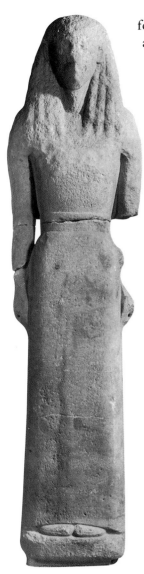

follows the type of the Daedalic statue as known from smaller limestone and terracotta examples. Like votive objects both earlier and later, its identity is unclear, and its inscription is typically uninformative. Drill holes in her hands may have held identifying attributes like arrows or leashes for lions, if Artemis (the recipient of this gift) is intended, or she may be a generic dedication as were the Archaic *korai*. There is disagreement whether this large-scale stone statue should be thought of as a direct translation from small Daedalic images in more malleable materials or rather a development from now lost wooden statues. Whichever side one takes in this dispute, there is no question that Nikandre's statue displays a Daedalic scheme and thus reflects the continuation of forms ultimately dependent on Oriental models.

At around the same time as the Nikandre, and at the same place, marble was worked into large (sometimes colossal) male figures, which were similarly set up in sanctuaries (FIG. 45). The male figure standing frontally with one leg advanced and hands to the side was at this time a millennia-old Egyptian tradition, and only the most desperate anti-Orientalist could deny the derivation of the *kouros* from an Egyptian model. Unlike Egyptian statues, however, the Greek *kouros* was carved entirely free of the block of stone from which it was formed; its arms are carved free from the body (except the hands), the legs are separated from one another, and the figure is nude. The result was more prone to breakage but better embodied the active ideal which the *kouros* was meant to exemplify. This interest extended to anatomy: whereas the Egyptian artist was adept at capturing the fluctuating surfaces of flesh, the Greek sculptor projected to that surface the underlying system of muscle and bone on which the physical vigor of the human figure depended. To the Egyptian, a

Below
44. Lady from Auxerre, ca. 640–630 BC. Limestone, height 25¾" (65 cm). Louvre, Paris.

The statue was discovered a century ago in a museum in Auxerre (when it was called the Auxerre Goddess) and was later acquired by the Louvre. No record of its provenance has been found. Its attribution to Crete rests on the discovery there of limestone statuary of a similar style. The garment is variously seen as a simple tubular dress with the back fastened over the shoulders at front, or as a two-piece combination of dress and cape.

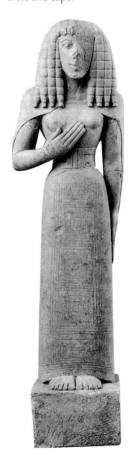

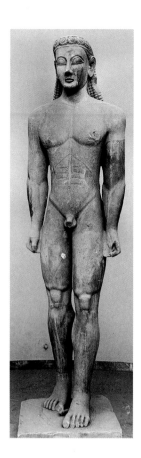

Above

45. Kouros, ca. 600–590 BC. Naxian marble, restored height 10¹¹/₄″ (3.05 m). National Museum, Athens.

This is the more complete of two similar colossal votive *kouroi* found at the sanctuary of Poseidon at Sounion, located at the very tip of the Attic peninsula. Its features are very sharply defined, some even incised, in a style that is reminiscent of contemporary black-figure pottery.

Right

46. The architectural orders, Doric on the left, Ionic on the right.

stable resting place for an immortal soul was essential; the Greek was more concerned with creating a permanent symbol of a living principle of virile virtue. Similar types could be adapted to each purpose.

That the Greeks became interested in monumentality and adept at working in stone during this same era is even more evident in architecture. It is in the seventh century that the first large-scale stone temples were built and that the first colonnades were erected around them (peristyles). Greeks familiar with Egypt, as by this time at least some certainly were, could not help but be impressed there by the massive stone temples with their simple, geometric forms and forests of columns. By the end of the century the experimental phases of Greek temple structure had settled on the Doric order; the Ionic, with its own eastern associations, came somewhat later (FIG. 46). Some characteristic forms (plain architrave, convex moldings, fluted columns, simple capitals) have close parallels in Egyptian architecture; others (especially the alternation of triglyphs and metopes in the frieze course) seem more like petrified versions of wooden construction. Indeed, the earliest well-preserved Doric temple displays vividly the transition from wood to stone (FIG. 47). The once bitter dispute over whether the Doric was adapted from Egypt or an indigenous development now seems familiar, simplistic, and even tedious.

The idea of large stone architecture, like the idea for large marble sculpture, emerged from the desire for a more conspicuous, permanent, and impressive monumentality. If other cultures had found solutions, technical or artistic, to some of the problems the Greeks might encounter in pursuing this desire, the latter were

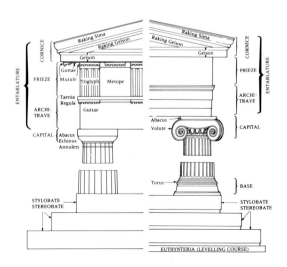

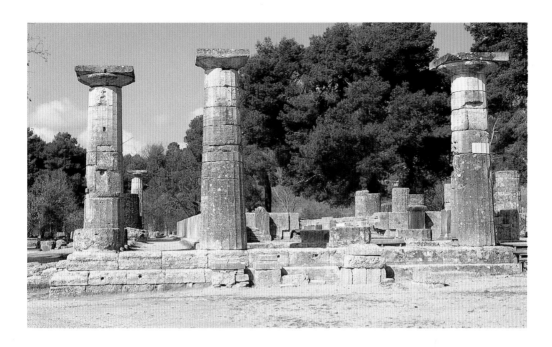

sufficiently pragmatic to learn from them. Nothing was borrowed unchanged because the functions of these objects, the motives for creating them, and their intended viewers remained Greek, not foreign. The seventh century was a time of rapid change for the Greek world, one in which competition among aristocrats expanded to include competition with increasingly empowered non-aristocratic classes and increasingly ubiquitous non-Greeks. The traditional expressions of ambition among individuals and among *poleis*—conspicuous tombs and votive objects, elaborate and expensive personal belongings, communal expressions of piety directly reflecting a *polis'* financial capability—developed along lines made possible by increased wealth, experience, and knowledge. But traditional they remained. Greece of the seventh century was a more cosmopolitan place than it had been a century earlier, but the sophistication which resulted from that exploration of alterity remained unshakably Greek.

Self-Definition

Interpretation of the Parthenon metopes detected themes suggestive of the communal values of Periklean Athens, a society that ancient writers portray as markedly self-absorbed. It may be unfair to judge Classical Athens too harshly, however, since those same themes can be found in Greek art well before the Persian Wars (490–479 BC) and long after Athens' defeat at the hands of Sparta

47. View of four of the extant columns of the Temple of Hera, Olympia, ca. 590 BC.

The capitals from this temple display conspicuously different shapes: from the sixth to fourth centuries, Doric capitals evolved from a broadly spreading form to a much more compact shape almost vertical in profile. Pausanias (*Description of Greece*, 5.16, 1) saw a wooden column in the Hera temple, from which we infer that wooden columns were replaced in stone, one by one, as the need or occasion for honoring the goddess arose. That each was done in the style of its time explains the differing forms.

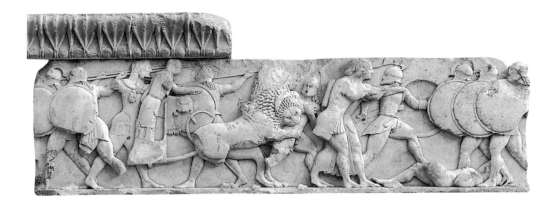

48, 49. North frieze scene and detail, Siphnian Treasury, Delphi, ca. 525 BC. Marble, height 24³/₄" (63 cm). Archaeological Museum, Delphi.

This section shows, from left to right, two giants, Dionysos wearing an animal skin, Themis (the mother of Prometheus) in a lion-drawn chariot, and the archer twin deities Apollo and Artemis, in front of whom the giant "Kantharos" flees right looking left. The frieze ran around the entire building. The north side is believed to be the work of the same sculptor responsible for the east frieze, depicting a scene from the *Iliad*. The topics of the other two sides are less clear, but appear to be the Judgment of Paris and Abduction of the daughters of Leukippos by the Dioskouroi (the twins Kastor and Polydeukes).

(404 BC). Fifth-century Athens seems simply to provide an especially well documented and clearly constructed example of a remarkably consistent set of Greek values and attitudes. The treatment of the Gigantomachy offers an example. As we saw, this myth plays a large role in the Parthenon specifically and more generally in the Athena cults of Athens; the goddess was herself instrumental in the defeat of the giants both by her own fighting and by securing the necessary assistance of Herakles. It was the subject of the first marble pediment in Athens, added in the late sixth century to the old temple of Athena. Since the battle involved all the Olympians and since its theme of order vanquishing chaos was broadly applicable, the Gigantomachy was the most frequently chosen subject for Greek architectural sculpture from its early Archaic beginnings to its latest Hellenistic examples. The effectiveness of the story depends on the otherness, or alterity, of the giants; different monuments suggest that quality in different ways, but its emphasis in all representations underscores its centrality to the myth.

The north frieze of the Siphnian Treasury at Delphi provides the most complete Gigantomachy in Archaic sculpture (FIGS. 48 and 49). Here as on the Parthenon the story is joined by other myths to form a program, including Trojan War themes and stories of local significance. The giants are differentiated from the Olympians not by size (as in some earlier depictions) or by some monstrous physiognomy as later, but by somewhat less obvious means. Only giants, for example, are seen getting the worse side of the conflict, especially the fallen and the unfortunate victim of Themis' lions. A still more subtle distinction can be seen in the protagonists' equipment. Most Olympians are not heavily armed, and their few helmets are small ones of the Attic type; the artist is concerned with revealing each god's identity through

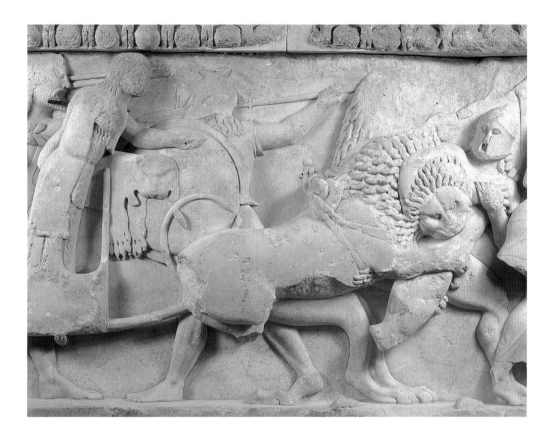

action, attribute, and aspect. Each giant, however, wears a concealing Corinthian helmet that gives each of them a bestial and masklike quality, especially in frontal view. The artist did not wish to suppress the giants individuality entirely; some names (barbarian names, as scholars have noted) are painted on the relief background, and a crest support in the shape of a *kantharos* cup appears atop the helmet of the similarly named giant. Yet these token efforts only emphasize the interchangeability of the giants' basic figural type, especially in contrast with the detailed differentiation among Olympians. Such blurring of identities is an effective form of marginalization for those deemed to be the other.

Perhaps the most complete and most famous Gigantomachy of all is that on the Hellenistic Great Altar of around 175 BC at Pergamon (see FIG. 34). Here the difference between gods and giants is spelled out by means of a variety of polarities—the many fallen and expiring giants as opposed to the ever-victorious gods, the dramatically anguished expressions of the defeated and dying giants as opposed to the beautiful and idealized ("classicized") Olympians, and, most conspicuously, the snake-legged anatomy of many giants, which derives from and refers to their

origin in the earth. Pergamon was a Hellenistic city that fashioned itself as a second Athens, and the choice of this subject in part alluded to the city of Athena. At the same time, the Gigantomachy functioned here, as in the Classical and Archaic periods, as a manifestation of a continuing need to see order maintained in a world that was, if anything, increasingly threatening.

The Pergamene Gigantomachy is conventionally read as a commemoration of victories over barbarian Gauls, but it dates to well after the most significant of these. It was probably meant to situate the Pergamenes within a recognizably Hellenic religious tradition, as with so much of the embellishment of Pergamon. The earlier kings of Pergamon, especially Attalos I (r. 241–197 BC) certainly did set up monuments to commemorate Gallic victories, some of which consisted of bronze statues representing the Gauls themselves. None survive, but several Roman marble statues are believed to copy third-century Pergamene originals. The Ludovisi group (FIG. 50) reveals an interest in ethnic characterization through its depiction of features like the man's moustache and unruly hair, which ancient authors have described as typical of Gauls. These features, like the deep-set eyes and emotional expression, also align the image of the Gaul with that of the giant, suggesting them to be equivalently "other".

The characterization of alien races can also be found in earlier Greek art. The Oriental garments of Amazons and Persians

50. Ludovisi Gaul, Roman Imperial date. Marble, height 6'11¼" (2.11 m). Museo Nazionale delle Terme, Rome.

The group is believed to copy a third-century BC bronze original on the Athena terrace at Pergamon. The Gaul has just killed his wife and is thrusting his sword into his own chest so that both should escape capture. Such nobly savage behavior is mentioned in ancient literature on the northern tribes, and here serves to characterize the Gauls as much as do their physical features.

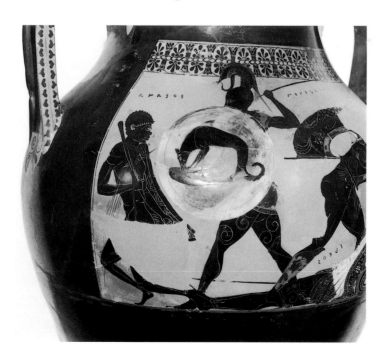

51. EXEKIAS (attributed) Black-figure belly amphora, ca. 540–530 BC (detail). University Museum, Philadelphia.

Menelaos, one of the Greek leaders, attacks a figure labeled "Amasos" in this Trojan War scene.

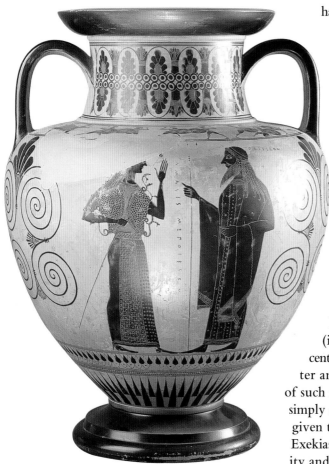

52, 53. AMASIS PAINTER
Black-figure neck amphora
with Athena and Poseidon,
and Dionysos and
maenads, ca. 540–530 BC.
Height of vase 13″ (33 cm).
Bibliothèque Nationale de
France, Paris.

The two similar
compositions invite
comparison between the
composed (and masculine)
goddess on one side and the
frenzied maenads on the
other. Traces of the original
white paint are detectable on
Athena's feet. The subject of

have already been mentioned. More distinctly characterized were sub-Saharan Africans. The Archaic black-figure vase-painter Exekias twice labeled depictions of youths with African features as "Amasos" or "Amasis" (FIG. 51). A potter (and presumably painter) with this name was active in Athens during the third quarter of the sixth century. If the vases attributed in modern times are all his, Amasis must have been one of the most productive and successful artists of his time and very likely a rival and competitor of Exekias. Interpretations of Exekias' "portrait" have varied. Amasis was the name (in Greek form) of an early sixth-century Egyptian pharaoh. Was the potter an emigré from Africa, or the son of such resident aliens? Is Exekias' image simply a joke, playing on a foreign name given to an Athenian citizen? Whatever Exekias' motive, his art illustrates an ability and an interest among sixth-century Greeks in developing images of other races that contrast with their own highly idealized self-image.

Representations of Africans are not frequent and usually have exotic overtones, but there may have been social implications in some examples. So-called "head vases" were pitchers and, less often, cups in the shape of human heads. According to a recent study, by far the majority of these depict women, although other subjects include a black African, Dionysos, a satyr, and Herakles. The last three are all associated with the (often excessive) consumption of wine and therefore would be appropriate for such symposium equipment. It is assumed that Africans, like women, were included because of their role as servants. That white males are not found among the several hundred Athenian examples suggests that inclusion in this group was a clear sign of otherness.

As we saw with the centaur, bestial behavior as a result of alcohol abuse certainly qualifies as a deviation from the Classical ideal of moderation and therefore as a sign of alterity. Among the

retinue of Dionysos it is only the male satyr—conceptually close to the centaur—and not the female maenad who is portrayed with animal features (pointed ears, tail, porcine nose). In a culture that marginalized women, it may have been the case that irrational behavior among men demanded such external explanation (immoderate drinking, a bestial identity) whereas for women it did not. The role and portrayal of women in Greek art is a huge topic not easily treated in summary fashion; many studies have shown how artistic representations did not simply depict but in fact helped reinforce a womans largely peripheral role in ancient Greek society. Here, comments on the alterity of women are limited to two basic and image-oriented observations. First, Greek art reveals a longstanding concern with gender distinction: women were portrayed differently from men and shown pursuing different activities. Secondly, extant representations reveal less interest in characterization among women than among men, as though women, like the giants of the Siphnian Treasury, were not a sufficiently important topic to warrant differentiation.

The very earliest painted images (like those of the Dipylon Amphora) show an already developed convention for distinguishing men from women, and in Geometric burials the different vase shapes (amphora for women, krater for men) had clearly different implications about expected behavior. Archaic art shows a continued interest in gender distinction. An amphora by Amasis shows two solutions used in black-figure painting (FIGS 52 and 53). In the scene with Athena and Poseidon, the female goddess was given white flesh through the addition of paint (now largely lost), which was the universally accepted method for articulating gender distinction, conventional already in Egyptian and Aegean Bronze Age art. On the other side, the maenads are kept light by being painted in outline.

the Athena/Poseidon scene is unclear. It may simply be a meeting of two deities who favored the same side (the Greeks) in the Trojan conflict, as the greeting gesture suggests. Since this is an Athenian work, it is tempting to read an allusion to the contest between the two deities, although the earliest clear reference in painting or sculpture to that episode is nearly a century later than this vase.

In Archaic statuary the nude *kouros* contrasts strongly with the heavily draped *kore*—a convention which is far from status-neutral. The *kore* is more fully adorned because a womans value derived less from her own virtues than from her identity as a possession or adornment for the men to whom she was related; one need only note, for example, that on the earliest extant marble votive statue (see FIG. 43), the dedicator Nikandre identified and situated herself by providing the names of her father, brother, and husband.

The strength of the convention of draped females is illustrated by the Aphrodite of Knidos, the exception that proves the rule (FIG. 54). Pliny (*Natural History*, 36.20) tells us that Praxiteles (fl. mid-fourth century BC) made two statues of the goddess, one draped and one nude. The conservative Koans, who chose first, picked the former as the proper thing to do. The novelty of the other statue, purchased by the Knidians, led to its wide-ranging fame and no small number of scurrilous and erotic anecdotes about the statue, the sculptor, and his paramour Phryne, the courtesan believed to have served as its model. Praxiteles made the Aphrodite's nudity her attribute as goddess of love, fertility, and beauty; he sought to explain the nudity by indicating her in her bath. Yet there can be no question that the statue's immense fame derives from its flouting of convention. Its contravention of communally constructed assumptions about gender, sexuality, and propriety would have forced a complex discourse in the mind of the viewer, whether male or female.

By and large, women were valued for the role they played within the family unit, and the most expressive representations of such units are found on Archaic and late Classical grave reliefs (FIG. 55). These *stelai* were set up on family plots; since it is the concept of family itself which is portrayed, identifying the deceased on many examples is notoriously difficult. In the Prokles and Prokleides example we see the older man distinguished from

54. Aphrodite of Knidos, Roman copy of Praxiteles original of ca. 350–340 BC. Marble, height 6'8¼" (2.04 m). Vatican Museums, Rome.

This and other copies of the marble original can be identified on the basis of Knidian coins portraying the statue.

55. Gravestone of Prokles and Prokleides, from Athens, ca. 330 BC. Height 5'10¾" (180 cm).
National Archaeological Museum, Athens.

Not only is the woman here pushed to the background and treated in a generic fashion, but she
alone is not named in the inscription. If this is a family grave relief, that omission is significant.

the youth by hairstyle, beard, pose, and garment. The woman who stands (appropriately) in the background is without identity, neither young nor old. She is shown to be a wife through her garment-lifting gesture but whose wife is she? Ancient portraiture consistently invests more effort in the characterization of men than of women, who are most often shown with heavily idealized and undifferentiated features. The very lack of interest in exploring the character of women is a symptom of their marginalized status.

"Character" portraits of famous men were increasingly common in late Classical times; an especially probing treatment of the subject is detectable in the portrait of the orator Demosthenes (384–322 BC; FIG. 56). Although known only from Roman copies, the identification is secure from ancient descriptions of the work and the inscribed name on one replica. Here we have an image that looks startlingly realistic in contrast with the idealized, even bland, images encountered so far. His features seem specifically conceived, and yet we know that the portrait was set up in 280 BC, forty-two years after Demosthenes' death, when few if any could have remembered details of his appearance. The image is biography as much as portraiture. The troubles endured throughout his life are written in the wrinkles of his brow, the hollows of his cheeks, receding forehead, downcast eyes, and the set of his mouth. A slight underbite recalls the story of his having achieved greatness as an orator only by overcoming a severe speech impediment. It is often argued that as time progressed Greek portraits became more faithful depictions of their subjects, but what is actually displayed is a growing interest in more detailed characterization. Indeed, actual appearances are irretrievable, so the first assertion is not demonstrable. While it may not be provable that a portrait such as Demosthenes' is more realistic than those of Classical times, it is certainly more descriptive. In fact, the implied distinction between

visual depiction and characterization is moot, since the Greeks believed in a close relationship between ones appearance and ones character (*ethos*). Aristotle, whose particular fondness for taxonomies led him to describe in some detail a variety of differing *ethoi*, displayed an especially deterministic view of the relationships of character, image, and actions.

Given this holistic view of the individual, exploration of the "other" cannot be seen as an idle exercise: it was an integral part of self-discovery and is traceable to the beginning of Greek thought. Greek art was, at first and always, fundamentally generic in its outlook, but from the beginning artists developed means to distinguish differing generic types: male from female, human from bestial, animal from monster. In Archaic and Classical times definition of the dominant youthful male ideal attained paramount importance. Some images, like the Archaic *kouros* or Polykleitos' Canon, struggle with the impossible task of embodying that ideal. Others describe those qualities that deviate from it; these are equally essential to the task, since without them the ideal image signifies in a vacuum. What did it mean not to be male, or Greek, or young, or human? The construction of other is indeed the construction of self. The implicit polarities form a framework within which the world was experienced and societal values crystallized, and although these values were far from unique to Periklean Athens, their multiple manifestation on and in the Parthenon underscores their essential role in understanding that monument's special message.

56. Portrait statue of Demosthenes, Roman copy of Polyeuktos' bronze work of 280 BC. Marble, height 6′7½″ (2.02 m). Ny Carlsberg Glyptothek, Copenhagen.

The original was set up in the Athenian Agora for all to see. The figure stands "with its fingers interlaced," exactly as described by Plutarch (*Life of Demosthenes*, 31.1).

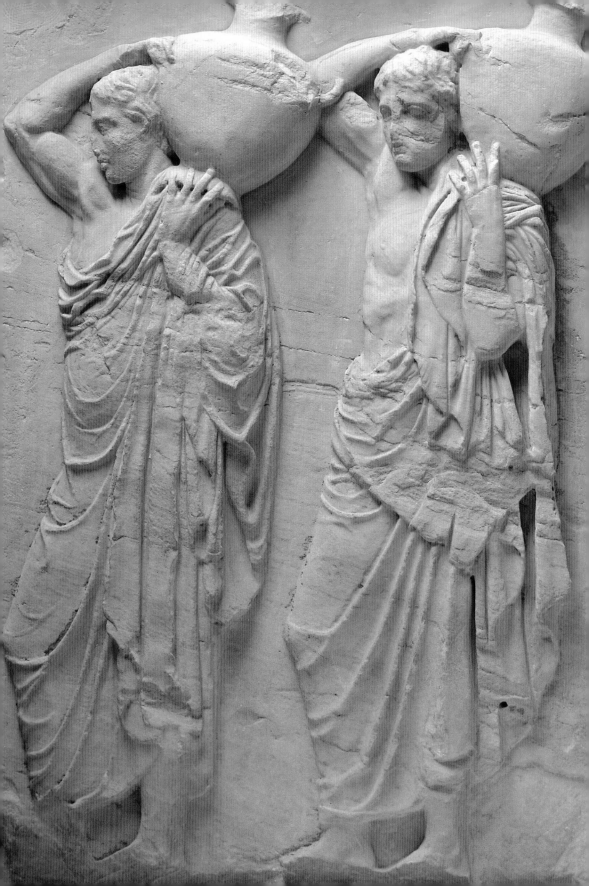

THREE

Myth, History, and Narrative

Notices of new and spectacular finds appear regularly in the popular press, since the romance of archaeology lends it a special appeal in the minds of the literate public. It is rare, however, that a new interpretation of an ancient work receives such treatment. For the most part the disputes of scholars over the who, what, when, and why of even the most well-known works are contained within a hermetically sealed sphere of interest. One revisionist reading, however, created such repercussions in that sphere that it did burst out into newspapers and magazines even before it appeared in a scholarly journal. What was all the fuss about?

The Parthenon Frieze and History

In addition to the traditional sculptured pediments and metopes, the Parthenon's program includes a continuous sculptured frieze, 525 feet (160 meters) long, around the top of the central block (cella). The subject is a procession of Athenians engaged in a variety of actions—on horseback, in chariots, leading sacrificial victims, and bearing offerings; it runs from west to east along the two long sides of the building and from south to north across the western end. The procession turns from the north and south sides onto the east frieze (FIG. 57) where it culminates in an enigmatic central scene before the assembled Olympian deities.

Since a frieze was unprecedented on a Doric temple, the standard comparative method of determining meaning is even less effective than usual. One well-documented annual religious procession of Athenians to the Akropolis was the Panathenaia. During the quadrennial "Greater" Panathenaia, a new robe

57. Block VI, north frieze, Parthenon. Marble, height 41¾″ (106 cm). Akropolis Museum, Athens.

Two youths carry water-jars (*hydriai*). These are preceded in the procession by other offering-bearers and immediately followed by musicians. Their faces show the idealized features shared by all the participants throughout the frieze.

(a *peplos*), woven with a depiction of the Gigantomachy and intended to drape the ancient olive-wood cult image of Athena, was presented to the goddess. In addition, the city held an agonistic festival nearly equal in status to the Panhellenic Games at Olympia and Delphi. Since this was the major Athenian event in honor of Athena, and since the climax of the frieze is a cloth folding or unfolding scene (FIG. 59), it has long been thought that the frieze depicts a Panathenaic procession. However, we expect architectural sculpture to depict scenes of myth, not contemporary scenes of cult activity, and the Parthenon procession does not really look very much like the Panathenaia as it has been described by ancient sources, so there has always been a certain level of discomfort with this reading. To compensate, scholars have suggested that it was the first Panathenaia conducted by the mythical kings of Athens, or the Panathenaia involving the heroized warriors who had died at the battle of Marathon in 490 BC, or that it is a generic representation of a recurring event or a symbolic religious procession not specifically meant to show the Panathenaia *per se*. Although the identifications vary in detail, some kind of Panathenaia, or at least some religious procession, has been universally accepted.

The question was entirely reopened in 1996 when an American scholar suggested a purely mythological reading having nothing to do with the Panathenaia. By considering the evidence of a fragmentarily preserved play by Euripides and by applying a close iconographic analysis to the elements of the frieze itself, the

58. Diagram of the east frieze of the Parthenon.

Myth, History, and Narrative

subject was argued to be the sacrifice by King Erechtheus of his three daughters. This unnatural act was demanded by the Delphic oracle, which prophesied that only by doing so could the king be victorious over the invader Eumolpos, who had come to claim Athens on behalf of his still-resentful father Poseidon. The remaining figures of the frieze are, as in other interpretations, the assembled Athenian citizenry, in this case present at the sacrifice. The interpretation has much to recommend it. For example, the two leftmost figures of the central scene—never satisfactorily explained as part of the Panathenaia—become the two older sisters with their funeral shrouds. On the right, the youngest, and first sacrificed, is unfolding her own robe with her father Erechtheus. The fact that Athena is not distinguished among the fourteen gods depicted and the lack of certain identifying features of a Panathenaic procession also become less troubling.

The reaction to this proposed reading has been swift and passionate by both its proponents and its opponents, and no resolution seems likely soon. No agreement has emerged from the particulars of argument and counter-argument (is the small figure in the "*peplos* scene" a girl or a boy? Is the material on the stools of the two figures at left that of cushions or of folded cloth?). If the topics of temple sculpture were selected in accordance with a "program", then we might expect that program, if retrievable, to help us identify the subject of the frieze. As we have seen, the subjects of the metopes and pediments are drawn from the realm of mythology, and, whether by design or not, they clearly function as reflections of Athenian views about themselves and others. Whether Panathenaia or mythological human sacrifice, the subject of the frieze is both unparalleled and (as the dispute makes clear) unsettling, yet both interpretations fit very well with the program overall. The sacrifice of the Erechtheids was a direct result of the contest between Athena and Poseidon—depicted on the Parthenon's west pediment. It reinforces not only Athena's favor of the Athenians but the Athenians' own sacrifice to protect the relationship between city and goddess. The Panathenaia is equally satisfactory. The Gigantomachy of the *peplos* repeats the subject of the metopes above and was engraved on the interior of the Athena Parthenos' shield. Moreover, its significance is not so very different from that of the alternative reading, since here too the Athenians are assembled in the service of both Athena herself and the Olympian pantheon as a whole.

It is this broader theme that is key. Most of the frieze—at least 98 per cent of its total length—depicts a procession of Athenians before the gods of Olympus; a section two yards (under

two meters) long shows a scene which cannot be identified with universal satisfaction. A solution to that problem might help us determine what the frieze depicts, but it is unlikely that it will change very much our understanding of what the frieze means. It is unparalleled in Greek architectural sculpture that such a small portion of a scene should be dedicated to the central activity of that scene. Attendant figures are included in mythological scenes, such as in the two Parthenon pediments, but these play an important narrative and compositional role; the main topic is always in view. The inescapable conclusion is that the subject of the Parthenon frieze is the procession itself, whatever the occasion for that procession might be.

Why then was this apparently unusual subject matter selected? First of all, for a long frieze a procession would be a natural selection, since it is infinitely extendable and thereby many compositional and iconographic problems are eliminated. Moreover, having a beginning (FIG. 60), middle (FIG. 57) and end (see FIG. 59), it moves the onlooker, who in this case must first approach the temple from its back (at the west), around one side or the other to the east front. Although processions had been depicted in Greek art as early as the Bronze Age, their use as a topic for architectural sculpture may have been influenced from the east, like the idea of the frieze itself. Assembled worshipers, some in procession, are detectable in the fragmentary temple sculptures of several Archaic Ionic temples in Greek Asia Minor (Ephesos and Didyma, for example). One especially ingenious reading sees the Parthenon frieze as an open response to the processions of obeisant subjects carved at the various Persian palaces; the liberty of the lively and dynamic Greeks stands thus in vivid contrast to the submission of the regimented rows of figures paying homage to the Persian king.

In any case, the Parthenon frieze clearly has to do with the Athenian citizens—historical or mythological—who make up nearly its entire length. The pediments describe an Athens which enjoys a privileged place in the eyes of the gods. The metopes focus

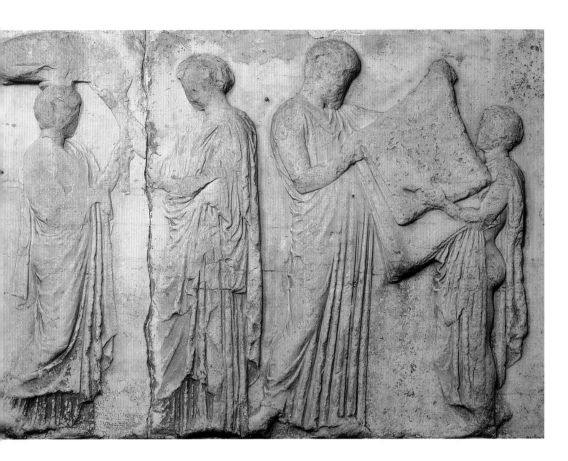

on those Greek virtues of virile power and civilized self-control which Athenians embody more than "others"; such qualities both explain and illustrate this divine favor. The Parthenon frieze, like Perikles' Funeral Oration, is more explicit still, portraying for us an Athenian citizenry in the company of deities from whom they are distinguished by scale alone, suggesting that Athens itself ("the people are the *polis*") is an object of veneration.

If the dispute concerning the Parthenon frieze affects so slightly our understanding of the building's significance, why then does it elicit such strong feelings and widespread interest? It is because the Parthenon is the pivotal monument for our understanding of Classical Athenian art, and it stimulates in every scholar—indeed, in everyone with even an amateur interest in the topic—understandably proprietary sentiments. One suspects, however, that there is more to it than that, since the varying readings derive as much from assumptions, expectations, and instincts about appropriateness as they do from the analysis of iconographic details. How could the jewel of the Akropolis portray so grim an episode from Athenian legend? How could it be a Panathenaia when, as

59. Five central figures (nos. 31–5) from the east frieze, Parthenon. Marble, height 41¾" (106 cm). British Museum, London.

From left to right are two attendants carrying stools bearing cushions (for no known reason) or the two elder daughters of Erechtheus, king of Athens; these objects are received by a priestess or Praxithea (wife of Erechtheus), a priest and child attendant handle the *peplos* or Erechtheus and his youngest daughter prepare her funeral shroud.

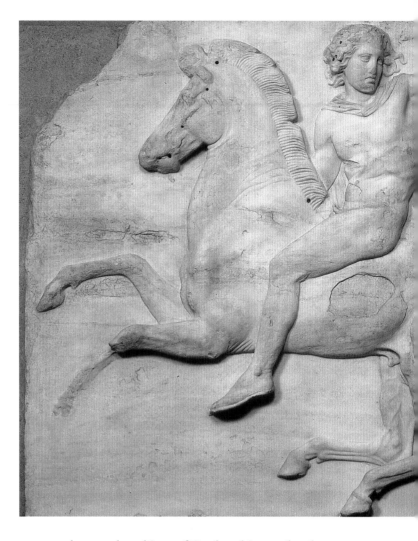

everyone knows, the subjects of Greek architectural sculpture were drawn only from mythology? We care so much about what is otherwise a dry, scholarly debate because that debate cuts to the very heart of how we look at ancient Greek art.

One aspect of this dispute involves the play among image, myth, and history. The Greeks did not, in most cases at least, choose to depict historical events in monumental art, as did the Middle Eastern civilizations before them and the Romans who came later. Yet dedicatory inscriptions and ancient authors alike tell us that monuments were paid for and erected using the proceeds of war. From this fact, and following modern expectations, scholars make two assumptions. First, although their ostensible function was religious, it is generally held that such monuments erected from the spoils of war were in fact intended to serve a secular

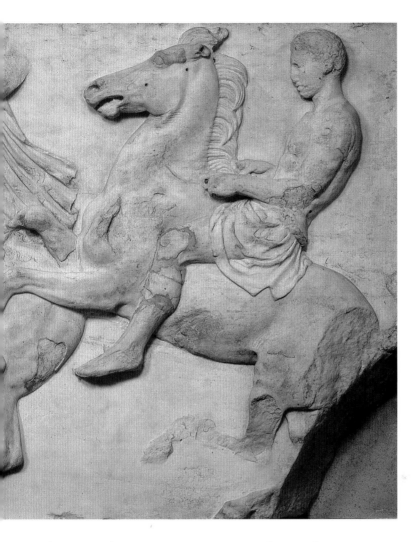

60. Block II, west frieze, Parthenon. Marble, height 41¾″ (106 cm). British Museum, London.

Horses make up much of the frieze. The entire west end shows figures on horseback or preparing to mount, and approximately one-half each of the north and south friezes show figures riding or in chariots.

function—the patent commemoration of a specific victory. Secondly, in the absence of a tradition of historical representation, it is generally taken for granted that the myths depicted on these monuments were meant to stand for the historical event itself. The rarity of historical depiction has caused us to believe there was a taboo against it—a situation which clearly contributes to the intensity of the debate over the Parthenon frieze.

Most readings of the Parthenon sculptures consider that the temple as a whole should be interpreted as a commemoration of the Greeks' victory over the Persians and, in particular, the Athenian role in that conflict. The myths depicted on the temple are held to allegorize these same events. This belief is grounded in historical context. Perikles' Parthenon was built to replace an earlier fifth-century temple; archaeological evidence suggests a

date after 490 BC for this older Parthenon, and so it is generally assumed that it was among the many monuments built from the spoils of Marathon and thus intended to commemorate that event. It is not agreed whether this building had a sixth-century predecessor, but there is evidence that it did, and one would expect the cult tradition on the spot to have had some impact on later developments. While the construction of the older temple may have been connected with the Persians, its destruction certainly was, since the building was demolished still unfinished in the Persian sack of Athens in 480 BC. Later sources record an agreement not to rebuild what the Persians had damaged, leaving it as a memorial to barbarian impiety—the so-called Oath of Plataia. Whether or not such an oath was actually taken, the temple to Athena and other Akropolis buildings were not replaced until at least a generation after the Persian retreat.

No fifth-century sources tell us why the earlier agreement, if it existed, was no longer considered valid when the Periklean program undertook the replacement of the Akropolis buildings destroyed by the Persians, but later historians offer some explanations. A peace treaty with the Persians is mentioned; we also hear of an intended conference of Greek *poleis* summoned by Perikles to discuss the ban. Whatever the justification, the Athenians decided to undertake this construction and to use defense monies of the Delian League to pay for it. It is also clear that a primary goal of the program, apart from providing for the cult functions of the fallen buildings, was the adornment of Athens as a site equivalent in its physical beauty to its political power (or even beyond, as Thucydides later suggested).

It is not difficult to read the Parthenon as a commemoration of the Persian Wars if one chooses. The greatness of Athena and Athens, made manifest in the pediments, was instrumental at Marathon and Salamis. The "others" in the metopes can all be cast in Persian garb: Persians were barbaric like the giants, hubristic like the centaurs, androgynous like the Amazons, and Oriental like the Trojans. The frieze has been seen as depicting the victors of Marathon and contrasting Greek liberty with Persian servitude. But what points explicitly to Persia? The pediments—the most apparent and important element—betray no Persian allusion. Nor do the subjects of the metopes, all of which are found in Greek art well before a Greek ever encountered a Persian foe. Even the Ilioupersis, which has been read as an allusion to the sack of Athens, can equally well be seen as depicting a people whose only crime was divine disfavor—in strong contrast with Athens itself. The purely Marathon reading of the frieze has been

widely rejected, and even if there were a Persian subtext to the procession scene, it would align the frieze with the metopes as emblems of Athenian virtue and self-definition.

If the images themselves support two different readings, one is left with arguments of likelihood and historical context. In Athens during the third quarter of the fifth century, would the designers of the Parthenon sculptures have intended a meaning that points to the Persian wars of a generation earlier or to the themes and values of contemporary Athens? That the latter were paramount needs no further argument, and Perikles may have had mixed feelings about invoking the former. After all, the money had been appropriated from a defense fund against Persia (albeit, as Plutarch suggests, unapologetically), and in Athens monuments commemorating the Persian Wars had been a conspicuous feature of the preceding era when Perikles' rival Kimon (son of Miltiades—hero of Marathon) was the most influential citizen. Athens' concern in the High Classical period was much less Persia than the rival *polis* Sparta. Reference to the Persian victory was not so effective in that context, since Sparta played as large a part in the defeat of Persia (especially during the second invasion) as did Athens itself. What was instrumental in a thematic war against rival Greeks (peer polity interaction, again) was the idea of Athenian superiority, as played out in Perikles' speech and the Parthenon sculptures. Did the latter, therefore, look back to the Persian Wars or rather look forward to the Peloponnesian? Of course, both readings were and are possible. What the Parthenon really presents are ideas that the Athenian democracy held about itself: continuing values, which resulted from a long history of contrast and conflict, determined the Athenians' assimilation of the Persian Wars experience, and prepared them for future confrontations. An insistence on a one-dimensional Persian reading obscures the range and depth of the iconographic program.

This is less a revisionist reading than a warning. Many of the works of art discussed so far are emblematic images of gods, heroes, and others that represent certain accepted values about the subjects depicted. Others, however, seem to tell stories: they are narrative. For the most part, we have interpreted works of both kinds as reflections of historical developments, cultural conventions, and communal values in ancient Greece; these are what we might call "broad" readings. They contrast with interpretations that see works as determined by or representative of specific historical events—"close" readings, which can be both seductive and dangerous. The peril is less that such an interpretation is wrong than that it necessitates a choice when multiple meanings

might be equally valid. Four points are crucial. First, mythological narrative is an indirect and non-specific means of suggesting historical narrative. Secondly, the distinction between myth and history is much firmer in our minds than it was for the Greeks themselves. Thirdly, Greek art does preserve depictions of what we should call historical events, although they are not common until fairly late. Fourthly, and most important, both the narrative process itself and the allegorization of history through myth are primarily constructs operating in the mind of the viewer, and thus definitive readings of ancient monuments are for us elusive at best.

The intersection of myth, history, and narrative raises a series of questions. Which stories and what kind of stories did Greek art tell? Are certain stories used in some kinds of works and not in others? How does Greek art tell these stories? Do the stories told in Greek art connect with specific historical events and if so, how? The first three, already addressed, will be taken up more fully at the end of this chapter. Let us begin with the last and turn to that era when, for the first time, our historical information is sufficient to support such a discourse—the Archaic period.

Archaic Art in Context

As we saw in the previous chapter, Archaic Greek art began at some point before 600 BC when all of the elements were in place—large-scale marble sculpture, Doric temples in stone, architectural sculpture, and black-figure vase-painting. In terms of political history, the end of the orientalizing epoch might be seen to coincide with the end of large-scale colonization around 590 BC—the foundation date of Akragas, the last important Greek colony. The Archaic period also brings with it the institution of tyranny; in this as in other matters the Corinthians were at the forefront, since their Kypselid dynasty was already well established in the seventh century. The other significant tyrannies, whether on the mainland like Athens, in colonies like Syracuse in Sicily, or at eastern Greek centers like Samos, were all sixth-century phenomena. Their rulers emerged from the growing conflict between a hereditary aristocracy and an increasingly enriched and empowered middle class. In the early Archaic period, resolution seems to have been sought in law, as suggested by the stories of lawgivers like Drakon and Solon in Athens or Lykourgos in Sparta. In some *poleis*, however, the power of law fell victim to the ambition of individuals who seized power by force and ruled through popular support. Most tyrannies did not outlast the

Archaic period, some were ousted by internal revolt, and some by external forces. Those in the east were absorbed into the growing Persian Empire; those in the west persisted a bit longer.

While there may be no agreement on when the Archaic era began or even how it should be defined, historians are unanimous that it came to a close with the Persian invasion of 480–479 BC. This is the first epoch in Greek history to be defined by an actual historical event rather than a culturally descriptive formula (such as "Bronze" Age, "Iron" Age, "Geometric" period). The story of the wars with Persia is preserved in the writings of Herodotus; this "father of history" lived and wrote around the time of Perikles and was the first Greek (whose writings we have) to research and record historical events in a narrative fashion. His interest in causes and effects (inherent, as we shall see, in the Greek mentality) led him to begin his story much earlier than the Persian conflict itself, and as a result his work is a history, although selective, of the entire Archaic period. Given that he lived later than all that he describes and that his work is literature as much as it is documentation, he offers a reasonable version of what a learned Greek of his time believed had happened during the preceding century or so. In addition, one can find in the works of the Archaic era itself, especially lyric poetry, direct or indirect reflections of contemporary historical events. Consequently, our sources for constructing a historical narrative are much fuller for the sixth century than for preceding times, and the temptation to explain works of art in terms of that narrative is thus much stronger.

One obvious benefit of the fuller historical record is a more precise chronology of works. Absolute dates before the sixth century are based on pottery styles, the arrangement of which is based on the presumed foundation dates of cities (especially colonies) where such pottery was excavated; it is an accepted and workable system but it lacks fixed points. From the Archaic period come works of art (albeit very few) that can be linked to specific datable events. The most significant of these is the Treasury of the Siphnians at Delphi (FIG. 61), discussed in part in Chapter Two (see FIG. 48). In relating the story of an attack of Samian exiles on the island of Siphnos—an event datable to 525

61. Reconstruction of the Siphnian Treasury, Delphi, ca. 530–525 BC. Now dismantled, Archaeological Museum, Delphi.

The porch columns in the form of *korai* (karyatids) provide examples of free-standing statuary. The styles of the reliefs resemble those found in vase painting at the stage when the very first red-figure vases were painted. The marble building has many sculptured moldings that provide dates for the sequence of architectural ornament.

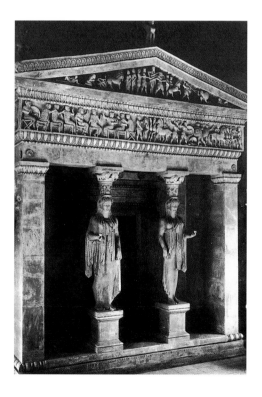

BC—Herodotus reports (3.57) that the Siphnians were at that time so enriched by their silver mines that they were able to dedicate a treasury at Delphi. Both because of its extensive decoration and because of its relatively fixed date, this structure has become the most important single monument for assigning dates to Archaic Greek art, not only for architectural sculpture but for statuary, architecture, and painting as well. In the 1980s, a serious attempt was made to re-date the building to a half-century later. The reaction was felt throughout the discipline, and the traditional date was defended, but the controversy pointed out how much the chronology of monuments even so late as this one remains as much convention as provable fact.

The desire persists to recognize in extant works objects that, like the Siphnian Treasury, are mentioned by historical sources. Two large *kouroi* found at Delphi (FIG. 62) offer a prime example. While reporting a seemingly anachronistic and perhaps apocryphal story about a meeting between King Kroisos of Lydia (r. ca. 560–546 BC) and the Athenian lawgiver Solon, Herodotus (1.31) has the latter tell the story of Kleobis and Biton. Models of the "most fortunate of men", these two Argive youths pulled their mother to the festival of Hera in an oxcart, fell to sleep exhausted, and were rewarded for their virtue by eternal rest. The Argives honored them by setting up their statues at Delphi. These twin *kouroi* of an apparently early sixth-century style were found at the sanctuary, and the signature of an Argive artist seemed to secure their identity as the statues honoring Kleobis and Biton. A recent suggestion that they represent the twins Castor and Pollux, the Dioskouroi, does not preclude their being the monument Herodotus mentions. It is, indeed, more likely that images of the twin sons of Zeus would be dedicated as an allegory for the virtuous sacrifice of the Argive brothers than that votive *kouroi* would function as portraits in the early sixth century.

This realm of myth as allegory for history supplies us with the most fertile field for connecting Archaic art with contemporary events. Sixth-century Athens was the time of Peisistratos, his career buoyed by military accomplishment and political manipulation. From Brauron in northeastern Attika, Peisistratos had been twice made tyrant of Athens and twice driven from tyranny before mid-century; when he seized control for the third time in 546 BC, at the head of an armed contingent, it lasted nearly twenty years until his death in 527 BC. He was succeeded by his elder son Hippias, who ruled until ousted by the Spartans in 510. Hippias returned with the Persians in 490, to rule as their agent if they conquered Athens. The Peisistratid tyranny was a benevolent one, and

62. Kleobis and Biton, ca. 580–560 BC. Marble, restored height 6'5½" (197 cm). Archaeological Museum, Delphi.

The Daedalic-looking hairstyle of these figures and the simple linear patterning of the ribcage and knee, for example, have led to the assignment of a very early date (ca. 580 BC) for these statues. Other features, like the modeling of the muscles around the chest and shoulders and the proper rendering of the eye as a sphere in a socket, seem more developed. The inscriptions (on bases, plinths, and perhaps on the figures themselves) are difficult to read and much disputed, but do at least state that one sculptor was from Argos, as were the brothers Kleobis and Biton.

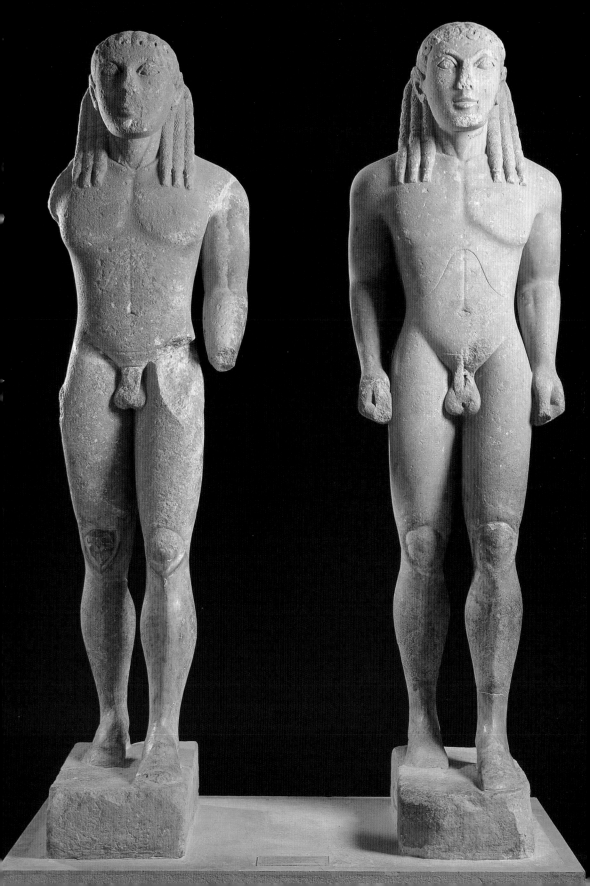

63. Pedimental snake-creature, the Bluebeard, ca. 550–540 BC. Limestone, height 35½″ (90 cm). Akropolis Museum, Athens.

If a political interpretation is correct, then we see, from left to right, a figure holding stylized waves (the *paralioi*, coastal people), a sheaf of grain (*pedieis*, people of the plains), and a bird (the *diakrioi*, hill people). Another proposed reading identifies the triple-bodied monster as Geryon, whom Herakles overcame in his eleventh Labor, but this creature does not resemble other renderings of Geryon.

Athens enjoyed unprecedented prosperity. Many buildings were erected and restored on the Akropolis and around the *polis*, and many cults were established or re-invigorated; the Panathenaia itself was made more grandiose. Athens became the dominant producer of fine painted vases, now exported to every corner of the Mediterranean. Extant signatures suggest that potters, painters, and sculptors flocked to Athenian workshops; their works thronged Athenian sacred spaces as testimony both to their skill and the patrons' prosperity.

Athenian art of the middle (or "Ripe", as it is sometimes called, invoking the now familiar metaphor) Archaic period therefore offers a vivid reflection of the Peisistratids' effectiveness in establishing that *polis* as a cultural and economic center. It is natural enough that more direct connections are sought. Explorations on the Akropolis itself have brought to light a series of painted limestone pedimental sculptures—more, in fact, than there are documented buildings to adorn. Numerous mythological scenes can be identified among which the exploits of Herakles play a large role. These can be dated by style around or shortly after 550 BC, and since Peisistratos is known to have resided on the Akropolis, it is possible that some of the works were commissioned by him. Tradition also holds that Peisistratos fancied himself a second Herakles, so the question arises whether he meant to be allego-

rized by the images of Herakles in the pediments. For example, one of the small pediments shows us the Introduction to Olympos scene, wherein Herakles is conducted by Athena to be made a god after the completion of his many tasks among mortals. The scene enjoys a parallel popularity in black-figure vase painting, and at least one scholar sees the scene as a direct reference to Peisistratos' status as Athenas favorite. Herodotus (1.61) even relates the popular but perhaps improbable story that during Peisistratos' second restoration as tyrant, he rolled into Athens aboard a chariot, accompanied by a statuesque woman dressed as Athena.

Another pediment has been read even more overtly as political allegory (FIG. 63). Opposite a group of Herakles and Triton (itself seen as a reference to Peisistratos naval victory against Megara, ca. 560 BC), is a creature commonly referred to as Bluebeard (from its painted beards). This triple-bodied, serpent-tailed concoction was a perfect fit for the low triangular pedimental corner, but it fits no known iconographic scheme. The only clues are the objects held, which seem to consist of water, grain, and a bird. Now, it is well known that the political turmoil which allowed Peisistratos to come to power arose from a dispute between the "plains" faction and the "coast" faction (put succinctly, old money versus new). The tyrant's power base, at least at first, consisted of the middle and lower classes termed by him the people "beyond the hills." With this as a key, one can read the three attributes as alluding to the three components of Athens' "body politic" and the creature, with its satisfied Archaic smiles and calm demeanor, as a reference to the peaceful unification of all Athenians under Peisistratos' leadership.

Anti-Peisistratid messages are also detectable in Archaic art. One of the best known of Attic black-figure vases shows a scene of Ajax and Achilles playing at a board game (FIG. 64). They hold their spears and are nearly fully armed; shields and Ajax's helmet are at the ready behind the heroes. The weaponry not only frames and focuses the composition but its strong presence also reminds

64. EXEKIAS
Black-figure amphora with Ajax and Achilles gaming, ca. 530 BC. Height 24" (61 cm). Vatican Museums, Rome.

The scene has many subtle touches. For example, Ajax, second-best of the Greek heroes, has thrown a three, while Achilles calls out a four.

the viewer that the two heroes are only just removed from warfare and are ready to resume battle at any instant. The drama of this scene is intensified by the contrast between this suggestion of violence and the trivial nature of the action itself. The composition and its narrative power are equal to the meticulous skill of the incision and painting. Although the scene suggests much about the destinies of the two greatest warriors among the Greeks at Troy, it may also refer to an episode once again in Herodotus' account of Peisistratos (1.63). In 546, he easily overcame the Greeks assembled at Pallene, we are told, because they had just finished their lunch and many were napping or playing dice.

Not all agree that Archaic representations of myth worked in this way, and scholars are especially skeptical that so programmatic an iconography would have reached the potters' quarter; yet some myths on pots doubtless reflect those in sculpture, and patrons' demands should have been as important as vase-painters' preferences. In its essentials the situation is not unlike that of the Parthenon. Various readings are possible, some purely mythological and some more directly referential to historical circumstances. The question really comes down to reconstructing the artists' intentions and the associations operating in the viewer's mind; in the absence of any documentation, the question remains literally academic.

Events of significance came fast and furious in late Archaic Athens, including the death of Peisistratos and succession of his sons (527), Hipparchos' murder (514), the failed (513) and successful (510) attempts to oust Hippias, Kleisthenes' reforms and the establishment of democracy (507), the disastrous expedition to free the Ionian Greeks (498), the Persian retaliation stopped at Marathon (490), and the final Persian invasion thwarted at Salamis (480) and Plataia (479), but only after the sack of Athens (480). Without external evidence, Athenian monuments assignable to those years on the basis of style are easy neither to attribute nor to interpret, and the mythological subjects will support almost any date.

At some point within this sequence of events a marble pediment depicting a Gigantomachy was erected on the old Athena temple. It was long called the Peisistratid pediment, thought by some to have been commissioned by Peisistratos himself but more often attributed to his successors. We know that Kleisthenes, an aristocratic opponent to the tyranny, funded a marble pediment for the new temple of Apollo at Delphi to bribe the oracle and secure the tyrant's ejection; this occurred at some time after 513. Was the marble pediment at Athens an earlier work of the

tyrant to which the Delphic pediment was a response, was it set up in response to the work at Delphi, or should it date to the era of the infant democracy—a kind of re-appropriation of the Archaic temple to mitigate its Peisitratid associations? Stylistic sequencing for the last quarter of the sixth century is not nearly so refined as to offer a solution, and the subject is no more revealing, since both tyrant and democrat would have seen themselves as substituting order for chaos, if political allusion was meant at all.

Similarly suitable for various historical contexts is the Athenian Treasury at Delphi (FIG. 65), although in this case Pausanias (*Description of Greece*, 10.11, 4) states explicitly that the monument was paid for from the spoils of Marathon. A date after 490 has always been accepted by the excavators of Delphi, but for decades other scholars, on the basis of architectural and sculptural style, have argued that the structure must date to the end of the sixth century and thus that Pausanias was mistaken (as is not without parallel); a compromise date in the 490s has also been suggested. More is at stake than this one building's position in stylistic sequence. Its sculptures seem to reflect a shift from a more Archaic, Herakles-oriented scheme to one that emphasizes relatively new themes of particular Athenian significance—the hero Theseus and the

65. East facade of the Athenian Treasury, Delphi, ca. 490 BC.

This small Doric, marble structure had Amazon akroteria (roof decorations) and sculptured metopes around its entire exterior. The north and west sides showed exploits of Herakles, a conventional Archaic subject. The more visible south and east showed exploits of Theseus and an Amazonomachy, respectively, which were both more novel at this time and prominent in Athenian legend.

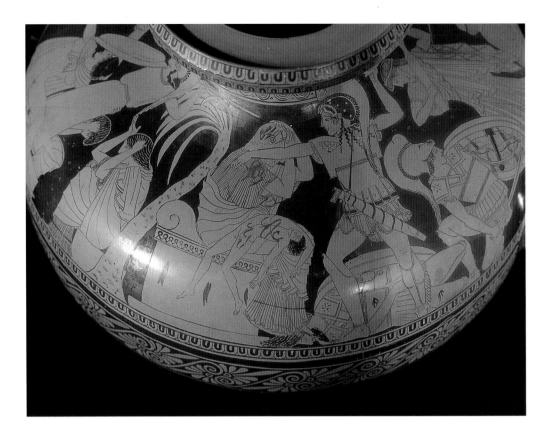

66. KLEOPHRADES PAINTER
Red-figure *hydria* with the
death of Priam, king of Troy,
ca. 480 BC. Height 16½″
(42 cm). Archaeological
Museum, Naples.

Especially pathetic and
impious episodes include
Priam, whose old age is
emphasized, being slain
on an altar with the lifeless
corpse of the boy Astyanax
on his lap and Cassandra
(far left) being torn from the
sacred statue of Athena
while prophesying Greek
doom.

Amazonomachy. To date the building is to determine whether this
development should be connected with the beginning of democ-
racy in Athens or with the victory over the Persians; should the
Amazons take on a specifically Oriental aspect, or do they stand
generally for dangers to the state? That both interpretations are
suitable is again a warning against excessively close readings.

The fact remains that without externally demonstrable dates
for these works, it is notoriously difficult to offer compelling his-
torical interpretations. A final case in point is a red-figure *hydria*
(water-carrier) painted by the Kleophrades Painter, an Athenian
master active in the first quarter of the fifth century (FIG. 66). Given
the style of the vase and the career of the painter, it is impossi-
ble to know if it was painted before or after 480 BC, although a
date near that is certain. The Ilioupersis depicted on the shoul-
der appears, at least to the modern eye, to emphasize strongly the
horror of the slaughter, the helplessness of the Trojans, and the
Greeks' violation of religious and moral precepts. If we knew
the pot was made after 480, we could more confidently assert
Athenian empathy and read an allegory of Athens' own sack. How-
ever, the Ilioupersis was a story of piety, impiety, and divine

retribution. The Trojans fell because the gods who favored their enemies prevailed. The Greek atrocities led to their tremendous suffering while and after they returned home. The theme was universally relevant regardless of period; it would certainly have been in the minds of Athenians as much before the Persian sack as after. The story itself appears in very early examples of narrative Greek art (see below, FIG. 69) and throughout the subsequent history of Greek representation. Again, the image is adaptable to the context, and thus even the most tempting associations between myth and history must remain speculation.

Greek Narrative

The range of topics that seem to have been considered appropriate for depiction in Greek art is fairly limited. By far the most numerous extant examples occur on painted vases, where we find many scenes of myth and some of ritual. Other scenes, such as the symposium or athletic training, are classed by some as generic depictions of "everyday life", but such activities were expected of only certain citizens, and thus their representation functioned as highly significant emblems of status within the *polis*, like the grave reliefs discussed in Chapter One. Possible subjects for sculpture were more limited still. The all but totally absent representation of historical events (Marathon seems the exception, to be considered below) presents only one of the problems in our attempt to make connections between image and history. A second lies in the nature of Greek narrative representation itself, which presupposes a high degree of subject familiarity on the part of the viewer and therefore exploits the cultural homogeneity that the *polis* system assumes. Just as myth only points indirectly to history, the figures and composition within mythological narrative often point only indirectly to the story portrayed. Narrative itself is a construct, its elements assembled in the viewer's mind. To understand more fully the relationship between image and historical context, therefore, we must consider how Greek art tells its stories—that is, the modes of Greek narrative.

Our treatment so far has used a loose and imperfect but nonetheless useful distinction between two kinds of images in Greek art. Emblematic images like *korai*, *kouroi*, funeral

67. Figure scene from an Attic Geometric *oinochoe*, ca. 720 BC. Height 8½" (21.5 cm). Staatliche Antikensammlungen und Glyptothek, Munich.

Most of the decoration on the wine-pitcher consists of conventional geometric ornament, but a figured scene given pride of place on the neck seems to show Odysseus astride his overturned ship, while his comrades fall to the fishes.

68. POLYPHEMOS PAINTER
Amphora, ca. 660 BC.
Height 56¾" (144 cm).
Archaeological Museum,
Eleusis.

The painter is named after
the scene on the neck
showing Odysseus blinding
the one-eyed Cyclops
Polyphemos. The animal
combat on the shoulder
represents both Geometric
and orientalizing traditions
and is typical of Proto-Attic
work. The imaginative
gorgons below are a
generation earlier than the
Nessos Painter's more
conventional examples (see
FIG. 41), but the composition
and significance are largely
the same.

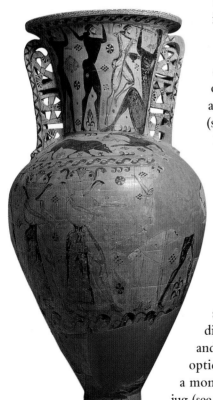

scenes, and portraits stand for something without telling a particular story. Narrative scenes, which can also be highly emblematic, also relate a story, almost always one drawn from myth. The question of just when the latter begin to appear is of course the first concern of the study of Greek narrative.

Most of the scenes found on Geometric vases fall into the categories already treated—episodes from the funeral rites or generic martial scenes that underscore the *arete* of the deceased. A few, however, suggest something more, or at least something else (FIG. 67). Scenes of shipwreck, especially those showing one figure clinging to the wreckage while others perish around him, are strongly reminiscent of the story of Odysseus, which should have been current at the time if the epics of Homer both date to the eighth century. On the other hand, this was a period of exploration, seafaring, and danger; could the scene on this wine-pitcher simply be a reference to such activity, perhaps identifying the owner's occupation? It is widely disputed whether any Geometric scenes depict mythological topics, but two points seem worth noting. first, the same historical circumstances that gave rise to the myth also gave rise to the depiction, whether a connection between them can be made or not. Secondly, in either case the image makes its point through suggestion to a viewer already conditioned to read it.

By the seventh century, mythological topics come to dominate even the large funery vases (FIG. 68), joining or displacing the more generic subjects. Identifications are no longer in doubt. This vase is dominated by a scene (set just below eye leve) of Odysseus blinding the Cyclops Polyphemos. The hero is distinguished from his companions in being painted white and, it seems, by his slightly smaller stature (in accordance with the Homeric tradition)—a subtle touch, if intentional. The one-eyed monster is given appropriately gigantic proportions. A drinking cup in his hand reminds the viewer that the Greeks needed to get him drunk in order to succeed in their plan. Yet he was already unconscious when skewered by the burning stake; his drinking binge was over. Thus the scene does not depict one stage in the story but seems to combine elements of different stages in order to suggest a sequence of events and passage of time. This type of narrative is termed synoptic (literally, "combining views") to distinguish it from a monoscenic treatment, like that on the Geometric wine-jug (see FIG. 67), which gives us a scene as it might theoretically

have appeared at a given point in time. Both depend on the participation of the viewer and, as will be seen, the distinction is not always easy to make.

A third type of narrative combines a series of episodes, each in itself mono-scenic or synoptic, which are physically separate (for example, in panels or friezes) but thematically linked. In most cases such cyclical narrative does not, in and of itself, establish relative positions of the stories in time, although a sequencing is often implicit in the story itself (as in the Labors of Herakles) and thus operational in the viewer's mind. Sculptured metopes provide the most obvious examples of cyclical narrative, but an early example can be seen in a seventh-century Cycladic relief *pithos* (large storage jar) depicting the fall of Troy (FIG. 69). The neck panel shows the wooden Trojan horse with (not very well) hidden Greeks, and several two-figure Ilioupersis scenes occupy smaller square panels on the body. That the

69. Relief *pithos* (storage jar) with Ilioupersis scenes, ca. 650 BC. Height 53¼″ (135 cm). Archaeological Museum, Mykonos.

Such works were created on the Cycladic islands during the seventh century in a local version of the orientalizing style.

Trojan Horse episode preceded the events depicted below is obvious to the reader familiar with the story but is in no way suggested by the vase itself.

Such cyclical narrative could achieve astonishing complexity, a kind of visual literature comparable to Homer's description of Achilles' shield. An elaborately decorated Archaic wooden chest, carved and inlaid with gold and ivory, which was believed to have been dedicated by the Kypselid tyrants of Corinth, was seen by Pausanias in the Hera temple at Olympia. It was engaging indeed: Pausanias' description of it is many times longer than his combined treatment of the temple and its other contents. The relationships of its many scenes reflect a characteristically Greek interest in puzzling out causes and effects, detectable as well in the extant scraps of sixth-century philosophy. A reflection can be read in a masterpiece of Attic black-figure painting, the François Vase.

An iconographic encyclopedia in clay, this volute *krater* stands over two feet (66 cm) tall and presents at least eight different mythological scenes (FIGS 70 and 71). The shoulder frieze—the

70 and 71. François Vase, ca. 560 BC. Height 26" (66 cm). Museo Archeologico Nazionale, Florence.

Both the potter (Ergotimos) and the painter (Kleitias), who were understandably proud, signed this volute *krater*. The numerous inscriptions (each figure and even some inanimate objects are labeled) may function as filling pattern and as a display of literacy as much as for identification. The vase was found in many fragments scattered between two tombs at Chiusi, probably dropped by tomb robbers looking for more valuable materials such as metal. It stands at the head of the era in which Attic products dominated the important Etruscan market; Etruscan chamber tombs are the source of most of the intact Attic vases in European and American museums. This was named after its discoverer, Alessandro François.

tallest and the only one to continue all around the vase—is surely the center of the program. Its subject is the wedding of Peleus and Thetis, the occasion of the dispute among Athena, Aphrodite, and Hera over the apple of discord, which led to the Judgment of Paris, which caused the Trojan War. The side on which the procession of wedding guests culminates is surely the obverse (fig. 71), and here Trojan War scenes are shown immediately above and below (Patroklos' funeral games, the ambush of Troilos). Other Homeric touches are Ajax and Achilles on each strap handle, and the battle of pygmies and cranes (an Iliadic simile) on the vase's foot. The Kalydonian boar hunt on the lip represents an earlier stage in the story of Peleus. The scenes of the reverse (FIG. 70), however, are less obviously related (Theseus' escape from Crete, a Centauromachy, the return of Hephaistos to Olympos), although almost any episode in Greek myth can be connected with another in some way. We are certain there is an underlying program, but there is little agreement as to what it is. A recurring theme of the non-Trojan scenes seems to be marriages, and it has been suggested that this extraordinarily elaborate vase was in fact commissioned as a present for use at a wedding. Such a function would not be without irony, considering the unhappy fate of the pairings depicted; perhaps the Etruscan owner puzzled over these scenes as much as we do.

The differences between synoptic and monoscenic narrative, or even between narrative and emblematic images, is not always clear-cut and is most often reader-determined. We have considered a powerfully suggestive monoscenic narrative by Exekias (see FIG. 64). On the interior of a drinking cup (*kylix*; FIG. 72) by the same painter we see the wine god Dionysos reclining on a ship, drinking horn in hand, his mast entwined by grapevines, with dolphins leaping in the surrounding "wine-dark" sea. The subject is most appropriate to a symposium vessel such as this one, and must have been enlivened when seen through a thin layer of properly diluted wine. Yet there is a story here. Dionysos in mortal form was once abducted by pirates; when they refused to release him he revealed his divine form and caused a vine to spring from their mast.

72. EXEKIAS
Black-figure *kylix*, ca. 540–530 BC. Height 5¼″ (13.6 cm), diameter 12″ (30.5 cm). Staatliche Antikensammlungen und Glyptothek, Munich.

The god of wine, Dionysos, floats among dolphins in his appropriately masted boat.

73. Sculptures of the east pediment from the Temple of Zeus, Olympia, ca. 460 BC. Marble, preserved height of central figure 10′2″ (3.1 m). Archaeological Museum, Olympia.

Zeus stands in the center flanked by (on one side or the other—neither the statues nor Pausanias' description is definitive) the hero Pelops and King Oinomaios, his wife Sterope and daughter Hippodamaia, two chariot teams, a variety of attendants and onlookers (including an aged seer; see FIG. 83), and river gods in each corner.

The terrified criminals jumped overboard, and the god turned them into dolphins. This could be seen as monoscenic narrative since it shows the aftermath of the action, but only through the functioning of the dolphins and mast-vine as synoptic clues is the story perceptible. This portrayal of a quiet stage before or, as in this case, after a suggested action is commonly termed the "Classical moment"—a misnomer indeed since such Archaic artists as Exekias used the narrative technique frequently.

Perhaps the most famous "Classical moment" is that captured by the east pediment of the Temple of Zeus at Olympia (FIG. 73). These massive sculptures (only slightly smaller than those of the Parthenon pediments) have been reconstructed in dozens of different arrangements, but each reconstruction preserves the same quiet yet vaguely unsettling mood. The story, as Pausanias tells us (5.10, 6–8), was the moment before the chariot race between Oinomaios and Pelops. The former, king of Pisa (a nearby town), raced the suitors of his daughter Hippodameia with a team of divine horses and killed those whom he defeated. Pelops, eastern in origin, prevailed through treachery (details vary), supplanted the king, and gave his own name to an entire land mass (the Pelo-

74. South frieze, Temple of Athena Nike, Athens, ca. 425 BC. Marble, height 19¼″ (49 cm). British Museum, London.

Although this temple replaces an Archaic predecessor, its sculptures tie it firmly to the Periklean program and the importance of Athena as bringer of victory during the concurrent Peloponnesian War.

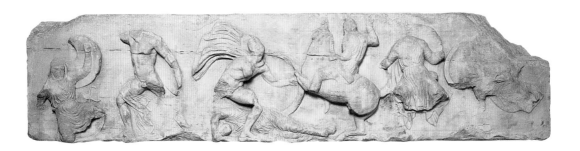

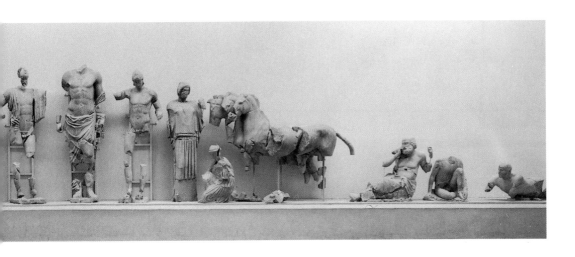

ponnesos, "Pelops island"). His misdeed caused Zeus to punish his progeny ("the curse of the house of Atreus"). Pausanias already recognized this as the "Classical" moment before the height of activity. If, as many think, the competitors are taking their oath before the central Zeus, then both the dramatic irony and the connection to the site is intensified. Cheating was little tolerated at Olympia, and divine vengeance was manifest in the stories of both protagonists here. In the pediment, an otherwise quiet scene is agitated by the gestures of one of the standing women and a seated "seer." The prescience of the latter is clearly indicated through his characterization as an old man, and, as one scholar has noted, his presence here "resonates" with similarly ominous scenes from Archaic vase-painting. Here as in Exekias' cup, the whole episode plays itself out in the mind of a viewer properly conditioned to comprehend the visual cues.

History and allegory work together in the narrative of the High Classical complex of Athena Nike overlooking the entrance to the Akropolis. The Ionic temple itself had a full complement of sculptures—akroteria, pediments, and frieze—which reflect the Parthenon in several aspects. The remains of the pedimental Amazonomachy and Gigantomachy are meager, but a gathering of gods on the east frieze is clear, even if its occasion is not. Battles occupy the rest of the frieze. That on the south pits Greeks against foes in Oriental garb (FIG. 74); these are not Amazons, so most accept, sometimes reluctantly, that Marathon is shown. There is less agreement whether the other two battles are historical or mythological, but it matters little: new ground has been broken. A monumental painting of the heroes at Marathon had been set up around 470–460 BC in the Painted Stoa of the Athenian Agora, so there was clearly no prohibition against public com-

Following pages
75. Alexander Mosaic, from the House of the Faun at Pompeii, ca. 100 BC (detail). Stone and colored glass, 8'10¼" x 17' (2.7 x 5.2 m). Museo Archeologico Nazionale, Naples.

Believed to copy a painting of ca. 300 BC by Philoxenos of Eretria. That it retains a certain Classical indeterminacy is underscored by the fact that scholars cannot agree which of the two confrontations between Alexander and Darius is depicted, although the Battle of Issus (333 BC) is preferred.

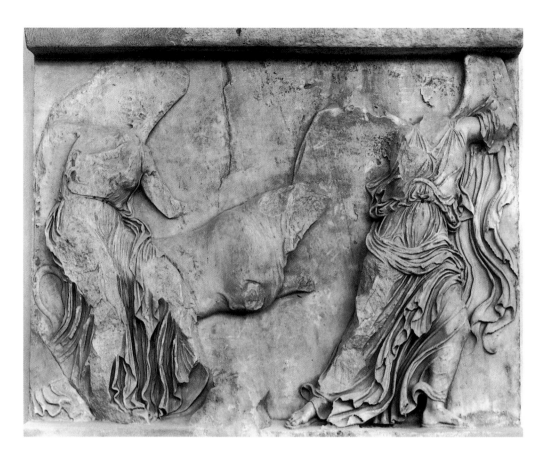

76. Scene of Nikai with bull, from the Nike parapet around the Temple of Athena Nike, ca. 420–410 BC. Marble, height 55¼″ (140 cm). Akropolis Museum, Athens.

It is not agreed when this barrier was set up. Arguments tend to rely on stylistic analysis, but the importance of its function suggests that it would have been in place fairly soon after the temple. The mannered linear patterns and diaphanous drapery typify late fifth-century styles, which remained popular for Nike and Victory figures into Roman times.

memoration through historical depiction. Yet it seems not to have been done often and this is the only example among temple sculptures. The theme of victory, treated fairly explicitly in the frieze, is handled more symbolically on the sculptured parapet set up around the temple (FIG. 76). Here a series of Nikai (winged victories—personifications became ever more common in an increasingly meaning-laden Greek art) set up battle trophies and bring sacrificial victims before the goddess Athena, present on three sides of the relief. The actions of the Nikai resonate with those of the Athenians on the Parthenon frieze, although the style and mood of the two reliefs differ sharply. The association was surely intended at a time when Athens was fighting not just for victory but for survival.

A century or so later, as Macedonian rulers and their Hellenistic successors adopted the trappings of Oriental monarchs, the depiction of victory in battle (a Mesopotamian staple) became more common in monumental art. Alexander the Great (356–323 BC) set up an elaborate sculptured group of the Battle of Granikos (334 BC) at Dion, a sanctuary in southern Macedonia; cast in bronze,

these figures are lost, but a Roman mosaic is believed to preserve an early Hellenistic monumental painting of Alexander's victory over Darius (FIG. 75). The limited number of figures, the neutral background and the dramatic confrontation between the intense but idealized young Macedonian and the terror-struck Persian king recall similar treatments of myths such as the Gigantomachy. Despite the novel topic, this remains an essentially Greek work.

The Alexander Mosaic retains the monoscenic tradition. Our final kind of narrative became common only in Roman and Christian times but its roots can be found in Greek art. The interior frieze of the Pergamon Great Altar (FIG. 77), in contrast to its very traditional Gigantomachy discussed in Chapter Two (see FIG. 34), provides an example of continuous narrative. The story is related over time, and images of the same figure are repeated against a continuously unfurling landscape. This form of narrative is especially suited to the subject: the hero Telephos, son of Herakles, was born in Peloponnesian Tegea, exposed, miraculously saved, and (after many exploits) founded Pergamon itself. Individual episodes in the story of Telephos are found in earlier Greek art, but this continuous narrative was needed to relate the story in all its detail and for the frieze to fulfill its function of fabricating a long Hellenic pedigree for what was, before the third century, an Anatolian town of no distinction.

The frieze is highly pictorial and its difference from other architectural sculpture may derive from a largely unpreserved tradition of monumental painting. However, the fact that continuous narrative is not commonly found earlier may simply mean that the need for it was less pressing. It was essential that Hellenistic art appeal to a heterogeneous array of viewers—an audience which it had to engage, as with the drama of the Pergamene Gigantomachy, and educate, as with the relentless and explicit detail of the Telephos narrative. The narrative of Classical and earlier Greek art takes place in the eye and mind of a viewer conditioned to accomplish the task. With the fall of the *polis* system, the designer of public art, at least, lost that luxury; narrative modes, like subject matter and style, had to evolve in response to the changing demands of changing times.

77. Telephos frieze from the Great Altar at Pergamon, ca.175 BC. Marble, height 62¼″ (158 cm). Pergamon Museum, Berlin.

This frieze was set up in the colonnade above the altar structure, and thus would read more like the monumental paintings in a stoa than as architectural sculpture *per se*. Here, Telephos' mother, Princess Auge of Tegea, is about to be sealed up in a boat and cast adrift, after her father the king learns she has borne Herakles' son. She, like her son, is miraculously saved. The extensive use of landscape and relatively naturalistic scale of figures to background are more reminiscent of pictorial than sculptural traditions.

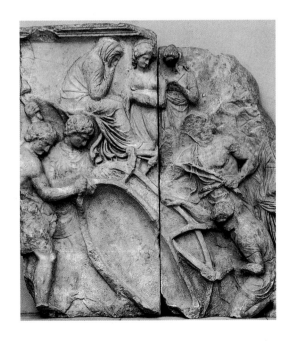

FOUR

Style

I
n 1970 Rhys Carpenter—one of the most eminent American classical archaeologists of the twentieth century—published his last book at the age of 81. His career had been characterized by controversial suggestions and observations, but none of his previous theories raised quite the ruckus as did this last offering; a generation later scholars still discuss the merits of his argument. Drawing on a wide range of evidence, Carpenter argued that there was a major stage in the building of the Parthenon between the long-recognized late Archaic temple and the Periklean structure which still stands today. Work on this so-called Kimonian Parthenon took place, he argued, during the 460s BC; the Archaic temple was substantially rebuilt on the same 6 by 16 column plan; about half was completed when work was suspended upon Kimon's exile in 461, and much of its building material, including columns, entablature, and some sculpture, was used in the Periklean building. The implications of this theory are far-reaching both for history and archaeology. It would seriously decrease the likelihood of the "Oath of Plataia" (see p. 86) and would force extensive revision of views concerning the originality of the Parthenon. For example, were the many variations in dimension found in the Periklean building the result of a master design or were they necessitated by the re-use of materials intended for a building with a radically different plan? It is no surprise that the proposition has found few adherents.

78. "Slipper-Slapper," from Delos, ca.100 BC. Marble, height 50¾" (129 cm). National Archaeological Museum, Athens.

This group of Aphrodite, Pan, and Eros was found in the House of the Poseidoniasts of Berytus (Beirut), a merchants' club devoted to a religious sect; thus the group was still votive, in Classical tradition, rather than an adornment, as was more common in Roman times.

Parthenon Styles

A key argument in favor of imagining an otherwise undocumented building is the stylistic discrepancy one finds among the Parthenon metopes. It is clear that these were the first sculptures executed for the building. Greek temples were built from the outside in, so the exterior columns with their entablature were erected before the *cella* with its frieze, and the pedimental statuary could be added last, since nothing was structurally dependent on it. Some of

the metopes seem very early indeed. We have noted the exaggerated, bestial, and mask-like centaur's face on the south metope 31 (see FIG. 37). The style is very similar to that found on the centaurs in the west pediment of the Temple of Zeus at Olympia, although that building was finished a decade or more before the Parthenon was even begun. The torsos of the two combatants, with their strongly marked rectangular muscular divisions, and the artificiality of the composition (note the Lapith's feeble punch) also recall Early Classical stylistic features. How different is south metope 4 (FIG. 79). Although still compressed within a shallow depth, the composition here is much more natural. The torsos of Lapith and centaur are modulated in a much subtler manner, the muscular divisions indicated by fluctuations of surface rather than incision. The faces are not the squarish bloated versions typical of Olympia, but slenderer and nearly identical to those on the Parthenon's frieze. Most conspicuously, the centaur's face is no longer that of a monster but is almost as human as that of his foe; the sculptor seems more aware of the increasingly ambiguous distinction between self and other that characterizes the High Classical Centauromachy.

Of the other south metopes, some are more like the "earlier" example, others more like the "later", and still others somewhere in between; the metopes on the other sides are not well-enough preserved to support any stylistic arrangements. The argument is simple; if some metopes look earlier, they must be earlier. If Olympia dates to the 460s, then there must have been work done for a Parthenon in the 460s, thus the Parthenon must have had a Kimonian stage. Scholars have always been aware of this stylistic variation, although only Carpenter was so troubled by it as to postulate an unknown building in order to explain it. It is not unusual, however, for a scholar to arrive at a conclusion on the basis of a rigid view of stylistic development and then to arrange the other evidence in support. Such is the power over us of the organic model of growth and decline that it seems to function as a universally valid law which dictates our interpretation of all other data.

If, as most would agree, all the Parthenon metopes were made for the Periklean building, then there must be another explanation. Most obviously, since there were surely older and younger sculptors working together, if

79. South metope 4 from the Parthenon. Marble, height 52¾" (134 cm). British Museum, London; Ny Carlsberg Glyptothek, Copenhagen.

The reconstruction shows the metope in London with the heads in Copenhagen. A Lapith and centaur fight.

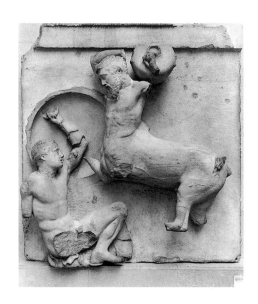

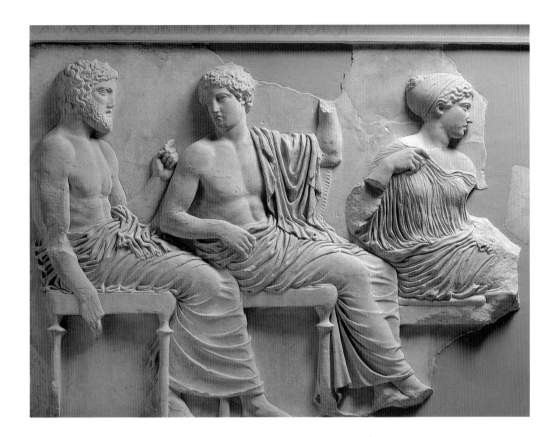

each worked in the style in which he was trained, then the styles would reflect different stages in development even if the works themselves were contemporary (the so-called theory of generations). However, there is no evidence at all that this was actually the case, and in other times and places we can surely detect significant progress in a single artist's style throughout her or his life. An important variation of the explanation emphasizes the rapidity with which stylistic development could happen when a large amount of sculpture was being produced in a short amount of time by a number of workers carving together. In this case, the entire development from an Early Classical to High Classical style is compressed within a span as short as five years—so brief that we can not even be sure that the earliest looking material was the earliest in date or carved by the oldest artist. What can be seen is that by the end of the process, a conspicuously consistent style had emerged.

The most developed of the metopes are stylistically consistent —and no doubt contemporary—with the frieze. The smooth delicate faces of three gods from the east frieze (FIG. 80) are similar to those seen on the more developed of the south metopes, as is

80. Three figures (nos. 38–40) of Block VI, east frieze, Parthenon. Marble, height 41³/₄″ (106 cm). Akropolis Museum, Athens.

In one of the best-preserved slabs from the frieze, the youthful twins Apollo and Artemis sit with, most likely, Poseidon to the left. As in the pediments, the artist has taken little trouble to identify the participants. Although some attributes added in metal or paint are now lost, groupings, garments, and poses were no doubt clues enough for the Athenian initiate.

81. North metope 32, Parthenon. Marble, height 52¼" (134 cm). Akropolis Museum, Athens.

This is the one metope on the north, east, or west not deliberately disfigured during the presumably Christian vandalism of the metopes. It is assumed that it was spared because of its similarity to an Annunciation, although there is no evidence for the theory. It probably depicts an interchange between two Olympian goddesses related to the Trojan slaughter played out in the other metopes.

the carefully but not harshly modeled delineation of anatomy. The drapery of the frieze figures is similar to that of the goddesses on one of the few extant Ilioupersis metopes (FIG. 81). Both reliefs use fold patterns as rational devices for the modeling of the body underneath: note how the lines flow around the contours of Artemis' torso on the frieze and curve to outline the hips of all three deities. The relatively thick folds on all five figures reflect a stage of development early in the High Classical, not far removed from the massive doughy drapery of Early Classical times (see the Olympia east pediment; FIG. 73). Moreover, the frieze's style is remarkably uniform across its entire length, despite being the work of probably dozens of sculptors; the experimental spirit manifest in the stylistic variety of the metopes is nowhere evident.

This change in style continues in the pedimental sculptures. More complex poses are attempted, and the anatomy of the male nude is both more subtly and more naturalistically indicated (see FIG. 15). Drapery folds can be rendered in increasingly fine linear patterns; a popular innovation is the use of such patterns to create the effect of clinging, even "wet", drapery as on the seated and reclining goddesses of the east pediment (K, L, and M; see FIG. 16). The Artemis on the frieze and the pedimental Aphrodite wear the same garment, and the latter clearly follows the general type of the former, including the slipped or slipping *chiton* sleeve. No more than about six years could have separated them, but the difference in style is as great as that seen in the metopes; the impossibly thin and diaphanous fabric on the later pedimental figure little resembles the thick, opaque garment that covers Artemis' torso on the frieze.

Comparison among pedimental figures suggests that these differences are not necessarily determined by chronology. In the opposite wing of the east pediment is a corresponding group of three goddesses (E, F, and G)—two seated and one striding quickly toward them (FIG. 82). They each wear the *peplos*, a woollen garment heavier than the linen *chiton* worn by K, L, and M. One can see in both groups a similar general arrangement of drapery which outlines the legs and describes, even defines, the pose

of the figures, but the surface of the *peplos* is broken up with many fewer folds, thereby forming a visual distinction between the two materials. The skirt of the striding figure differs more obviously still; here we see a few massive and deeply cut folds which curve in an unrealistically simple but visually compelling pattern that functions to express her rapid movement across the compositional plane. In this case the rendering is as much descriptive of position and motion as it is dependent on garment type.

The Parthenon styles are very instructive. Most obvious is the illustration of a general development in stylistic features across much of the third quarter of the century—a "classic" example of organic stylistic development. At the same time, the exceptions to such a model are sufficient to make one wary. If it is accepted that the pace of development seen on the Parthenon is unusually fast, then it must be admitted that stylistic development proceeds irregularly. Thus, reconstructed chronologies based on style alone are suspect. Moreover, different styles can co-exist on the same temple—even on the same part of that temple, and the differences can be variously explained and motivated. They can reflect different chronological stages in the development of the building or within a part of the building. They can be contemporary and reflect the hands of different artists who were born or trained at different times or by different masters. They can

82. East pediment figures E, F, and G, Parthenon. Marble, height of G 68¼″ (173 cm). British Museum, London.

The identity of these figures is much disputed, but they may be Persephone and Demeter (or Horai) with Hekate (or another birth goddess such as Artemis or Eleithuyia).

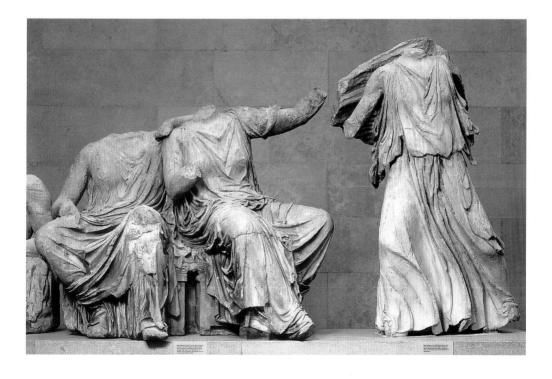

describe different kinds of fabric or garments, which themselves again describe different kinds of deities. Or they can simply distinguish a fleeing from a standing figure or a seated from a reclining figure. It seems, then, that style is not determined by date alone: subject, function, pose, and even narrative play their roles in determining the appearance of sculptures—and this within a space of fifteen years.

As noted in the Introduction, the chronology used today for ancient Greek art differs little from that formulated by Winckelmann more than two centuries ago. It was and is based on the assumption of regular, steady, and inexorable progress from abstraction to naturalism and is patterned after the model of growth and decline in the natural world. It was grounded in ancient rhetorical scholarship and buttressed through the invocation of actual works of (mostly Roman) art; Greek art, most examples of which were known in Western Europe only after 1800, were assimilated into this predefined structure. Thus, what may be most stunning about Winckelmann's construction is its continuing validity. In the course of our story, proceeding from Geometric to Orientalizing to Archaic, we have indeed seen a movement (largely unremarked so far) from highly abstract figures in the eighth century, to the still conceptual but far more detailed figures of the seventh and sixth centuries, to the more experimental and three-dimensional renderings of late Archaic sculpture and red-figure vase painting. Within this development, there have also been consistent features. While we have stressed the uniformity of function and iconography, we have also noted that the figures themselves retain a generic, analytical, and structural quality that is fundamental to all Greek art, even the most naturalistic.

However, our dependence on the organic model is rooted in more than its overall validity. First, it is a highly useful tool. As frequently noted, only a small number of the extant monuments of ancient Greek art can be dated on external grounds; the organic model allows the placement of objects within the sequence—and thus the assignment of a date—based on visual analysis alone. The method derives from the archaeological process of seriation, in which excavated material can be arranged chronologically according to the levels in which it was found; a sequence is inferred from changes detected in the features of objects so arranged. In the study of sculpture and painting, however, the material is most often not dated, and the sequences and dates are inferred from style itself. Since the study of classical art is grounded in the study of history, dates are essential for analysis, and exact dates, as we saw in the last chapter, invite close historicist

interpretations. Thus the system has been developed to a remarkable precision, allowing some scholars to assign dates within a decade, especially during the Classical period proper.

Secondly, stylistic development itself functions as a distinguishing feature of Greek art. The phenomenon of change from generation to generation in the appearance of artifacts such as painted pottery is a feature of even the earliest Iron Age; this continual inclination toward improvement seems to have evolved from the very nature of Greek society—participatory, inquisitive, rational, and highly competitive. In this respect, Greek art contrasts sharply with the equally accomplished products of Egypt and Mesopotamia, where satisfactory solutions to the ultimate and eternal stylistic problem—balancing the demands of formalism and naturalism—were achieved early on and, once achieved, did not proceed according to anything like an organic development. Thus the very fact that Greek art changes over time functions in the modern mind as an emblem of the rational humanism of Greek culture, and offers a contrast with the more spiritual and obeisant mentality implicit in Middle Eastern art. In Western Europe, where the process repeated itself from medieval to modern times, this contrast came to distinguish western from eastern cultural traditions generally at a time when such concerns were of no small moment. The model took on and still retains an importance that transcends by far its function as a scholarly tool.

Despite its validity as a general organizing system, the organic model fails as a universally applicable principle, since the exceptions are too frequent and too varied to be summarily dismissed. Styles and figural types continued in use long after the time of their first appearance; many became associated with particular subjects or scenes and so were repeated with little change. In other cases, styles that were well out of date according to the organic model were consciously revived or imitated in later times. Moreover, the transitions between stylistic eras did not take place at the same pace or in exactly the same way throughout the different Greek city-states in Sicily, South Italy, mainland Greece, and Asia Minor. finally, as we saw in the case of the Parthenon, differing stylistic features could be used at precisely the same time on the same monument, if different subjects were depicted or different effects were desired.

The style displayed on a given work of ancient Greek art thus reflects a choice among co-existing possibilities, whether that choice was made by an individual artist or whether it was already an artistic convention. For style, meaning resides in difference, and a more defensible version of the organic model allows for differences not

simply between stages in development but within those stages. In this version, style is far more important for the determination of meaning than if it is taken as a chronologically determined dictate. To understand better both the developmental ("diachronic", in semiotic terms) aspect of style and the meaningful associations of contemporaneously available ("synchronic") stylistic choices, we shall first consider how style changes within the Classical period, then return to the issue of style pluralism across the entire history of Greek art.

Three Critical Periods in Classical Style

Tripartite divisions pervade historical and archaeological scholarship, since just about everything seems to have a beginning, middle, and end. The division into "Early Classical" (or "Transitional" or, more descriptively, "Severe"), "High Classical", and "Late Classical" stages introduces into the era a more compressed version of the same organic model used to organize Greek art generally. The arrangement also suggests that a significant stylistic change occurred at the start of each era—the dates 480, 450, and 400, respectively—and explanations for such changes are inevitably sought in historical events. Each such transition is potentially, therefore, a "critical period".

The stylistic differences between Archaic and Classical are clear enough. The rigid convention of the *kouros* (see FIG. 27) suspended weightless, ageless, and block-like, indeterminately striding on two unflexed legs, his arms held tightly to the sides, is finally—and, it seems, suddenly—abandoned in the early fifth century. A small marble statue of a youth from the Akropolis (FIG. 84), although it is a frontal, standing nude male like a *kouros*, marks an obvious departure from the type. He stands with his weight entirely on his left leg, the right leg slightly flexed and advanced. His hips and shoulders adjust in response to this weight shift, as do the muscles of his back and but-

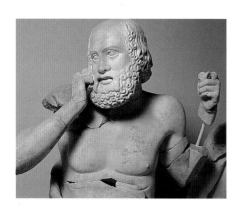

83. The seer from the east pediment of The Temple of Zeus, Olympia (detail).

tocks. This figure further breaks with the frontality of the *kouros* type by shifting his gaze slightly to the side of the relaxed leg. Such subtlety of anatomical division evolved over the sixth century, but in this figure the anatomy is so slightly indicated that characterization as a boy, rather than a mature youth, must be intended. Other Early Classical works—the Tyrannicides (see FIG. 11), the Ilioupersis *hydria* (see FIG. 66), the Olympia seer (83 and

116 *Style*

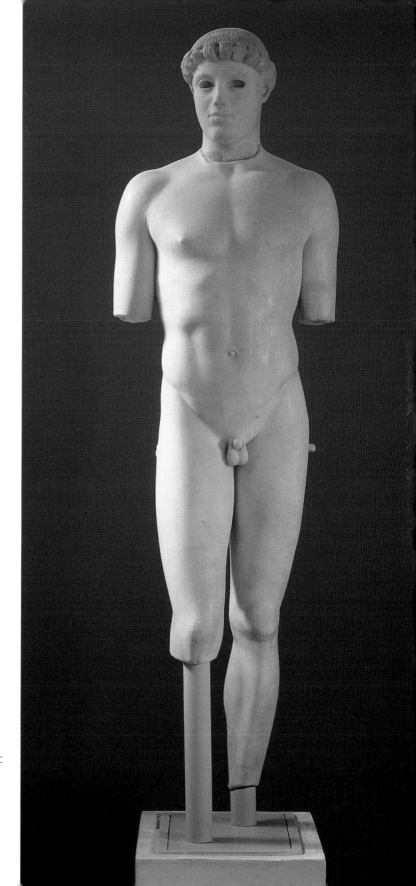

84. Kritios Boy, ca. 480 BC.
Marble, height 46¼″ (117
cm). Akropolis Museum,
Athens.

The nickname derives from
a perceived similarity to the
Roman copies of the
tyrannicide Harmodios by
Kritios and Nesiotes, and has
become a convention not
meant to imply authorship.
This statue has been called
the "Poster Boy for Athenian
Democracy" because his
stylistic freedom from Archaic
restraint is seen to mirror
political developments in
late Archaic Athens.

see FIG. 73)—likewise illustrate a marked interest in the physical distinctions between youth and old age.

The Kritios Boy is therefore an integrated whole. Its difference from the *kouros* is not limited to a simple shift of weight; it extends to the way in which every part of its body reacts to, reflects, and even describes this weight shift. A similar development can be seen in pedimental sculpture. Around 500 BC a small limestone temple was erected to the nymph Aphaia on the island of Aigina in the Saronic Gulf, about halfway between Attika and the Peloponnese. Marble sculptures were erected in each pediment soon after the temple's construction and, for reasons still not clear, those in the east pediment were replaced about twenty years later. Therefore, the pedimental sculptures that stood on the building for the remainder of antiquity embody two noticeably different styles. Since the subject and general composition of the two pediments are similar, and since they can be placed on either side of the transition from Archaic to Classical, comparison of corresponding figures from the two pediments illustrates well the nature of this change.

The corners of each pediment are occupied by reclining dying warriors. That in the south corner of the west pediment is arranged in an expressive yet artificial pose reminiscent of earlier Archaic art (FIG. 85). His hips and torso are rotated forward to a fully frontal view, thus denying any collapse in response to his predicament (he is extracting an arrow from his chest). His right leg is bent and crossed impossibly in front of his left, and his right foot twists into a profile view. His right arm is similarly angled parallel with the plane of the pediment; with it he tugs at the embedded weapon— happily, it seems, to judge from his Archaic grin. The artist is not at all concerned with arranging the figure to respond either to his own weight or to the fact that he is dying. A legible, "eloquent" outline is paramount; this figure, although a three-dimensional statue, retains a typically Archaic two-dimensionality.

His counterpart in the south corner of the east pediment is entirely different in this respect (FIG. 86). He collapses in what is, for this time, an unusually momentary pose: he has just lost his grip on one shield strap, and his arm is slipping through the other. His torso falls forward and his hips fall back, creating a torsional pose which has presented obvious problems in the rendering of abdominal musculature. His right foot is obscured by the left shin, his right arm crosses and blocks our view of the torso. The Archaic concern with an eloquent silhouette is replaced with a Classical emphasis on three-dimensionality, a rational relationship of part to part, and a convincing depiction of pose and activity. Like

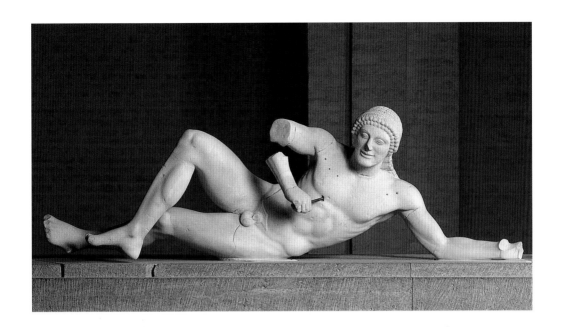

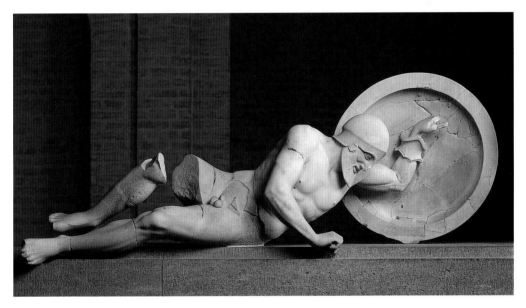

85. Dying warrior from the west pediment of the Temple of Aphaia, Aigina, ca. 500–490 BC.
Marble, length 62¾″ (159 cm). Staatliche Antikensammlungen und Glyptothek, Munich.

Placed in the right corner, this figure continues the outward thrust of action from the center to both wings.

86. Dying warrior from the east pediment of the Temple of Aphaia, Aigina, ca. 480–470 BC.
Marble, length 72¾″ (185 cm). Staatliche Antikensammlungen und Glyptothek, Munich.

Placed in the left corner, this figure moves the viewer's eye back toward the center, more like the Classical
pedimental compositions at Olympia and on the Parthenon.

the Kritios Boy, this figure exists in space, it has weight, and its every feature responds to that weight as it succumbs in death.

The Classical transformation of the draped female is just as thoroughgoing as that of the nude male, as can be seen in a small marble statue of Athena from the Akropolis of Athens (FIG. 87). Her weight shift repeats that of the Kritios Boy, and the prominence of her raised weight-bearing hip is accentuated by the placement of her left hand. The arrangement of surface features co-ordinates with the pose, but here drapery folds rather than muscle groups provide the description. The garment is the Doric *peplos*, which at this time replaces the *kore*'s Ionic *chiton* and diagonal mantle as the preferred garb for women. Its thick woollen material is not uniformly treated here: over the right, free leg, it clings tightly and seems thin, while over the left, weight, leg it falls in a few simple heavy folds resembling the flutes of a column—an intentional visual metaphor emphasizing that leg's supporting function. Similarly, the few thin folds that curve around the thigh and calf of the right leg outline the projecting form of the flexed limb and emphasize its more relaxed state. The nearly geometric repetitive linear patterning of the *kore* has given way to an entirely new and simpler (sometimes termed "severe") scheme of fewer and heavier "doughy" folds. Here too we see an emphasis on mass, substance, and weight; this body too reflects the consequences of its shifting pose.

These "weighty" figures find their way into painting as well. The Early Classical period was one in which wall-painting and panel-painting seems to have taken on great importance. Artists like Mikon and Polygnotos—the earliest painters mentioned by our later sources on Greek art—were active at this time, creating elaborate tableaux at Athens, Delphi, and elsewhere in which the exploits of gods, heroes, and mortals were played out over the walls of public buildings. These are lost, but a reflection may be seen in a handful of vases whose compositions seem to imitate the spatial illusion natural to wall and panel (or "free") painting. The Herakles figure in the center of the Niobid Krater (FIG. 88), repeats the weight shift of contemporary statuary,

87. Athena figure dedicated by Angelitos, ca. 480 BC. Marble, height 30¼" (77 cm). Akropolis Museum, Athens.

This small marble Athena is associated with a base bearing a dedication by Angelitos and the signature of the sculptor Euenor.

as does the *peplos*-clad Athena to the left. The greater three-dimensionality of these figures is accommodated by the creation of a visual space through the raised and lowered ground lines. The scheme had limited popularity in vase-painting; the implication of spatial penetration was no doubt seen as incongruous when applied as decoration to a vessel's impenetrable surface. Vase-painting characteristically accentuates rather than denies the physical structure of the pot itself.

The abandonment of Archaic artificiality seems to lend such figures, in painting and sculpture alike, more than just a physical gravity; they seem to think and reflect more than did their stiffly striding and broadly smiling predecessors. It is no accident that Polygnotos was particularly known for his skill at depicting the *ethos* or character of his subjects. Early Classical subjects achieve not simply a physical existence within three-dimensional space but also a psychological awareness reflected in enigmatic and introspective facial expressions. If the overall development of Greek art is from abstraction to naturalism, it is clear that a major step in this direction occurred around 480 BC; given that date, explanation is inevitably found in the Persian Wars.

The experience of having defeated the Persians is believed to have imbued the Greeks with an enhanced sense of liberty and personal responsibility, both of which are thought to be reflected in the "humanism" of Early Classical style. Moreover, the simplicity or severity of that style is held to be a deliberate rejection of the Oriental overtones of Archaic linear patterning and conceptually posed figures. One problem with this view is that the change itself cannot be pegged to 480 BC. Such central pieces as the Kritios Boy and Angelitos' Athena are felt by some to be earlier than that date, and the archaeological evidence is ambiguous. Another view is that the individualistic qualities implicit in the Early Classical style evolved as a result of the establishment of democracy in Athens and were disseminated from that

88. NIOBID PAINTER
Niobid Krater, ca. 460 BC. Height 21¼" (54 cm). Louvre, Paris.

The name of this vase and painter comes from the scene on the other side. The subject shown here is much debated; most often suggested are the visits to the underworld by Herakles (center) or Odysseus (at right), or gods and the assembled heroes at Marathon. The composition has been seen as a reflection of the principles of wall or panel painting or even as a direct imitation of a particular work known from literary sources.

center during and after the Persian Wars as Athenian power was waxing.

While there is no doubt that both historical developments had their effect on Greek thought and its cultural manifestations, too firm an insistence on a single interpretation obscures the degree to which Classical art is itself rooted in Archaic. Development itself is, as we have seen, ingrained in the competitive and participatory society that emerged in Greece during the first millennium. Red-figure vase painters of the late Archaic period struggled for two generations with the problem of implying three-dimensional form within the limitations of their craft (see FIG. 66). As noted, the poignancy of Classical iconography is present already in the dramatically suggestive compositions of a painter like Exekias from the 540s BC. Just as the connection of individual monuments to specific historical events can require a forcing of the evidence, so also in the case of stylistic development it is necessary to consider the larger picture as well as a more narrowly defined context.

In our consideration of the Parthenon styles above, we have already encountered the basic features that distinguish Early from High Classical style. Most obvious was the refinement of the thick drapery patterns of the Severe style to more delicate, varied, and ostensibly more realistic treatments of cloth on the Parthenon figures. The rendering of the anatomy of male figures followed a parallel development, and both trends can be understood as a direct continuation from and "improvement" on Early Classical forms. However, we also saw in the depiction of centaurs a rejection of the monstrous in favor of more human facial features— one example of a decreasing interest in characterization that many scholars detect in Greek art beginning about mid-century. It is often said that the Early Classical was moving directly toward a patently naturalistic effect when it was interrupted by a High Classical reversion to more idealized and conceptual forms as seen in the relentlessly uniform faces of the Parthenon sculptures or in the Canon of Polykleitos.

That statue, as we have seen, is known only from copies (see FIG. 7) but is much mentioned in ancient literature and much imitated in Classical and later art (FIG. 89): it fulfilled a need of the time. Its weight shift differs from that of such Early Classical figures as the Kritios Boy (see FIG. 84) or the Riace Warriors (see FIG. 10); the displacement of the non-weight-bearing leg produces an ambiguity reminiscent of the Archaic *kouros*. Unlike earlier figures that clearly stand at rest, Polykleitan statues exist in a deliberately undefined state suspended between walking

and standing. The artificiality is further displayed in the quality of *chiasmos*, a schematic balancing of opposites (curved/straight, flexed/relaxed, raised/lowered) across a curving longitudinal axis. Conceptual too is the mathematical basis for deriving ideal proportions; although the treatise that described Polykleitos' formula has not survived, we can perceive its effect in the overdefined musculature of the Doryphoros.

The perceived shift from the real to ideal is variously explained. Some attribute it to a philosophical shift toward idealism (eventually manifested in Socratic and Platonic thought) that found its way into art through the genius of individual artists such as Polykleitos and Pheidias. Others detect a general discomfort with the depiction of divine subjects—necessarily anthropomorphic—in an increasingly realistic style; that is, it was acceptable to show the gods as people as long as they did not look like real people. While all of these factors may well have been in play, two facts seem most significant. First,
that this idealizing trend is obvious and early at sites other than Athens saves us from the temptation of connecting its emergence to the increasingly idealized Athenian self-image, although the Athenians were obviously adept at exploiting the style. Secondly, different styles seem again to be connected with different subjects, as we have already noted in the varying drapery treatments on the Parthenon. If we compare the Doryphoros with, for example, the reclining male of the Parthenon's east pediment (see FIG. 15), the difference in the treatment of anatomy is obvious. Some have seen the distinction as artist-dependent, others as Attic versus Peloponnesian. It is equally likely that the Polykleitan scheme was considered appropriate for embodying the athletic ideal of *arete*, and the other mode for a relaxed, reclining god. Indeed, if figure D is Dionysos, as is generally thought, we see here an early version of what became his characteristic treatment in Late Classical and Hellenistic times.

89. ACHILLES PAINTER Amphora with Achilles, ca. 440 BC. Height 24½″ (62 cm). Vatican Museums, Rome.

This, the name vase of the painter, shows the Homeric hero standing in a pose that was clearly derived from that of the Doryphoros (see FIG. 7)

90. Nike from the Temple of Asklepios, Epidauros, ca. 380–370 BC. Marble, height 33½" (85 cm). National Archaeological Museum, Athens.

The winged victory figure's right shoulder and left leg are both thrust forward, giving the body a spiral torsion that denies High Classical frontality. This and other fourth-century features stand out when compared with the earlier Nike of Paionios at Olympia (see FIG. 30

The simultaneous availability of differing styles becomes more of an issue as we move into the fourth century, a topic to be more fully explored below; it is necessary first to identify what new features the Late Classical era brought in. Early fourth-century architectural sculpture displays a style similar to that of late fifth-century Athenian monuments like the Nike parapet (see FIG. 76), especially in the case of similar subjects like the Nike *akroterion* from Epidauros (FIG. 90). However, even here one sees unmistakably Late Classical traits. As in earlier sculptures, folds are used here to model the body, but folds are also used to create modeling shadows like those above the right breast or along the left side. Fourth-century sculptors and painters seem to have concerned themselves much more than did their predecessors with the visual effects of their works. The distinction between the real and the perceived was a concern of Greek philosophy from at least the sixth century onward, and has remained a central philosophical question throughout history. Any work of art must be a compromise between the two and can be situated variously along the polarity. Art of the fourth century BC shows a decided shift toward the perceptually real, and in doing so it often deliberately rejects such High Classical conventions as frontality and intellectually descriptive drapery patterns.

A sculptured column drum from Ephesos in Asia Minor (FIG. 91) preserves both draped and undraped figures. The Hermes at right and the winged, armed figure at left both display such typical fourth-century features as slender proportions, exaggerated lean, and softness of modeling—all of which deny Polykleitan conventions. The last reflects a greater interest in surface than structure—a reversal of fifth-century priorities. More deeply set eyes create a more convincingly three-dimensional treatment of the head. The draped figures here are enveloped in heavy masses of folds that obscure the body more than reveal it, while the cloth itself is textured; again, surface is more important than structure.

A more blatant rejection of the High Classical can be seen in the preferred poses of the athletic male nude, still an important subject. In addition to the exaggerated lean toward the weight-bearing leg, one sees an exactly opposite effect in figures that lean toward the free leg, creating an unbalanced and momentary

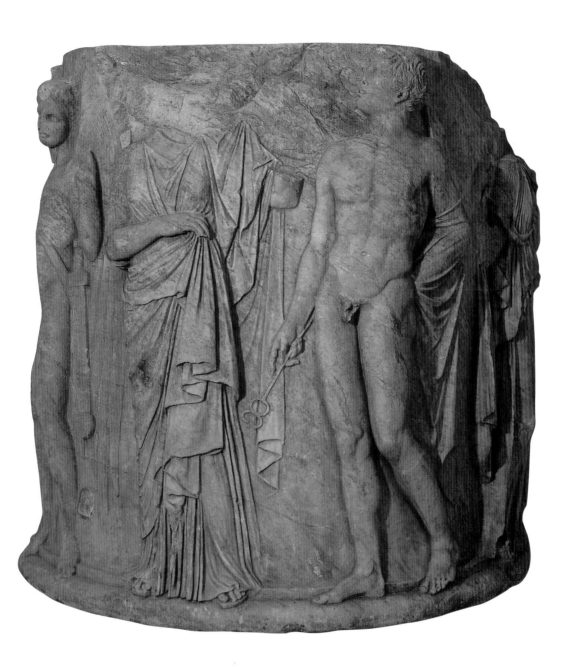

91. Column drum from the Temple of Artemis at Ephesos, ca. 320 BC.
Marble, height 71¾″ (182 cm). British Museum, London.

The temple was burned down, it is said, on the night of Alexander's birth in 356 and was still unrestored when he passed through 22 years later. It was an enormous project on which work continued for some time, but the sculptures on the columns were probably completed before the end of the century. Here, we see Hermes with his caduceus (wand) conducting a woman to or from the underworld.

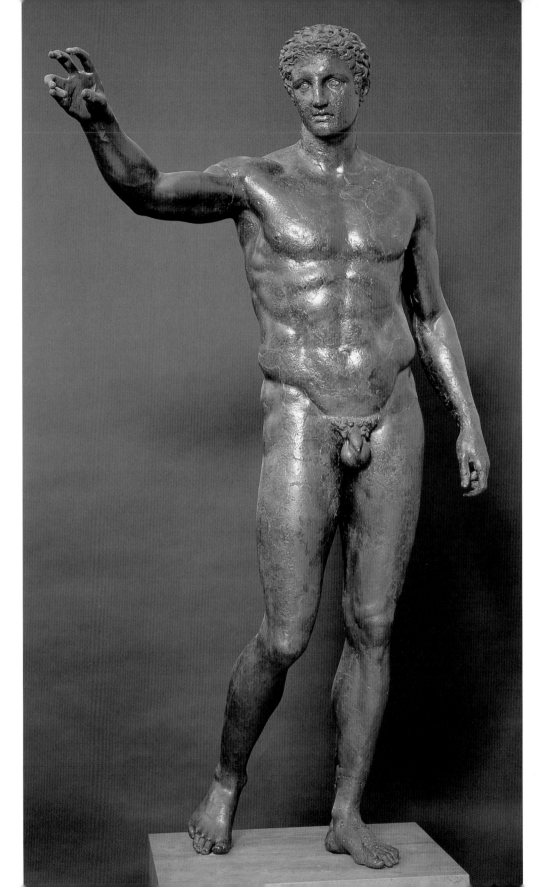

pose (FIG. 92). Such a pose forces the eye to move up and down the figure in an attempt to reconcile the irreconcilable and thereby creates in the viewer's mind an impression of movement; in this way an illusionistic device produces a realistic impression. Illusion was certainly a concern of fourth-century painters. Later writers repeat numerous anecdotes about competitions in pursuit of verisimilitude, even *trompe l'oeil* effects. Parrhasios defeated Zeuxis, for example, because his curtain fooled Zeuxis himself while the latter's grapes only deceived a bird. Although almost all monumental painting is lost, an interest in optical effects can be seen in the Alexander Mosaic (see FIG. 75); features surely copied from its fourth-century painted predecessor include strong foreshortening, complex highlights and shadows, and the reflection of a dying Persian's face in a polished shield.

This shift in interest from the ideal to the real is often seen as a result of the decreasing importance of the *polis* as the central element in the life of the individual. Indeed, the *polis* as an independent political unit was stung by the struggles of the Peloponnesian War (431–404), further damaged by the incessant warfare among shifting confederations of city-states during the early fourth century, and mortally wounded by the rise of Philip and Alexander. Although the *polis* remained the local political unit into the Roman Imperial epoch and beyond, and alliances among *poleis* were formed at various times, from Alexander onward the *polis* generally had no real political or military power beyond its own borders. With the disappearance of the *polis* as an orienting force, the individual looked inward: individualism and personal choice reigned supreme in the spheres of philosophy, literature, and art. This process was further encouraged by the social environment of the Hellenistic city, which was far more heterogeneous than the Classical *polis*, and thus choice itself became more prevalent.

Despite the validity of these observations, they do tend to paint a picture that overlooks the degree to which Hellenistic culture emerged directly from a Late Classical background. This fact forces us back in time to seek an explanation for the apparent shift in emphases between the High and Late Classical epochs. One answer is that the pursuit of increasing naturalism detectable in Greek art from its beginnings exhausted its possibilities within the conceptual constrictions of the High Classical era, so that conceptualism itself needed to be scrapped in favor of something new. Another points to the new patrons for Greek art, from Asiatic dynasts like Mausolos (r. 377–353 BC) to Macedonian kings like Philip, powerful individuals with alternative values, contrasting

92. Antikythera Youth, ca. 340 BC. Bronze, height 6′4½″ (194 cm). National Archaeological Museum, Athens.

The identity of this figure is variously interpreted as Paris displaying the apple of discord, Perseus with the head of Medusa, or a generic athlete.

iconographic traditions, and very different messages to convey. It can also be argued that it was only in the fourth century that individual artistic creativity began to emerge. Indeed, we hear more about the personalities and lives of the sculptors and painters of this time than of those from any other era; unfortunately this picture is almost entirely a literary construct. Yet all these factors do point to what is truly significant about fourth-century Greece: it was a time of unprecedented variety, whether it be of political systems, philosophical schools, literary genres, or in the functions, subjects, patrons, audiences, and styles of sculpture and painting. It is to the history of such variation that we now turn.

Style Pluralism

Regional variations in artistic styles can be detected in Greek art from its very beginning. Works on Protogeometric and Geometric pottery distinguish among several local schools, each with its own favored shapes, motifs, and decorative schemes. As figural decoration increased over the seventh century, these distinctions become clearer still; we have already considered examples of Attic, Corinthian, and Cycladic orientalizing pottery. Still another style was favored in the Greek cities of the eastern Aegean, in which the animal friezes found on Protocorinthian black-figure pottery were rendered using the outline technique common on Proto-Attic; the result was something all its own (FIG. 93). Moreover, there seem also to be distinct local versions of this Wild Goat Style among the Greek cities of Asia Minor. During the Archaic and Classical periods, many local black-figure and red-figure styles can be distinguished, including those of Attika, Corinth, East Greece, Sicily, South Italy, Lakonia, Boiotia, and Euboia; many of these vases, as we saw, come from Etruscan tombs, and for some styles, like

93. Wine jug from Rhodes, ca. 620 BC. Height 12¾" (32.5 cm). Staatliche Antikensammlungen und Glyptothek, Munich.

The decoration on this *oinochoe* is known as East Greek Wild Goat Style, from the goat frieze and such orientalizing motifs as the lotus and bud frieze below.

Chalkidian and Pontic, it is disputed whether they are Greek or local Italic wares.

In sculpture, we saw how a local Cretan style, the Daedalic, spread to the Cycladic islands and the mainland but seemed to die out around the end of the seventh century. The sixth-century marble *kouroi* and *korai* we have considered were all of Attic provenance and style, but distinctive figures were created in Archaic East Greece; in fact, the *kore* type was no doubt born there. Cheramyes the Samian dedicated three such figures to Hera in her sanctuary on his home island (FIG. 94). The figure now in the Louvre wears the same *chiton* and diagonal mantle as do such Attic *korai* as Antenor's (see FIG. 28), but the rendering is entirely different. The folds do not project as three-dimensional masses but are indicated by a pattern of shallowly carved, almost incised, lines. Those portraying the heavier overgarment are more broadly spaced than those characterizing the thin linen *chiton*. The figure is columnar rather than block-like in its structure; as a rule, East Greek Archaic sculpture approximates curvilinear shapes more than the sharply carved angular patterns favored by the Cycladic and mainland workshops. The products of the latter, in fact, evolved from the East Greek *kore* type, which appeared first, and by the late Archaic period a more consistent "International" *kore* type appeared across the Greek world. Nonetheless, scholars have been able not only to distinguish mainland from East Greek sculpture, but also to differentiate among the different centers of Asia Minor, the Cyclades, and the mainland.

The sculpture of the Sicilian and South Italian Greek cities (Greater Greece, or "Magna Graecia") seems also to have followed its own course. This is especially apparent in the Early Classical period when the replacement of Archaic linear patterning by the Severe style is less sudden and thorough than on the mainland. The metopes from the Temple of Hera ("Temple E") at Selinus in Sicily illustrate this clearly (FIG. 95). These limestone reliefs are inset with white marble for the faces and arms of female figures, but both male and female heads are fully Severe in style. The figural types and poses are also Early Classical; the garments sometimes, but not always, are more Archaic. The drapery patterns

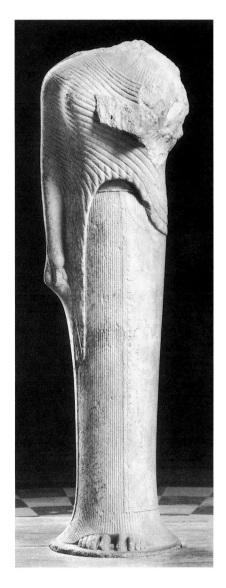

94. *Kore* from Samos, dedicated to Hera by Cheramyes, ca. 560 BC. Marble, height 6'3¾" (192 cm). Louvre, Paris.

A nearly identical figure similarly inscribed is still on Samos, and another is in Berlin.

95. Metope with Zeus and Hera, from Temple E at Selinus, Sicily, ca. 460 BC. Limestone with marble, height 63¾" (162 cm). Museo Archeologico, Palermo.

Hera's head closely resembles those from the Temple of Zeus at Olympia. She wears a long diagonal mantle with overfold over a thin *chiton*, a garment that resembles the Archaic scheme, but is found primarily on such Early Classical works. She stands with her weight on her right leg and her left leg flexed. Despite the many Archaic drapery patterns, the thick folds around Zeus' torso are Severe in style.

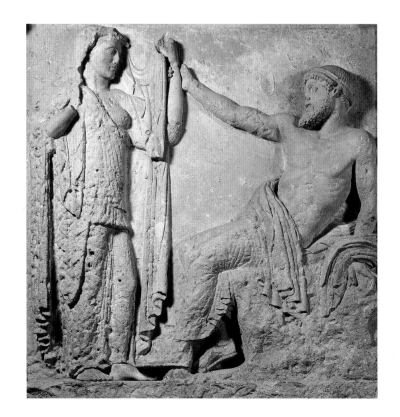

Opposite

96. Derveni Krater, from Derveni in Macedonia, ca. 330 BC. Bronze with copper and silver, height 35¾" (91 cm). Archaeological Museum, Thessaloniki.

The vessel was found with coin of Philip II (d. 336) in a chamber tomb. Some have identified the scene as inspired by Euripides' play *The Bacchai*, which if true would constitute another sort of classicism. The Athenian tragedian became a guest of the king of Macedon and died there in 405 BC.

themselves display Archaic-looking pleats and zigzag edges in some places, heavy "doughy" folds in others. This style is so typical of Early Classical work in Western Greece that it is difficult to dismiss it as provincial or "retardataire" (out of date). It seems a deliberate choice, stimulated perhaps by an aversion to excessive naturalism or by a preference for elaborate linear patterning, as can be seen in Magna Graecian work from other eras.

It is clear that the stylistic sequence worked out through mainland, especially Attic, work is not universally applicable throughout the Greek-speaking world, that transitions took place at different times and at different paces throughout the various regions of Greece, and that local styles emerged in response to local tastes and demands. In addition, different styles developed for different subjects and functions, particularly in late Classical and Hellenistic times.

One source of this sort of style pluralism is an eclecticism that can result when a culturally less advanced people exerts control over one with a richer artistic tradition. We are familiar enough with the phenomenon as it was played out in Roman times, but in this respect the Macedonians preceded the Romans by centuries. Elaborately decorated vessels in precious metals formed a major

part of artistic production in every era of ancient Greece and were particularly beloved by the newly enriched and empowered Macedonian lords of the fourth century. Fortunately, they used them as cinerary urns or funerary offerings in their built chamber tombs, some of which have remained unlooted. Excavations of the past few decades have provided a whole new medium for scholars to consider. Unquestionably the finest of extant works is the Derveni Krater (FIG. 96). The drapery of the ecstatic maenads who circle its body reminds us of the Epidauros Nike from a generation earlier, but there is a much stronger contrast here between the highly calligraphic drapery—a mannered version of the Athenian late fifth-century Nike parapet style—and the strong torsion of the figures themselves. The animal frieze on the neck recalls orientalizing pottery from three centuries earlier, but it could just as easily have been derived from true Oriental prototypes—a new source of influence even before Alexander's conquests. We are here on the eve of the Hellenistic.

The snakes on the volute handles of the Derveni Krater repeat

a motif common on some late Geometric funerary amphorae, although it would be difficult to maintain that their presence here constitutes a deliberate revival. Nonetheless, during the fourth century the use of long outdated, typically Archaic drapery patterns (the "archaistic" style) became more widespread. Previously limited to a narrow range of functions, archaistic figures are now found on painted pottery (especially the prize amphorae of the Panathenaic Games), votive reliefs, statuary, and even architectural sculpture (FIG. 97). The parallel pleats, mannered zigzags, stiff poses, and diagonal mantles are here integrated with clinging and flowing drapery to form a true amalgam of the Archaic and Classical. The style had great currency in Hellenistic and Roman times, and although its precise significance remains elusive, it added one more option to the increasingly rich stylistic palette of late Classical and Hellenistic art.

One typical fourth-century feature already noted is the deeper setting of eyes in the head, which represents a stage in a continuous struggle to co-ordinate and integrate four views.

97. Frieze from the Propylon of the Hall of Choral Dancers (formerly "Temenos"), Samothrace, ca. 330 BC. Marble, height 12¾" (32 cm). Kunsthistorisches Museum, Vienna.

This frieze is transitional between the narrative figured friezes of Classical art and the Hellenistic practise that favored decorative, repetitive, usually floral forms for its architectural sculpture.

ATHENA

Such a placement often creates distinct shadows around the eye, which artists were not slow to exploit for dramatic effect. An early example from the Epidauros pediments shows the head of a figure who is grasped by his cap and hair and who reacts to his fate with an unprecedented degree of intensity (FIG. 99). The furrowed brow is nothing new; centaurs and Lapiths alike at both Athens and Olympia express their pain through this device. But the exaggeratedly pinched brows and deeply set eyes lend the terror-struck face from Epidauros an entirely original aspect. This head marks the beginning of a new stylistic mode termed "baroque" by analogy with similarly emotional renderings in seventeenth-century European art. It becomes a significant tool for Hellenistic artists, such as those who worked on the Pergamon Altar (FIG. 98; see FIG. 34), because its visceral appeal cuts across the various cultural boundaries within a heterogeneous Hellenistic society. As we have seen so often before, function and audience condition stylistic choice.

Such perceptually realistic effects were consciously pursued by painters of the fourth century. Moreover, the rise of psychological portraiture at the same time (see FIG. 56) shows how images can appear "realistic" even if fabricated from concepts rather than appearances. At least one sculptor from this period, called Demetrios of Alopeke (in Attika), was long renowned, even criticized, for the excessive verisimilitude of his sculptures. The second-century AD writer Lucian (*Philopseudes*, 18) describes one portrait as having "a pot-belly, a bald head . . . with some hairs of his beard windblown, and with his veins showing clearly, just like the man himself." A bronze boxer's head from Olympia (FIG. 100), conventionally dated to the fourth century, preserves something of his effect. The wildly curling locks of his hair and beard suggest the violence of his sport. His cheeks, forehead, and ears seem flattened and battered, and his small, intense eyes are deeply set within the swollen flesh. This piece, however, is a model of Classical reserve compared to the relentless detail of the Hellenistic bronze boxer now in Rome (FIG. 101). His muscular frame collapses in exhaustion. His oft-broken nose, cauliflower ear, and bleeding lacerations dramatically highlight the violence of his sport. As with Pergamene baroque, this realistic manner is captivating because the viewer can understand it and can empathize with its subject without foreknowledge of any associated story.

Of course, in order for styles like the archaistic, baroque, and realistic to convey meaning, they must exist as alternatives not only to one another, but also to the more idealized forms of the High Classical itself. The latter was a continuously available option

from the fifth century onward and was especially favored for images intended to lend dignity to their subjects, whether mortal or divine. Moreover, certain works created in Hellenistic and later times alluded to or imitated monuments of the Classical epoch. The "Slipper-Slapper" from Delos (FIG. 78) is typical of the new types of sculpture that appeared in Hellenistic times. It was not dedicated in a sanctuary but in a privately owned structure—at that time an increasingly common use of large-scale sculpture. Style contrast is evident between the smooth Classical-looking Aphrodite and the much more fully characterized and baroque-looking Pan. Each style is appropriate to its subject, and the difference is critical to the implied narrative, in which the reserved Olympian is in conflict with the more bestial, only semi-anthropomorphic Pan. Aphrodite's nudity and pose recall, perhaps deliberately, the Classical

Aphrodite of Knidos (see FIG. 54) and thereby imply a seriousness that heightens through ironic contrast the implicit comedy of the composition. Pan accosts the goddess, she seeks to fend him off with her sandal, and Eros intervenes, although his role is ambiguous, since he both connects and separates them. This is a form of Hellenistic parody sometimes classed as "rococo."

The humor and eroticism implicit in this group are often seen in Late Classical and Hellenistic art and, like other trends already noted, reflect a desire to appeal to individual taste on a common level. The effect is heightened, increasingly so from Classical times onward, by using distinctive styles to sharpen contrasting identities. For Greek art of exactly this same period—from about 400 BC onward—scholars have frequently bemoaned the difficulty of establishing so clear a style sequence as that constructed for earlier times. The simple answer is that stylistic sequence is complicated not only by the co-existence of differing styles, but by the necessary reliance of those styles on one another as frames of reference for conveying meaning. The styles are contemporary because that very contemporaneity allowed them to signify; stylistic eras are elusive not because, as some have said,

99. Head of Priam, from the Temple of Asklepios, Epidauros, ca. 380–370 BC. Marble, height 5¾″ (15 cm). National Archaeological Museum, Athens.

This fragment of Priam attacked by a Greek comes from the east pediment of the temple, along with another of Cassandra's hand clutching her sacred statuette, which together identify the subject of the pediment as an Ilioupersis or Sack of Troy.

100. Head of a boxer, from Olympia, ca. 350 BC. Bronze, height 11″ (28 cm). National Archaeological Museum, Athens.

The eyes, once inset and now lost, would have lent the head even greater intensity.

Opposite
101. Boxer, first century BC. Bronze, height 47¼″ (120 cm). Museo Nazionale Archeologico, Rome.

The sculptor has inset copper blood into wound cuts in the bronze to create nearly pictorial coloristic effects.

the evidence is insufficient to define them, but because they did not exist.

The sequenced scheme of stylistic development that has served since Winckelmann as the primary organizing structure of Greek art is a useful tool indeed, but like any tool, it must be used appropriately. Within the sequence there is variation, and only if that variation is acknowledged and understood, can the organic model be of any use at all; otherwise the scholar is its servant, not its master. Early on, styles varied primarily along regional lines. Just as these distinctions became blurred in Late Archaic to Early Classical times, new ones developed in response to increased artistic skill, growing creative competitiveness, and most importantly the demands of new subjects, functions, and audiences. By Late Classical times we find several "Classical" styles that were later manipulated and exaggerated by artists working in the much changed world of the Hellenistic kingdoms. The turning point came, it seems, around the time of the Parthenon, which in this as in so many other ways assumed the central and normative role.

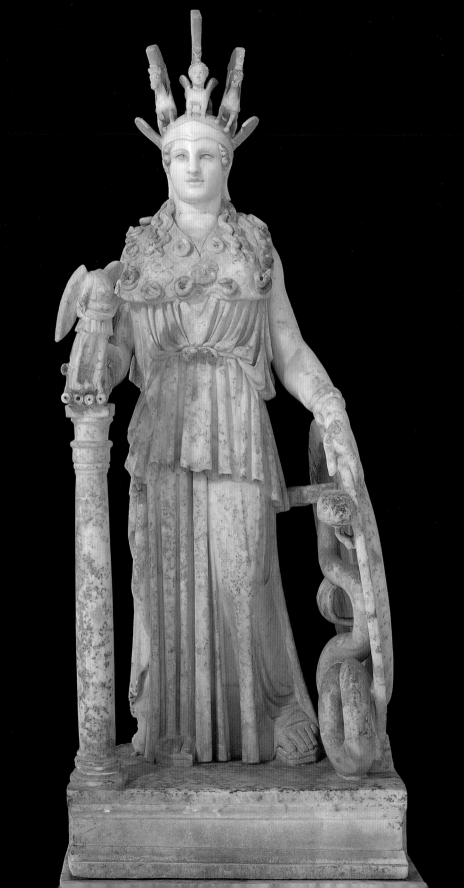

FIVE

(Re)constructing Classicism

P lutarch describes Pheidias as overseer of the entire Periklean
building program, but today scholars agree only that he was
responsible for the image of Athena set up inside the
Parthenon. The commission brought unmatched fame and seem-
ingly unending troubles. It is clear that the Romans, especially the
"rhetorical analogists" like Cicero (106–43 BC) and Quintilian
(b. ca. AD 30), respected Pheidias' ability to depict the Olympian
gods; in the latter's words (*Institutio Oratoria*, 12.10, 10), Pheidias
"added something to traditional religion" by creating the mon-
umental Zeus at Olympia and the Athena. Cicero (*Orator*, 8–9)
believed these statues to have been conceived as divine images
in the artists mind (*phantasia*) without recourse to human mod-
els—a sentiment echoed in the works of Seneca and the later writ-
ers Philostratos and Plotinos.

The Athena Parthenos and its Legacy

The Athena Parthenos was surely meant to be noticed. Over forty
feet tall, its exterior entirely covered with gold and ivory, the work
stood with a Nike (itself larger than most ancient statues) in
her outstretched right hand and a spear, snake, and shield at her
left (FIG. 103). It was as much assemblage as statue, put together
from many parts in various materials and with narrative relief
adorning several details—not unlike the Parthenon itself. The two
main sources that describe the statue—Pliny and Pausanias—both
devote the bulk of their treatment to these decorative features:
sphinx and pegasoi on the helmet, Medusa on her aegis, an
Amazonomachy and a Gigantomachy on the exterior and in-
terior (respectively) of the shield, a Centauromachy on the sandal

soles, and the birth of Pandora on the statue's high base. Indeed, Pliny (*Natural History*, 36.18–19) pointedly says that it is in these small details, not in the enormity, style, or expense of this statue (or of its even more famous counterpart at Olympia), that the genius of Pheidias might best be seen.

Despite our association of divine idealism with the stylistic forms of High Classical sculpture, it is probable that the god-like quality in these works resided less in details of style than in their enormous scale, sumptuous materials, and dazzling effect—rather like the awesome epiphany of an Olympian as contrasted with the more humdrum, mortal guise in which the gods sometimes descended from Mount Olympos. Such was the quality of divinity inherent in these gigantic chryselephantine temple statues. It may be that Pliny and Pausanias focused on the decorative details of Pheidias' Athena exactly because these were of more mortal scale and thus more comprehensible than the statue in its overwhelming entirety. It is certain that others also noticed such features. Several anecdotes report charges against Pheidias for stealing gold and ivory from the snakes scales and for rendering certain figures of the Amazonomachy as portraits of Perikles and himself. The veracity of these stories is suspect, nor is there any agreement among them concerning either Pheidias' crimes or his punishment. Nonetheless, the later observers who heard and repeated the stories surely noticed these details and pondered their significance.

There is no doubt, then, that the Athena Parthenos and Olympian Zeus ensured the success of Pheidias, who thereby became, and remains today, the most famous of all Classical Greek sculptors. Oddly, while the latter statue was classed among the seven wonders of the ancient world in Hellenistic times, no copies of it in whole or in part (aside from a simple profile view on Roman coins of Elis) have ever been securely identified. It is the former which prompted imitation and allusion, both in part and as a whole, beginning almost immediately after its construction and continuing throughout Roman times. Such was the power of the image, and the prestige of its context, that it came to epitomize Athenian culture at its height, a visual symbol for Perikles' "school of Hellas."

Given its scale and technique, this was not a statue which easily lent itself to copying through any exact mechanical means. Yet a reliable reconstruction can be put together from a variety of sources—marble statues and statuettes, terracotta figurines and reliefs, coins, gems, and jewelry—which reproduce the statue, or parts of it, on a necessarily reduced scale. The single most useful piece is a Roman Imperial marble version found at the

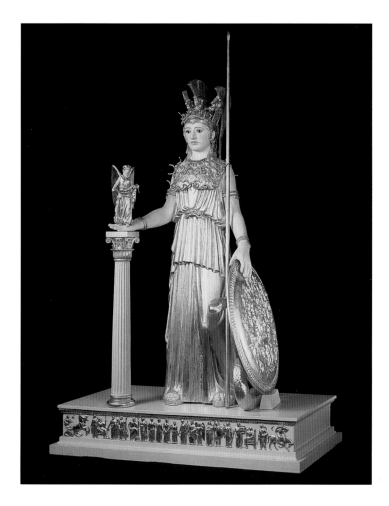

103. Reconstruction of the Athena Parthenos, original 438 BC. Scale 1:10. Royal Ontario Museum, Toronto.

This model results from the careful scholarship of Dr. Neda Leipen, whose study remains the fundamental work on the Parthenos. Others, too, have made reconstructions, including a full-scale statue in the Parthenon of Nashville, Tennessee.

Varvakeion gymnasium in Athens (FIG. 102), as a quick comparison with the Toronto reconstruction reveals (see FIG. 103). The presence here of sphinx-and-pegasos-mounted helmet crests, the Nike, snake, and shield secure the identification with the image described by Pliny and Pausanias. All the statue's basic features are preserved: *peplos* belted at the waist over a long overfold, the symmetrically draped aegis, the resting pose with weight borne on the right leg. The proportions, drapery patterns, and facial features agree with those on similar figures from the Parthenon frieze— exactly what one would expect at the date of 438 BC, when the Parthenos was dedicated. The carving reflects skillful craftsmanship, but in no way can reproduce the artistic quality of the original, which was in any case impossible to preserve in a reduced marble replica. Nonetheless, the Varvakeion piece can allow us to visualize the Pheidian colossus and, perhaps more important, does enable us to identify other replicas.

104. Patras Athena
Parthenos, second century AD
(detail). Marble, height 33¼″
(86 cm). Archaeological
Museum, Patras.

In the center of Athena's
shield is the gorgon
Medusa's head encircled
by snakes, while all around
rages an Amazonomachy.
A coil of the goddess's
snake is visible round the
shield.

The Varvakeion Athena bears no trace
of the Parthenos' elaborate program of
narrative relief, but other copies do pro-
vide some help. For example, a simi-
larly scaled statue from Patras retains
about half its shield with reliefs depict-
ing a battle of Greeks and Amazons
(FIG. 104). On the basis of this piece,
other replicas with shield reliefs, and
marble shields preserved apart from
statues, it is possible for scholars to
reconstruct the entire Amazonomachy,
which was rendered in relief on the
Parthenos' shield (FIG. 105). From this
composition, individual combats were
extracted and reproduced on Roman
marble panel reliefs and sarcophagi.

Considering the frequency with
which the Amazonomachy figures have
found their way into later decorative
art, one might expect to find figures
from the Parthenos Gigantomachy and
Centauromachy as well, but they are
lacking. Only a small trace of a painted Gigantomachy is preserved
on one of the copies of the shield, and we have no direct evidence
for the Centauromachy. These subjects were common enough
in Classical and later art, and no doubt some figural types and
groupings are preserved, but it is difficult, if not impossible, to
identify them now.

We are a little more fortunate in the case of the Pandora scene
that adorned the base, since two copies (see FIG. 109) preserve figures
from that composition. The subjects of all these reliefs were
clearly chosen to tie the Parthenos to the iconography of the build-
ing as a whole, repeating three of the four themes of the metopes.
As for Pandora, her connection with Hephaistos and Athena (father
and stepmother respectively of the Attic king Erichthonios,
who is also suggested by Athena's snake) reinforces the local nature
of the temple, its cult, and its message. It has also been suggested
that Pandora's folly can be read as a warning about the limits of
humanism and as another sign of Athenian misogyny.

Much earlier than these reproductions of the Parthenos reliefs
are the reflections that proliferated in the Classical era itself. These
consist not of copies *per se* of the Amazonomachy figures but of
figural types and groupings from among those found on the Parthenos

144 *(Re)constructing Classicism*

shield, adapted to new circumstances on later temple sculptures and other works. Among the groups on the Patras shield (see FIG. 104) are those of a Greek pulling an Amazon by her hair, and a Greek helping a fallen compatriot. About a generation after the completion of the Parthenon, a sculptured frieze was erected inside the *cella* of the Temple of Apollo at Bassai in Arcadia, in the Peloponnese (FIG. 106). It included two themes—an Amazonomachy and a Centauromachy—and numerous features reminiscent of High Classical Athens; indeed, the temple itself was said to be the work of Iktinos, the architect of the Parthenon. The frieze displays a local and exaggerated variant of the Athens wind-blown Nike parapet drapery, while the deep-set eyes and widely spaced arrangement of figures are consistent with fourth-century work. Many figures derive from fifth-century Attic prototypes, such as the hair-pulling and comrade-helping scenes and the types of Harmodios and Aristogeiton (the Tyrannicides).

While we see allusion to the Parthenon, the motivation for the persistence of these types was far more practical. The eloquent outlines of such figures retained a visual association with certain activities, and these types had become a system of figural hiero-glyphs readily perceived by a viewer at ground level far below.

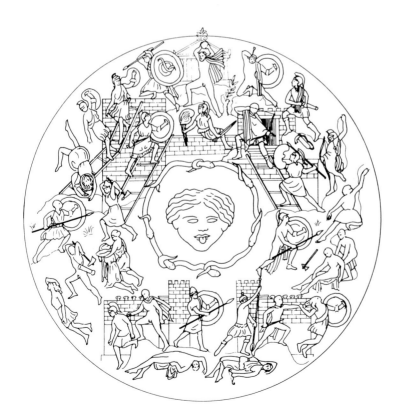

105. Reconstruction of the Parthenos shield by Evelyn Harrison (1981). Diameter of original shield ca. 15'9" (4.8 m).

Certain Roman ("Neo-Attic") reliefs that excerpt groups from the shield preserve a background of cut stone masonry. Harrison has plausibly argued that these derive from a composition that originally depicted Athenians defending a fortified Akropolis against the Amazons invasion. The Harmodios type (see FIG. 11) recurs in a striding figure wielding an axe with both hands (at left in this reconstruction); a variation of the Aristogeiton can be seen just above it.

106. Slab 531, Amazono-machy frieze, from the Temple of Apollo at Bassai, ca. 400–390 BC. Marble, height 25¼" (64 cm). British Museum, London.

Note the Amazon helping her companion at right—a variation of a similar grouping of Greeks on the Parthenos shield (see FIG. 105). At left, a Greek confronts an Amazon in an exact reiteration of the Tyrannicide types, also on the Parthenos shield.

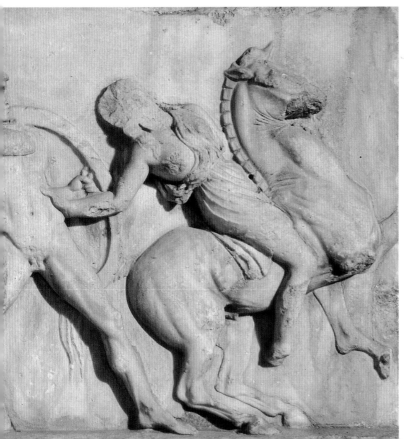

107. Slab 1006, Amazon frieze from the Mausoleum at Halikarnassos, ca. 350 BC. Marble, height 35½" (90 cm). British Museum, London.

This relatively small frieze was probably located high on the structure. To compensate, the sculptors left spaces against which the figures' profiles stand out, and drilled channels in the stone to form dark linear outlines.

108. Mosaic floor from a house in Pella, Macedonia, ca. 300 BC. Pebbles, 10′6″ x 16′ (3.2 x 4.9 m). Archaeological Museum, Pella.

Given the characterization of this as a Macedonian scene, some have seen here a specific episode of Alexander hunting lions, as was the custom of Near Eastern monarchs, but such a reading is far from clear. The technique of flooring with smooth, uncut river pebbles was venerable, but the arrangement of these stones into representational scenes seems to have begun in High Classical times. The cut-stone ("tessellated") mosaics familiar from Roman and later times were invented in the Hellenistic era.

It was this same desire for narrative legibility that since Geometric times had lent Greek art its reiterative, conceptual, and conservative quality, while competition among craftsmen and patrons produced increasingly naturalistic forms.

These types became ubiquitous in Late Classical and Hellenistic art. On the Amazon frieze of the monumental tomb the Mausoleum in the Greek East at Halikarnassos (modern Bodrum; fig. 107), a pair of Greek warriors converge on a fallen Amazon, their poses clearly derived from the Tyrannicide types. To the right of this group, a Greek soldier pulls an Amazon from her horse by the hair; his broadly spaced legs and torso set off against his shield are concessions to comprehensibility, although he grasps her with a right arm (the reverse of the corresponding figure on the Parthenos shield), which thus crosses his torso. The result is a more torsional and three-dimensional pose, which, like the slenderer proportions, deeply set eyes, and highly modeled anatomy, reveal these figures to be fourth-century reworkings of High Classical types.

Similar figures could be used for entirely different media and subject matter. A pebble mosaic floor from a wealthy house built around 300 BC in the Macedonian capital Pella depicts a lion hunt (FIG. 108)—a theme of increasing popularity with the growth of Near Eastern regal iconography in the wake of Alexander's conquests. The figure to the right of the lion is precisely the Harmodios type; his companion is only slightly modified from the figure of an archer defending the Athenian heights at the top of the Parthenos shield (see FIG. 105). Although given a Macedonian cap, the figure is similarly clad in a simple cape (*chlamys*) covering his arm; the derivation from the Parthenos figure is especially clear from the sword (still in its scabbard) thrust out in the left hand—an illogical action since he attacks with a spear in the right. The arrangement here repeats the extended bow-bearing arm of the Parthenos figure and at the same time mirrors the pose of its companion; it is as much design as depiction.

More than a century removed from the Parthenon, such a figure may or may not in any way have been intended or perceived as a reference to the Parthenon itself or any other pre-existing monument. In some cases—like the Athena (see FIG. 98) and Zeus from the Pergamon Altar, which seem to cite Athena and Hephaistos from the Parthenon's west pediment—one can argue intentionality on the basis of programmatic probability. In other cases, however, it is more likely that artists were simply drawing on a standard and evolving selection of figural types, which they modified as their project demanded.

Several points emerge from this review of the "copies" of the Parthenos. first, it is clear that the impact of the Pheidian colossus—itself documentable in literary sources—was such that it prompted a demand for reproductions, since references to it are frequent in later works of art. Secondly, works which make allusion to the Parthenos do so by quoting unambiguous indices like the Nike, helmet crests, or even excerpts from the decorative reliefs; these were included because they functioned to construct a connection to the Parthenos itself. Thirdly, not every image that resembles some aspect of the Parthenos need necessarily be read as a deliberate allusion to it. Many stock scenes from, for

example, the Amazonomachy, joined a repertoire of figural types and groups which included earlier figures (like the Tyrannicides) and from which later artists drew elements for their own purposes. Finally, the frequency of references to the Parthenos in contrast with the total absence of such for the far more famous Zeus suggests that the motivation for allusion has less to do with the artist or artistic quality of the source than it does with the associations inherent in that allusion. That is, there seems to have been more reason to evoke Athens than Olympia.

Thus the phenomena that resulted in the creation of copies, imitations, and allusions are far more complex than they first appear. Copies need not be direct or exact mechanical productions in order to be understood as such; in the case of the Parthenos it was all but impossible. Small reproductions, or even the depiction of the statue's head only on a coin or gem, could function sufficiently well as a citation of this prominent statue and everything it stood for. Conversely, images which were closely copied, like the Amazons from the shield, may or may not have been intended as references to their source images; they may simply have become accepted forms for rendering the myth. Artists could modify these figural types into new compositions that depict not only Amazons but also other subjects both mythological and non-mythological. Much of our understanding of Greek, Hellenistic, and Roman art alike is based on a traditionally confident attitude toward distinguishing "copies" from other post-Classical manifestations of Classical style and a continued reliance on the assumption that visual resemblance necessarily denotes an intentional reference. Moreover, on the basis of a handful of extant examples, it is traditionally asserted that such intentional references are limited to, or at least characterize, particular periods of "classicism"—a model that seems in contrast with the patterns of continuity we have observed up to this point. It is appropriate then that we close our survey by considering these later occurrences of Classical form in Hellenistic and Roman times, with particular attention to those so-called "eras of Classicism."

Hellenistic Classicism

The kings of Pergamon were not subtle in professing their attachment to Classical Athens, as their building programs in both cities make clear. Enormous stoas were built to the north (see FIG. 6) and south of the Athenian Akropolis by the Pergamene kings Attalos II (159–138 BC) and Eumenes II (197–159 BC), and it was probably Attalos I (241–197 BC) who erected a sculptural group on

the Akropolis itself. This last monument, mentioned only by Pausanias (1.25, 2), must have revealed the very nature of the Pergamene-Athenian relationship. Depicted were battles against giants, Amazons, Persians, and Gauls, although there is no agreement whether the subjects were limited, as at Pergamon, to the dead and dying vanquished or included the victors as well. Located in the very shadow of the Parthenon, this assemblage could not have helped but intersect with that building's familiar iconographic program and thereby elevated the Pergamene victories to the heroic status of Marathon, itself associated in turn with the mythic struggles against giant and Amazon. In typically Hellenistic fashion, what was implicit in the Parthenon was then made explicit for all to comprehend. The statues themselves are lost; copies of the Roman era have been identified with reasonable plausibility, and their style is not unlike that of the Ludovisi group (see FIG. 50)—the dramatic baroque of the Pergamon Altar rather than the Classical restraint of the Parthenon. As much as the iconography functions to connect the Pergamene monument to the Periklean, so does stylistic contrast underscore the vastly different natures of the times: Pergamon was the new Athens, not the old. The Athenocentric classicism of Hellenistic Pergamon was not so much a revival of style as an associative relationship meant to envoke concepts of prosperity, power, and culture.

Nowhere is this clearer than in Pergamon itself. When this town was transformed into a city of substance during the third century BC, Athena Polias Nikephoros (combining Athen's own Athena Polias with Athena Nike) was chosen as the *polis'* central cult. The focal terrace on the precipitous citadel was made Athena's sanctuary, surrounded by an elaborate two-story colonnade in Hellenistic style and provided with a proper temple. Here that most expansionist of Pergamene kings, Attalos I, erected the Gaul dedications and other commemorations of Attalid military success. On the terrace immediately below and to the east, Eumenes II, his son and successor, added the Great Altar. Between these two terraces he erected a library second only to that of the Ptolemies at Alexandria. Each Hellenistic capital was primarily a new foundation—a city built up from all but nothing. Kings could amass wealth, build fleets, and hire mercenaries; their resources far outstripped those accumulated by any Classical *polis*. Nonetheless, they operated in a largely Greek-speaking world to which respect for Greek artistic and literary culture and tradition had already been

109. Athena, from Pergamon, early second century BC. Marble, height 10'2" (3.1 m). Pergamon Museum, Berlin.

The huge statue was found in the library of Eumenes II (197–159 BC) on the citadel of Pergamon.

extended well before Alexander's time. An active cultural life must have been deemed a necessary component for a city with aspirations for panhellenic leadership, since these dynasts devoted considerable resources to building centers of learning and to filling them with texts and scholars.

Dominating the Pergamene library was a colossal statue of Athena more than ten feet (three meters) tall (FIG. 109). As goddess of wisdom, Athena was a logical choice for the spot, but there is a much more particular reference at work. The figure stands in the pose of the Parthenos and wears a *peplos*, aegis, and helmet similar to those of the Pheidian statue. That the connection is not incidental is assured by the relief figures on the statue's base, which are clearly derived from the Birth of Pandora on the Parthenos. However, the stylistic features of the figure—from the deeply cut drapery and modeling shadows flanking the free leg to the softly modeled facial planes, deep-set eyes, and drilled hair—are those of its own Hellenistic era. This is not a copy of a fifth-century original unconsciously updated by a sculptor using features of his own time: it is a thorough rethinking of the type in contemporary terms. The allusion to the Parthenos is clear and deliberate; the intended scholarly audience in the library would have grasped the connection easily. Yet it is not a highly idealized style that constructs this association, it is the pose, garment type, and especially the base relief that certify the connection (would that the shield were preserved!). Nor was such a means of constructing allusion unique to this Pergamene piece. A statue of Athena at Elateia (in Boiotia) was the work of artists known to have been active in the second century; its shield bore relief figures recognized by Pausanias (10.34, 8) as copied from those of the Parthenos.

These quotations were no doubt necessary because an idealized style alone did not constitute a sufficiently explicit reference to the Classical era in cases where such a reference was intended. As we have seen, during the fourth century and later times, many co-existing styles were available and artists tended to associate particular styles with particular subjects and effects. An idealized style similar to that used in Classical times (thus, conventionally, "classicizing") was widely used for the depiction of gods and goddesses, especially the massive, quietly standing or seated figures, located centrally in temples (the so-called cult statues). A group of such figures from Lykosoura in the Peloponnese (FIG. 110) was seen by Pausanias (8.37, 3–5); he attributes them to Damophon of Messene, who is said also to have repaired Pheidias' Zeus at Olympia. There is no other record of this repair, but scholars have often assumed it to have followed an earthquake

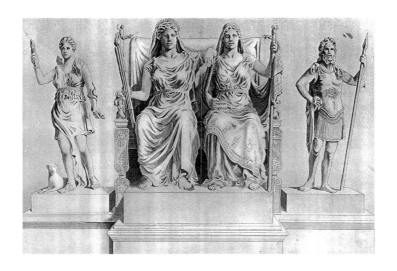

110. Reconstruction drawing by G. Dickins of the statue group from Lykosoura, Peloponnese, original ca. 200 BC. Marble, height of group as reconstruction 18′8″ (5.7 m). Some fragments in National Archaeological Museum, Athens.

The marble cult group is known from the heads of the figures and other parts. It once stood nearly 19 feet (6 metres) high; the figures of Artemis (left) and Anytos (a local hero, right) were over life-size while the seated goddesses Despoina (Persephone) and her mother Demeter were colossal.

of 187 BC; Damophon is supposed to have become familiar with High Classical style through this commission, on account of which he thereafter rendered his own marble works in a classicizing manner.

Certainly the Lykosoura sculptures display a strongly idealized aspect. The large central goddesses are seated in simple, dignified poses; their broad faces are constructed from smooth, hard, and continuous planes connecting forehead to cheeks to chin. Of the smaller flanking figures, Artemis is rendered in the same style as Demeter and Despoina. Anytos, on the other side, displays more modeling around the forehead and cheekbones as befits a male and giant—a characterization similar to those discussed above. The Classical forms seen here—the facial shapes and proportions, garment arrangement and girding, Artemis' hairstyle—are more Late Classical than fifth-century, so there is no obvious indication that Damophon was trying for a Pheidian style. Moreover, very similar works by the same artist at Messene can reasonably be placed around 200 BC, before the supposed damage to the Olympian Zeus.

The chronology of Damophon's works is significant since Hellenistic classicism is widely assumed to be a phenomenon limited to a late stage following and resulting from the second-century Roman conquest. A "classicizing" style period is assumed to follow, indeed to reflect a reaction to, a mid-Hellenistic period characterized by the dramatic "baroque" style of the Pergamon Altar. Damophon's works indicate that those idealized forms interpreted in modern times as revivals of, or allusions to, the Classical were in fact continuously used following the end of the Classical period proper, a pattern which is consistent with the system

of several interdependent styles demonstrated in the previous chapter. Assignment of one stylistic trend to a particular stage in Hellenistic art results from an unsupportable imposition of an organic developmental model on a historical epoch for which it holds no validity.

As Roman control spread over the Hellenistic world during the second century, Italians of wealth and power began to demonstrate their status through the display of goods, including architecture, painting, and sculpture. Always well aware of cultural developments in the Greek world, the citizens of Rome became at this time a part of that world; both the opportunity and the need to accumulate outward manifestations of Hellenized culture increased precipitously. The Hellenistic artistic tradition from which Roman art emerged offered a rich variety of forms and subjects with already established relationships between iconography and style. The Romans brought their own artistic traditions, especially for commemorative art, and new uses for art in both the public and private spheres. Within these developments, Classical idealism played an important role.

The combination of Roman and Hellenistic traditions is sometimes jarring to the modern eye. The Cycladic island of Delos was made a free port following the Roman defeat of Macedon in 168/167 BC. Thereafter, until a series of setbacks early in the first century, the promise of wealth drew many Italian opportunists, and the island became a significant locus for the mingling of Greek and Roman traditions. It was here, for example, that the earliest to-scale Roman "copy" of a Classical bronze was found, the Polykleitan Diadoumenos (see FIG. 5). Such statuary came to be extensively used in the decorative programs of Roman theaters, baths, fountains, villas, and other spaces both public and private. The same workshops were responsible for the creation of Roman portraits that combined heroic nude bodies in a Classical style with heads unlike any seen in earlier Greek art. Statues like the "Pseudo-Athlete" (FIG. 111) are often simplistically dismissed as crude juxtapositions of the real and ideal, but this fails to do it justice.

Our understanding of Roman portraits as "veristic" (that is, unstintingly lifelike) derives from literary sources, coin images, and our own expectation for things to look more Greek. In fact, Roman commemorative portraiture seems to have been very much like Hellenistic portraiture in its desire to describe the nature and character of its subject. Just as Demosthenes' portrait (see FIG. 56) is marked by features that reflect the life and accomplishments of the famous orator, so do the furrowed brows, lined faces, and serious expressions typical of Roman portraits underscore those

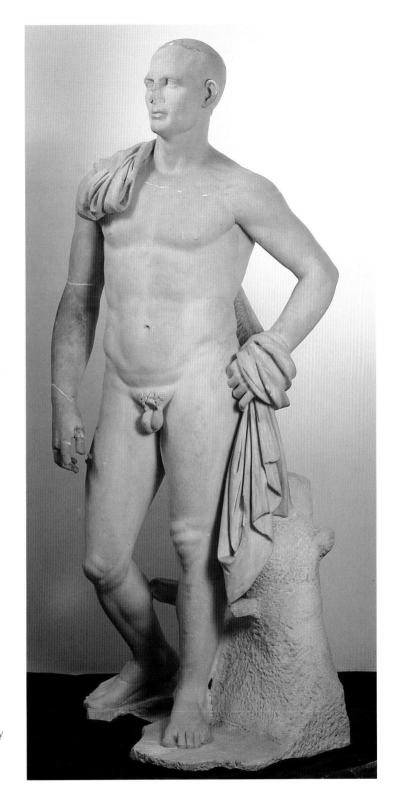

111. Portrait of a Roman, the so-called "Pseudo-Athlete," from Delos, ca. 100 BC. Marble, height 7'5" (2.25 m). National Archaeological Museum, Athens.

To modern eyes, this statue seems to violate the Classical sense of propriety, given its juxtaposition of a heroic, nude, idealized body with the starkly realistic portrait of a middle-aged Italian entrepreneur.

qualities of maturity and experience much valued by Roman society. The difference here is that a Greek character portrait of an orator or philosopher would continue the characterization to a fully draped and mature body. The patron of the Delos portrait has opted for a nude Polykleitan form, which was selected both to imbue the statue with athletic and heroic qualities and to mark the subject as a member of the Hellenized elite. Although such statues are much derided by modern observers, their popularity throughout Roman Imperial times is ample testimony to their appeal and effectiveness at conveying the desired message. They became particularly useful to members of an Imperial family much concerned with suggesting for themselves a liminal status between mortality and divinity.

In an increasingly Roman-dominated Hellenistic world, works of art came to be more frequently designed for display within private spaces. Portraits and images of household gods had long played an important political role in the public areas of Roman houses, and with the growth of wealth and Hellenization, the possibilities for a powerful Roman to create an environment reflecting his status grew enormously. Since the Roman domicile had this important public function, it is incorrect to class as "decorative" those works of sculpture carefully selected for display. Many of the same types of works—portraits, copies of Classical bronzes, images of deities in Classical style—were set up in private as in public contexts, and in both cases the assemblage was designed to reflect the principles and values inherent in the space so equipped.

One entirely new class of monument consists of marble objects (vases, candelabra, altars) bearing relief decoration, often in a Classical or Hellenistic style (FIG. 112). A few conspicuous examples bear signatures of Athenian artists, and long ago the term Neo-Attic was attached to all such sculptures, although the connection to Athens is tangential at best. The Neo-Attic workshops drew elements from a repertoire of figural types, and artists felt free to mix, match, and modify them in myriad possible combinations. The most commonly encountered group of figures consists of orgiastic maenads in a style reminiscent of the Nike Parapet in Athens (see FIG. 76), and many attempts have been made to reconstruct and identify a Classical "original." Indeed, one can find in Classical painting,

112. " Neo-Attic" volute krater, signed by Sosibios of Athens, first century BC. Marble, height 26½" (67 cm). Louvre, Paris.

The figures here are maenads of the so-called Kallimachean type, because they are assumed (almost certainly erroneously) to copy a work by the late fifth-century Athenian artist Kallimachos.

relief, mosaic, and metalwork any number of similar-looking frenzied maenads with wildly blowing drapery: the style is appropriate to the subject and the connection became a convention. Given the persistence of Classical figural types in the artistic repertoire, the connection of this late Hellenistic maenad group to any Classical source is probably indirect at best. Both in its overall form and in the style of the maenads, the Sosibios vase is very similar to the Derveni Krater (see FIG. 96). It is likely that the Neo-Attic workshops produced luxury objects specifically in response to the Roman demand for what might be called "environmental" sculpture, and that both shapes and relief types were drawn from the tradition of metalwork, a mostly lost but highly significant art form in Classical and Hellenistic times.

One famous maker of metal vases who can be connected with the Neo-Attic school is Pasiteles, a South Italian Greek of the first century BC. According to Pliny (*Natural History*, 35.156; 36.39), this sculptor and metalworker never made anything without first constructing a model and wrote five volumes on famous works of art. From such statements one can visualize an artist acutely aware of the traditions within which he worked (early "art historians" seem all to have been artists themselves), a manufacturing process which included working from prototypes, and workshops within which a wide variety of media (bronze, marble, ivory statuary, reliefs, metal vases, and engraving) were worked by the same artists. This is precisely the sort of industry that one would expect to have emerged to meet the insatiable Roman hunger for objects that resonated with their wealth, political power, and philhellenic aspirations. Only one extant work can be associated with Pasiteles even indirectly—the youth signed by his pupil Stephanos in the Villa Albani, Rome (see FIG. 4). This is clearly a Roman statue worked in a Classical style. Its hairstyle, basic pose, facial structure, and anatomy are Severe in style, while its proportions are much more elongated, similar to those of Late Classical works. What is more interesting, the type recurs, alone and in groups, where it is combined with other classicizing works, themselves embodying a variety of styles (FIG. 113). These statuary types are used in much the same manner as the relief types on Neo-Attic works like the Sosibios Krater, again suggesting the existence of a closely co-ordinated and multi-faceted artistic production that employed a repertoire of stock figural types.

The late Hellenistic era, then, was less a "classicizing" style period than a time when many works of art were used, produced, and displayed in different ways and for different purposes from those that had prevailed in earlier times. Styles, especially but not

exclusively the Classical, were used as appropriate to the subject matter, according to traditional associations inherited from Hellenistic practise. The images themselves include both copies of earlier Greek works and new creations in an ostensibly older style; it is doubtful whether this distinction was significant to the Roman viewer, and it is in many cases irretrievable today. Then, as earlier in the Hellenistic period, Classical idealism was a meaningful stylistic option, both in itself and as a frame of reference for more dramatic and more realistic forms. As a continually existing norm, Hellenistic classicism cannot be limited in time nor can it be used to define an epoch; like the Classical itself, it incorporates both the timeless and the momentary.

Classicism and the Roman Empire

Just as Hellenistic kings and the societies they ruled developed novel uses for inherited Greek artistic traditions, so also did the Roman emperors exploit the visual resources at their disposal. In many ways Roman Imperial practise simply continued a tradition established already in the Hellenized late Republic. The display of sculptural arrays in public and private contexts, the making of copies and "classicizing" creations, and the Neo-Attic production of applied relief persisted into the later Roman Empire. The consistency of this output is demonstrated by our inability to construct a chronology of these monuments on anything but subtle (and disputable) technical criteria. Classical styles played a large role in this artistic sphere, since the preferred subjects—gods, goddesses, heroes, and scenes of myth—demanded or at least suggested such a choice. Roman official state reliefs often incorporated divine, heroic, or allegorical figures and these too tend to resemble Classical Greek counterparts. It may even be questioned whether Roman classicism is a meaningful category at all, since the distinction between the traditional use of Classical idealism and a deliberately retrospective classicizing allusion is not often simple to make. Nonetheless, there are some particular ways in which Roman emperors used Classical forms to convey specifically Imperial concepts. Since these too contributed to the construction of the concept of the Classical, a survey of a few examples will aptly bring our story to a close.

The initial problem of representation that faced the first Roman emperor was self-presentation. At about the same time that C. Julius Caesar Octavianus (63 BC–AD 14) chose and assumed the Imperial title "Augustus" in 27 BC, a portrait was developed that modified his earlier, more Hellenistic-looking, brash and youth-

113. "Electra and Orestes," early Roman Imperial. Marble, height 59" (150 cm). Museo Archeologico Nazionale, Naples.

The female figure here combines an Early Classical male head type—not unlike that of the Kritios Boy (see FIG. 84)—with a somewhat masculine version of a late fifth-century body type (the "Venus Genetrix").

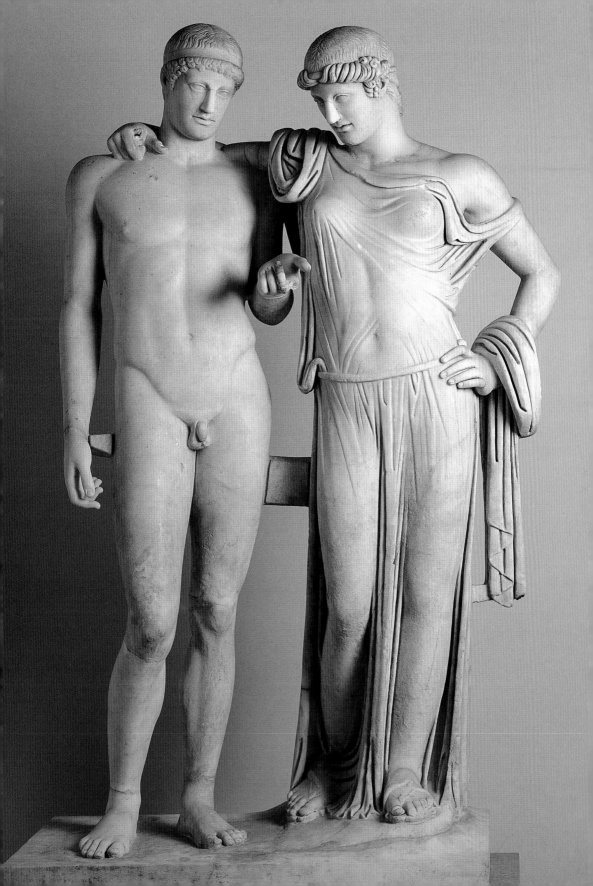

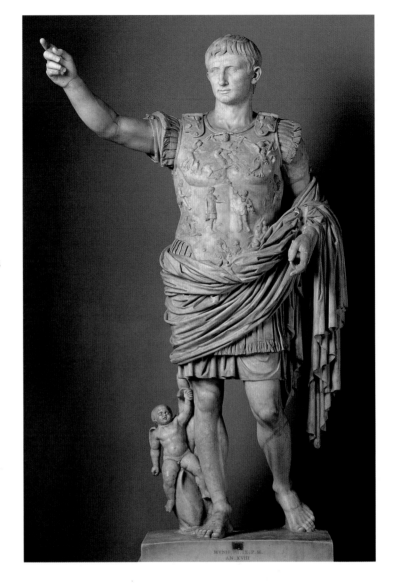

114. Portrait of the Emperor Augustus, from Primaporta, after 19 BC. Marble, height 6'7¾" (2.03 m). Vatican Museums, Rome.

A clue that this figure refers to a Hellenistic type rather than a Classical one can be detected in the wrapped hip-mantle, a garment entirely unsuited to an armed figure and not found on Classical figures. Such a draping is relatively common on Hellenistic depictions of gods and is worn by posthumous images of Julius Caesar as a god.

ful type by smoothing out the facial planes, arranging the hair in a simple pattern of crescent-shaped forms, and eliminating any facial expression. The type is called "Primaporta" from the famous cuirass statue found at the Empress Livia's villa in that suburb of Rome (FIG. 114). The portrait, like the title "Augustus," was meant to suggest a mutable status between mortality and divinity. Romans would not tolerate a divine king, and indeed Augustus took pains to appear to rule within constitutional limits, but the Hellenistic world that comprised the greater portion of the Empire was accustomed to more unapologetic forms of monarchy. For this particular message, the language of Classical

idealism was both perfect and precedented, since the style had long been used to suggest the distance of the gods from the real world and could here serve a similar function for Augustus. By negotiating between the polarities of mortality and divinity and of continuity and change, this style spoke to Greek and Roman alike in an idiom that each could understand.

We are left to wonder whether the Primaporta Augustus constitutes "classicism" in the sense of a stylistic revival or even, as many have interpreted, an implied parallelism between Augustan and Periklean "golden ages." The correspondence in pose between this statue and Polykleitos' Doryphoros (see FIG. 7) seems to suggest this, unless one considers the even greater similarity to more immediate and more compelling precedents in Roman art, including the image of the divinized Julius Caesar himself. That the Classical elements of style here function to convey certain ideas about the nature and status of the Emperor is clear enough. Whether they also function to relate the image to that particular past era in which those elements first appeared is a trickier question, and in the end the association must be both determined by the viewer and secondary to the more overt and timeless significance of the style itself. As in earlier times, the message emerges from a discourse between viewer and image, and our history of Classical and Hellenistic art has shown a continued ability to adapt images for new audiences. In that sense, Roman Imperial art is continuous with its Hellenic background.

Best-preserved and best-known of Augustan commemorative monuments is the *Ara Pacis Augustae* (Altar of Augustan Peace), dedicated in 9 BC at Rome. At least three distinctive styles are represented. The altar itself bears a depiction of a sacrificial procession in a straightforward, prosaic, typically Italic style. Four panels flanking the structure's two entrances reproduce mythological scenes of Romes early history (west) and allegorical assemblages (east; FIG. 115). The use of complex symbolic figures and a rich tapestry of landscape situate the latter in the Hellenistic tradition and, as was common in Hellenistic times, Classical features are used in meaningful ways. The central figure of the "Tellus" panel is clearly an earthy, maternal, nurturing figure; through her drapery she resonates with figure M of the Parthenon east pediment (see FIG. 16), and thereby also invokes the concept of Aphrodite, who as Venus was the divine progenetrix of the Emperor's own Julian family. This sort of visual intertextualization is as frequent in Hellenistic as in Roman art; we saw similar relationships on the Pergamon Altar. It is all but irrelevant whether we term it a "citation."

115. Allegorical relief from east facade. Ara Pacis Augustae, Rome, 13–9 BC. Marble, height 63″ (160 cm).

The message is clear enough: the central figure stands for a nurturing earth, specifically Italy, according to some; this concept is reinforced by the luxuriant landscape, livestock, fruits, and twin babies. The personified breezes to left and right seem to stand for land and sea, respectively, suggesting the extent of the Roman peace. More specific readings are debated, for example, exactly which deity the seated female represents (Tellus, Italia, Pax, Venus, or several of these) or the relationship of the children to Augustus' grandsons and heirs, Gaius and Lucius Caesar.

Perhaps more directly referential is the procession relief on this same structure (FIG. 116). Although the procession *per se* is a common enough topic in Roman art (especially triumphal and other sacrificial processions), the scene portrayed on the north and south wall of the Ara Pacis is unusually ambiguous for a Roman work—a quality it shares with the Parthenon frieze. There is no agreement whether the subject is the vowing of the monument, its dedication, or some other religious procession that may or may not have to do with the Ara Pacis itself. The participants are the Emperor, his family, and a wide array of attendants, priests, and other officials. Certainly, the Roman viewer knew the topic, as did an Athenian looking at the Parthenon frieze (see FIGS 57–60), and in both cases the main point was the procession itself with its implicit concept of piety. Each scene elevates its participants' status in the eyes of the gods; those on the Parthenon are shown as the best of the Greeks; the Imperial family is shown, in a pseudo-Republican context, as the present and future leaders of Rome. The two friezes also resemble one another in their figures' quietly standing poses, the degree of interaction among them, a relatively shallow depth of carving, predominantly profile treatments, and the arrangement of parallel processions on two sides both culminating at the structure's front. The idealized features of most figures on the Ara Pacis reflects a now standard treatment of all members of Augustus' family—a clear sign of his dynastic

aspirations. Here, too, the connection with the Classical is in the eye of the beholder. It is impossible to imagine that the designer of the Ara Pacis was unaware of the Parthenon, but this is not a slavish imitation or obscure quotation. Principles of Classical art, which never disappeared in Hellenistic times, were here employed for specifically Roman ends. The Ara Pacis does not indicate that Augustus was "reviving" any one lost golden age, but that he was willing and able to learn from a rich and varied past.

About a century after Augustus' death, an emperor was proclaimed with philhellenic tastes so marked that his contemporaries called him Graeculus, "little Greek." P. Aelius Hadrianus or Hadrian (r. AD 117–38) arrived with a very different background from that of Augustus. Born and raised in the Roman province of Spain, he was related to the Emperor Trajan and, it seems, groomed by him for Imperial rule. When he became emperor in 117, having spent much of the previous five years in Greece and Syria, he was acutely aware of the critical strategic and economic importance of the eastern Mediterranean to the Empire as a whole. He rejected the traditional idealized clean-shaven Roman-style portrait instituted by Augustus and imitated by Trajan, and projected an entirely new image of bearded philosopher-ruler

116. Releif scene from south enclosure wall, Ara Pacis Augustae, Rome, 13–9 BC. Marble, height 63" (160 cm).

This side begins with the Emperor, his lictors, and priests, followed by, from left here, Marcus Agrippa (Augustus' close friend and advisor), who is given identifying facial features, and members of the Emperor's family whose very idealized treatment forms a visual connection to Augustus himself.

117. Portrait head of Emperor Hadrian, from Ostia, second century AD. Marble, height 17½″ (44 cm). Archaeological Museum, Ostia.

The especially Classical-looking head displays an obvious similarity to Severe style works, with its highly patterned hair and beard and extremely simplified facial structure.

in a patently Hellenizing mode (FIG. 117). This new fashion is often explained as an affectation of Hadrian's personal taste for things Greek, especially art, literature, and other trappings of cultural connoisseurship.

Such an assessment underestimates the Emperor as a consummate politician. Hadrian was the first to recognize the increasing interdependency of Rome and her provinces, especially those lands of the former Hellenistic kingdoms that were Rome's major source of agricultural and other physical resources. Rome and Italy had become just one part, albeit an important one, of a single large political entity in need of cultural unification; the model of a central Rome with provincial satellites would no longer work. Hadrian needed to create a new image of the emperor that would speak to the entire Empire in the only visual language that could hope to effect that unification—Greek. He traveled widely throughout the Empire not only so that he could see it for himself, but so that the Empire could see him as well. At his villa near Rome, as we saw in the Introduction (see FIG. 3), he created an extensive and complex architectural evocation of the many environments he had experienced. In the provinces themselves, portraits were set up everywhere as tangible reminders of his benevolent presence, as were the temples, baths, libraries, and other public works undertaken on an unprecedented scale in Hadrian's time. The "classicism" of Hadrian's image is a multivalent phenomenon. It perpetuates the traditionally elevated status of the emperor and associates Hadrian with Augustus, god and founder of the Empire. As a different version of Classical form, it also marks a break from that tradition and reflects a changed attitude toward an empire now making new demands of its leaders.

A particularly revealing example of Hadrian's manipulation of the Classical can be seen in the figure of Antinoos (FIG. 118). Historians record that this Bithynian youth (the Emperor's companion and lover) drowned in the Nile and, as was customary

for those who died in this way, was considered divine by the Egyptians. The Antinoos cult was not, however, limited to Egypt; it quickly spread throughout the Greek-speaking east, where it was perpetuated by religious guilds or clubs. Statues of Antinoos were set up everywhere and, according to Pausanias (8.9, 8), "mystic" rites were observed in his honor yearly, an agonistic festival was held every four years, and most of his portraits portrayed him as Dionysos.

In Hellenistic and Roman times, the decline of *polis*-oriented religious rites and the emptiness of the state Imperial cult fostered the expansion of more personally oriented religious activity, especially the so-called "mystery" religions. The attraction of these lay in the sense of belonging that results from initiation and in the promise of an eternal spiritual life. Some, especially the popular Dionysiac cults, also involved orgiastic rituals, which had their own appeal. The Antinoos cult was clearly modeled after Dionysiac mystery religions, but because of the open association with the Emperor, it was aligned with Imperial cult as well. Hadrian established an entirely new cult that cut through both categories. Its adherence by small local associations of citizens disseminated its effect widely throughout the Greek-speaking population of the eastern Mediterranean, demonstrably an important audience for Hadrian. The youthful Classical form of Antinoos himself is a clear reminiscence of the Late Classical iconography of Dionysos that persisted through Hellenistic times. Like Hadrian's portrait, Antinoos' image too speaks the visual language to which its intended audience was accustomed.

Lucius Vibullius Hipparchus Tiberius Claudius Atticus Herodes (AD 101–77) was a native of Marathon, son of the first Greek to hold the Roman consulship, and consul himself in AD 143; by his very name and pedigree he symbolized a fusion of Greek and Roman culture. Herodes came of age in the reign of Hadrian, was a friend and associate of the Emperor Antoninus Pius (r. 138–61), and had a close relationship with his successors Marcus Aurelius (r. 161–80) and Lucius Verus (r. 161–69), beginning from their youths when both studied with him in Athens. One of the most conspicuous private benefactors of antiquity, he built the Odeion (enclosed theater) on the south slope of the Athenian Akropolis, which is still today one of that city's most prominent (and most used) ancient buildings. During the second century AD, the responsibility for providing

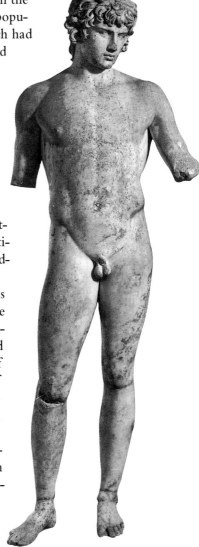

118. Portrait of Antinoos, from Delphi, ca. AD 130. Marble, height 70¾" (180 cm). Archaeological Museum, Delphi.

The languid, youthful aspect recalls treatments of Dionysos from Late Classical times, while the actual pose and anatomical rendering is more Severe or Early Classical.

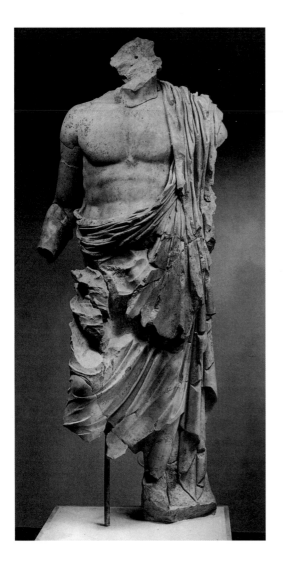

cities with public buildings and other amenities was increasingly borne by the local aristocracy, who were rewarded with Imperial honors and titles.

Especially representative of this symbiosis is Herodes' fountain building or Nymphaeum in the sanctuary of Zeus at Olympia. Although entirely ignored by Pausanias, this tall and elaborately marbled structure was filled with statuary and must have dominated views of the sanctuary after its construction in Antonine times. The dominant element is a two-storied semicircle of colonnaded statue-bearing niches. The lower group portrays Herodes, his wife Regilla (who dedicated the monument, according to the inscription), and other members of their family. The upper row shows Hadrian and the Antonine emperors with their wives and children. The connection between the emperors' family and that of Herodes is further underscored by the stylistic similarity among the various images, each of which continues the strongly Hellenizing trend begun by Hadrian.

At the center of each assemblage stood a statue of Zeus. One is seen as a copy of a High Classical original (FIG. 119) and the other as a classicizing creation (FIG. 120), but the implicit interchangeability of their usage here only emphasizes for us again the elusiveness of that distinction. The overtly High Classical style of both establishes their divine status in this gathering of idealized mortals; it may also have been meant to suggest Zeus' longstanding presence at Olympia—at that time over 900 years old and traditionally most prestigious of the panhellenic sanctuaries. Thus, the comparative and associative power of style continued undiminished—here linking the emperor with gods, the Imperial family with the emperor, and the commissioning family with this whole complex of powerful images, both mortal and divine.

Herodes Atticus cared deeply about the Classical past. From Philostratos' *Lives of the Sophists* he is known to have been a leading figure of the Second Sophistic. Based on the conscious imita-

tion of Classical models, this long-lived rhetorical movement provided an intellectual environment that encouraged such re-assessments of Classical achievement as that with which this book began. In Herodes and the works of his time, we see both the continued use of Classical forms for traditional purposes and a conscious speculation about the special qualities and normative status of the Classical works themselves. Form alone is not sufficient to distinguish between the two, and the dichotomy may be a false one since multiple meanings, readings, and motivations are not simply possible but certain.

An eminent scholar of ancient Greek art is reputed to have said that one gets the Pheidias one deserves. It is certainly true that later generations have found much of use in the features of Classical art, have eagerly used them for the purposes of their own day, and have created a concept of the Classical era designed to support that usage. It is also true that those themes and qualities which we associate with the concept of the Classical, as traced in this book, are fundamental and universal features traceable in Greek art from its Geometric origins to its merging with Roman traditions in late Hellenistic times. The "Classical," then, is a much-

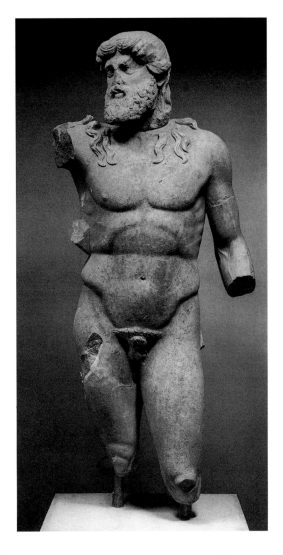

constructed entity. Winckelmann's teleological approach to organic development cannot help but construe the "older styles" of pre-Classical centuries as an anticipatory stage, the object and inevitable result of which was constructing the Classical, just as the "imitators" of succeeding ages contributed to a post-Classical construction of another sort. Classical style functions in the modern mind as a norm both for what preceded it and for what followed. To the ancient viewer it was that and more—an ideal of perfection continually but variably valid for each succeeding generation. As Plutarch in the first century AD realized (and in even more ways than he could have meant), the Classical was and is both momentary and timeless; that is its perpetual power and that is its eternal appeal.

119, 120. Classicizing statues of Zeus, ca. AD 160–70. Marble, height of 119 6'3¼" (191 cm); height of 120 65¾" (167 cm). Archaeological Museum, Olympia.

These two works were originally displayed in the Nymphaeum at Olympia. Fig. 119 replicates the "Dresden" type, held to follow a bronze statue of ca. 450–440 BC. Since fig.120 is not a replica, it is probably Roman.

Historical Events

Geometric
900–
700 BC

ca. 800–750	Greek alphabet invented
776	First Olympic Games
ca. 750	*Iliad* and *Odyssey* of Homer

Oriental-izing
700–600 BC

ca. 750–590	Greek colonization
ca. 650–580	Kypselid Tyranny in Corinth
ca. 620	Drakon lawgiver in Athens

Archaic
600–480 BC

ca. 590	Solon lawgiver in Athens
ca. 560, 546–527	Peisistratos Tyrant in Athens
ca. 550–520	Persians conquer Asia Minor, Mesopotamia, and Egypt
514	Assassination of Hipparchos by Harmodios and Aristogeiton
510	Hippias expelled from Athens
507	Reforms of Kleisthenes; institution of democracy in Athens
499–494	Ionian Revolt, crushed by Persians
490	First Persian invasion; Battle of Marathon
480	Second Persian invasion; Sack of Athens; Battle of Salamis

Classical
480–323 BC

479	Battle of Plataia, Persians withdraw
477	Delian League founded
ca. 476–461	Kimon leading citizen in Athens
ca. 460–429	Perikles leading citizen in Athens
454	Delian League Treasury moved to Athens
431	Peloponnesian War begins
421–416	Peace of Nikias
416–413	Sicilian Expedition; second stage of Peloponnesian War
404	Defeat of Athens, end of Peloponnesian War
ca. 404–362	Era of Spartan ascendancy to 371; Era of Theban ascendancy
ca. 359	Philip II becomes King of Macedon
338	Battle of Chaironeia (Greece under Macedonian control)
336	Death of Philip II, Alexander becomes King of Macedon
334–330	Alexander conquers Persian Empire
323	Death of Alexander

Hellenistic
323–30 BC

ca. 323–280	Hellenistic kingdoms formed: Ptolemies in Egypt, Seleucids in Syria, Antigonids in Macedon
241–197	Attalos I rules as first King of Pergamon
197	Philip V of Macedon defeated by Romans
167	Delos made free port under Athenian control
146	Macedonia made a Roman province
133	Pergamon willed to Rome by Attalos III
129	Asia (former Kingdom of Pergamon) made a Roman province
86	Athens sacked by Sulla, Roman general
31	Antony and Cleopatra defeated by Octavian at Actium
30	Death of Cleopatra; Egypt made a Roman province

Roman Empire
30 BC–AD 192

27 BC–AD 14	Reign of Augustus
14–68	Julio-Claudian dynasty
69–96	Flavian dynasty
98–117	Reign of Trajan
117–38	Reign of Hadrian
138–92	Antonine dynasty